THE CREATIVE HANDCRAFTS SERIES

W9-DBZ-242

JOHN ADKINS RICHARDSON

has been a sports cartoonist, a commercial illustrator,
and a technical illustrator
and has in recent years contributed to
underground comix.
Holder of a doctorate from Columbia University,
he is the author of two previous books:
Modern Art and Scientific Thought (1971)
and *Art: The Way It Is* (Prentice-Hall, 1974).
He is Professor of Art and Design
at Southern Illinois University in Edwardsville,
where he teaches art history and criticism,
drawing, and cartooning.

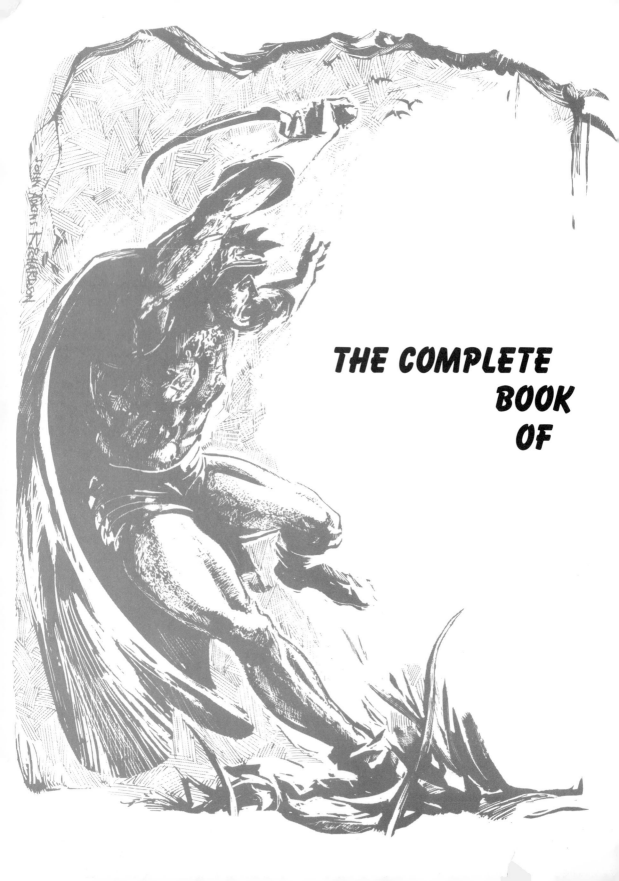

THE COMPLETE
BOOK
OF

THE COMPLETE BOOK OF CARTOONING

CARTOONING

John Adkins Richardson

Prentice-Hall, Inc., Englewood Cliffs, New Jersey 07632

Library of Congress Cataloging in Publication Data

RICHARDSON, JOHN ADKINS.
 The complete book of cartooning.

 (Creative handcrafts series) (A Spectrum Book)
 Bibliography: p.
 Includes index.
 1. Cartooning. 2. Caricature. I. Title.
NC1320.R5 741.5 76-28407
ISBN 0-13-157594-5
ISBN 0-13-157586-4 pbk.

Caricature of the author on the back cover by Robert J. Shay

The Complete Book of Cartooning
by John Adkins Richardson

© 1977 Prentice-Hall, Inc.
Englewood Cliffs, New Jersey

A SPECTRUM BOOK

Printed in the United States of America.

22 21 20 19 18 17

PRENTICE-HALL INTERNATIONAL, INC., *London*
PRENTICE-HALL OF AUSTRALIA PTY., LTD., *Sydney*
PRENTICE-HALL OF CANADA, LTD., *Toronto*
PRENTICE-HALL OF INDIA PRIVATE, LIMITED, *New Delhi*
PRENTICE-HALL OF JAPAN, INC., *Tokyo*
PRENTICE-HALL OF SOUTHEAST ASIA PTE., LTD., *Singapore*
WHITEHALL BOOKS LIMITED, Wellington, New Zealand

For Christopher and Robin

CONTENTS

LIST OF ILLUSTRATIONS

ACKNOWLEDGEMENTS

Although they are recognized elsewhere in captions and credit lines, I offer my appreciation to the publishers, artists, museums, galleries, and private collectors without whose assistance a book like this could never be published. And my gratitude, too, goes to Lynne Lumsden of Prentice-Hall for support and assistance. Richard Corben, Don Newton, Mark James Estren, and Jonathan Bacon have been extremely kind in their willingness to give advice and contributions of artwork. Also, the administration of Southern Illinois University at Edwardsville deserves much credit for being as tolerant of my interests in cartooning as my colleagues, my wife, and my students. But most of all, I wish to thank the members of "fandom," whose devotion to the comic pages caused me to conceive this volume, but particularly to: G. B. Love, Bill Pearson, James Van Hise, Alan Light, Bill Wilson, Jerry Bails, Jan Strnad, Gary Groth, Jean-Pierre Dupont, Meade

Frierson, Martin Greim, John Ellis, Ray Miller, Don Rosa, Bill Black, Kurt Rossman, Allen Matsumoto, Steven Grant, Fred Burkhart, Charles Pitts, Gary Johannigmeier, Gary McNaughton, John Brill, Bruce Mohrhard, and about a dozen others whose names will surely spring to mind the moment I see this in final print. Thanks!

DRAWING, TALENT, THIS BOOK, AND OTHERS

1

Most buyers of such books as this one dip and skip through them, settling upon those portions which seem most pertinent to their immediate interests. I do that myself. But it is not always a good practice. And this book is based on the assumption that you will commence at the beginning and follow along step by step, as if you were in a class pursuing a formal course of instruction— an assumption faulted by my inability to prevent you from doing whatever you want to do. If you simply cannot *bear* to proceed in the expected fashion then do this: find your way through the book by means of the index rather than the pictures. Why? Because material on different kinds of cartoons is distributed throughout the discussion and what you want to know may crop up in altogether unexpected contexts.

The second point to be made is that this is not a drawing text although it does, of course, deal with a particular

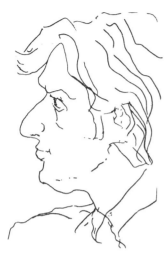

Fig. 1. Drawing made with pen held in the author's teeth

From John Adkins Richardson, *Art: The Way It Is,* p. 15 (Prentice-Hall, Inc., and Harry N. Abrams, 1973). Reprinted by permission of Harry N. Abrams

kind of drawing. Presumably, most readers already have some interest and experience in art. Abilities will vary enormously, just as they do in any group. For a few of you will be trained artists or printers adding another string to an already strong bow while others will be armed with nothing more than curiosity. Most will fall between. Given so wide a range, one can hardly do more than focus on the fundamentals. But that is not the same thing as restricting ourselves to what is elementary. In years of experience in university teaching I have learned that many people who believe they can draw do not draw well. I do not exempt myself. Frequently, those of us who have mastered one kind of draftsmanship are inadequate in another. Thus, the specialist in life drawing may prove quite inept with the landscape. Skilled realists are often incapable of painting a decent abstraction. (Curiously, the reverse is not so often true, despite the layperson's common-sense expectation.) These variations in abilities have very little to do with some sort of innate gift for the figure, landscape, realism, or abstraction; they have to do with learning, with emphasis, with interest.

Knowing how to draw is, for the most part, a question of knowing what to look for. Some will say that it is, in any case, a matter of something called "talent." Well, of course, some people have greater talent for grasping the visual facts than do others—just as some have a superior ability in mathematical reasoning, and others a gift for sleight of hand. But competency in drawing requires practice rather than extraordinary aptitude. Even manual dexterity has very little to do with it. Figure 1 is a drawing of a man's head that I have done with a felt pen held in my teeth. Figure 2 is a similarly shaky rendering of my right hand done by my left, the one that rarely holds a pen. No claim of quality is made for either case. And I am not particularly dextrous. Nor peculiarly facile with my teeth. I am not ambidextrous. Still, neither of the drawings looks amateurish. That is because even when the pen is infirmly held, so that its movements are ragged, knowledge is directing the positioning and general direction the lines will take. Now, had I tried to draw a horse I'd have failed. I don't know my quadrupeds the way I do human heads and hands.

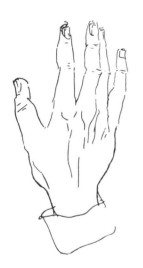

Fig. 2. Author's left-handed drawing of his right hand

From John Adkins Richardson, *Art: The Way It Is,* p. 15 (Prentice-Hall, Inc., and Harry N. Abrams, 1973). Reprinted by permission of Harry N. Abrams

The premise of this volume is a bit different from that of the usual how-to-do-it text. Typically, an instructional

manual on cartooning will have been written by a profes-
sional cartoonist of modest rather than major pro-
minence. And what you will learn from it is the way *that*
artist works, from pencil layouts to the finished product.
Of course, lip service will be tendered to the need for
originality, constant practice, further study, and so on.
The actual content of the book, however, will be
restricted to how that particular person does his work.
Volumes that survey the techniques of several different
comic artists are similar except that they condense the
treatment of each to the point of no return. Either kind of
book may be of genuine assistance to the neophyte. At
the very least, they can provide a false confidence in one's
ability to draw something, even if only by rote, and that
may lead to practice, to experiment, to something unique.
But learning to imitate a second-rate imitator of Milton
Caniff, Neal Adams, Charles Schulz, or Mort Walker im-
poses its own limitations and puts hazard in the way of
progress.

In this book we will devote a lot of attention to
various styles and techniques. But instead of providing a
sampler of things to imitate we will attempt to divine the
principle behind the techniques employed by the different
practitioners of this inky trade, cartooning. To take a
very simple example, there are at least three ways to
enhance the illusion of depth in the schematic landscape
in Figure 3A. One way is to make the light areas pro-
gressively darker as they recede into the distance (Figure
3B). Conversely, you could lighten the darks, leaving
the light areas alone (Figure 3C). Finally, you might com-
bine the effects (Figure 3D), making the lights grow
darker and the darks grow lighter. The principle involved
is always the same: *things high in contrast appear closer
than things low in contrast.* That is, the difference be-
tween lights and darks is greater nearby than far off.
Shrouding the distance in progressively deepening gloom
diminishes contrasts; losing things in a luminous haze
also does this. A combination of the two effects is most
common because it is relatively neutral and, therefore,
less apt to suggest a peculiar atmospheric condition or a
special mood.

It is important to understand that Figure 3 ex-
emplifies a principle and not just an academic device.
Since it *is* a principle it can be applied with unfailing ef-

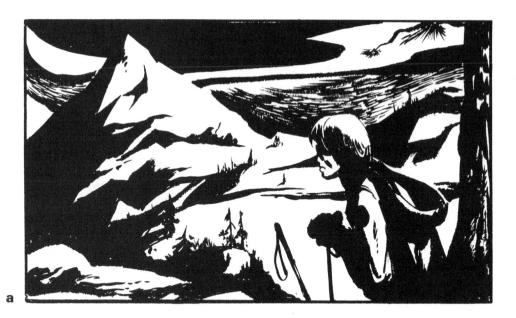

a

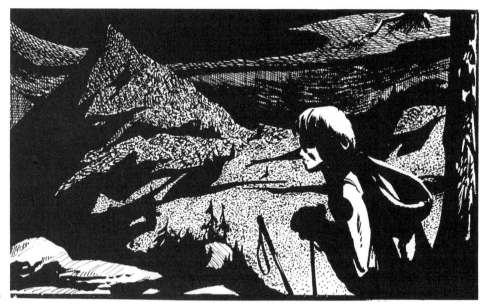

b

Fig. 3. a: *A landscape that needs an illusion of depth;* b: *Achieving depth by making light areas progressively darker as they recede into the distance;* c: *Achieving depth by lightening the darks and leaving light areas alone;* d: *Achieving depth by making the lights grow darker and the darks grow lighter*

4

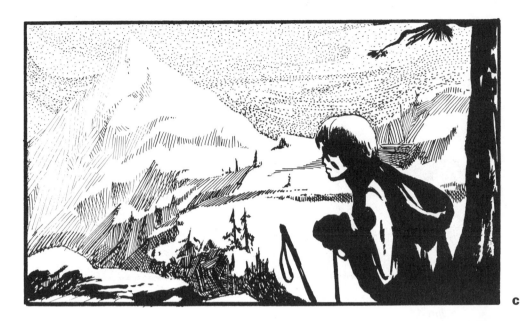

c

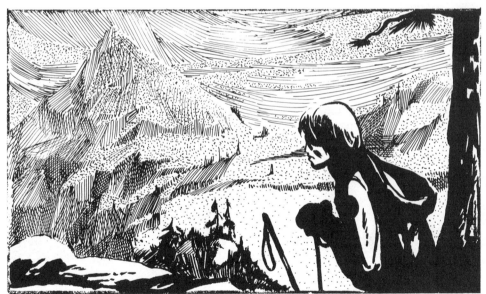

d

fect in any situation. For instance, if we wanted to emphasize the flat pattern of the mountains for the sake of a design with higher impact, we could simply reverse the light and dark relationships of Figure 3D, destroying most of the illusion (Figure 4). The picture does not,

5

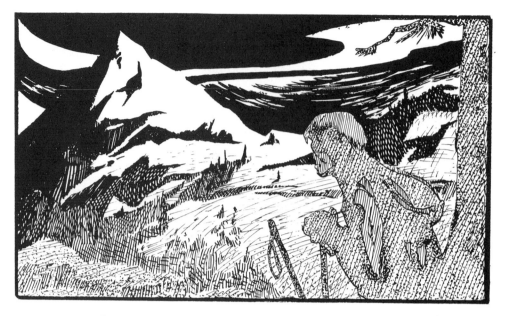

Fig. 4. Reversal of the light and dark relationships shown in Figure 3d

however, look flat because two spatial clues far more powerful than relative contrast have been retained in the design. One of these is the relatively smaller scale of things seen far away; we know that mountains only one-third the height of the figure must be distant. But the most important space principle of all is that of overlapping. Objects between the viewer and other objects overlap them. Thus, in Figure 5 the skier is overlapped by

Fig. 5. Overlapping used to indicate bizarre scale relationships

the mountains and we cannot resist the impression that the human being is gigantic relative to the landscape. Either the world is a miniature world or the skier is enormous.

Overlapping is so obvious a requirement of spatial order that it is rarely discussed. Even raw beginners understand that the relationships in Figure 6A are confused in Figure 6B. They learn swiftly, too, that coin-

Fig. 6. Unconventional use of overlapping can create misleading effects (b)

a

b

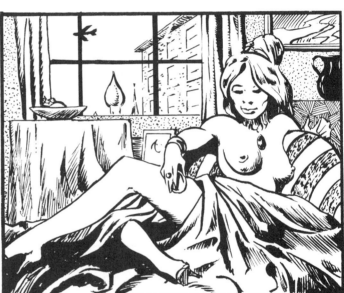

Fig. 7. a: *Ambiguous alignments (A), tenuous contacts (B),
and distracting parallels (C);* b: *More harmonious relationships*

cidences such as those in Figure 7A are disturbing and
that ambiguous alignments (labeled A), tenuous contacts
(labeled B), and distractingly obvious parallels (labeled C)
are to be avoided in favor of arrangements like those in
Figure 7B. What students may not be so quick to grasp is

8

that there are times when just such "errors" can complement otherwise realistic effects (see Figure 8) and that some styles derive a charming decorativeness from consistent application of exaggerated continuities. In overlapping, discontinuity evokes space while continuity stresses pattern at the expense of spatial clarity. Once the principle is understood it can be employed by the artist in any number of ways for diverse purposes.

Centering our attention on fundamentals will afford us a great economy of means and the capacity to explore

Fig. 8. Deliberate use of composition based on continuities for a special effect

many different styles, techniques, and fields of cartooning. Still, some of the things do not really involve visual principles so much as they do conventions that have emerged during the history of the medium. The balloons in which words appear in most comic strips, the tendency for things in humorous strips to be seen at a constant distance from the viewer while adventure strips shift the viewpoint from panel to panel, the expectation that "gag" cartoons are looked at before their captions are read—all of these, as well as certain ways of rendering figures and symbolizing emotional reactions, are more or less arbitrary. But because they are widely understood and their graphic effectiveness has been proved by prolonged exposure, they are things we cannot ignore. Therefore, while our focus will be upon the principles underpinning all of graphic art, the overall approach to cartooning will not be doctrinaire. A doctrinaire approach would, perforce, be narrow, and our coverage of the field should be as broad and thorough as possible in a book of less than gargantuan proportions.

In these pages the reader will learn not only how to draw cartoons but also how those images are handled by printers. Marketing and distribution systems are discussed. There is even a brief exposition of copyright law as it pertains to comic art. "And," as the pitchmen always cry, "much more!"

Still, let's face it. We can't possibly deal with everything one might need to know. To do a comic strip like *Prince Valiant* or *Rip Kirby* the cartoonist needs a very strong academic background in life drawing, perspective, illustrational composition, etc. To deal with all of those things is utterly beyond the scope of this book—or any one book. There is, however, a very complete bibliography beginning on page 249, organized for the student's convenience in terms of typical areas of interest. Also there is a glossary of studio and printing terms, some of which I have not had occasion to employ within this book.

CARICATURE AND CHARACTERIZATION 2

Why begin with caricature? Why not start with a discussion of comic art in general, or with a description of the tools and techniques used to create publishable cartoons? These are reasonable questions and plausible alternatives. But there is good reason for us to begin where Thomas Nast (Figure 9) concluded. Although we think of caricature as being his kind of specialty, it is in fact the basis of every cartoon. Even realistic comic strips are rooted in a tradition of the grotesque; thus the melodramatic contrast between Prince Valiant and ignoble Horritt (Figure 10) pays homage to the satirical origins of the medium.

In the second place, beginners frequently are so frustrated by first failures with artist's gear that they give up without really trying. Handling unfamiliar equipment at the same time one is learning how to draw demands too much of any student. Art schools do not

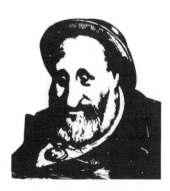

Fig. 9. Caricature is the basis of all cartoons

Thomas Nast, *Boss Tweed.* From *Harper's Weekly,* 6 January 1871. Private collection

11

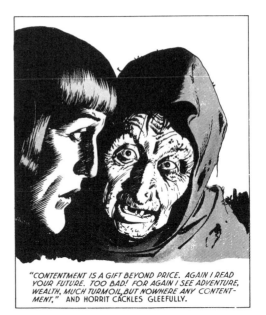

Fig. 10. The melodramatic contrast between Prince Valiant and Horritt acknowledges the satirical origins of cartooning

"CONTENTMENT IS A GIFT BEYOND PRICE. AGAIN I READ YOUR FUTURE. TOO BAD! FOR AGAIN I SEE ADVENTURE, WEALTH, MUCH TURMOIL, BUT NOWHERE ANY CONTENTMENT," AND HORRIT CACKLES GLEEFULLY.

begin their curricula with courses in oil painting and etching; introductory classes usually employ paper, pencils, charcoal, and crayon. Similarly, we shall commence by using the minimum—just paper and pencils.

SUPPLIES TO START

Plain bond typing paper will do nicely for the first exercises and you will need only three pencils to begin with. Drawing pencils are graded according to their hardness or softness on a fairly standardized scale. Commonly, those labeled H contain harder graphite (i.e., "lead") than those labeled B. The letter designation will usually be accompanied by a numeral. The higher the number, the harder (5H to H) or softer (B to 6B) the pencil, with the full range divided at center by a pencil called HB. An HB, 2B, and 4B should serve all your needs for the present. Actually, you can restrict yourself to just the 2B, but most people want a little more variety than that. You will, of course, also require a eraser. This can be of either so-called "pink pearl" or art gum. Initially, table height, lighting, and so forth can be just as it would be for writing. If you have a drawing table, so much the better. But it is not really essential.

A CAUTIONARY NOTE

And now, an important caution. Do *not* try to imitate the appearance of the lines and marks in my examples! For reasons to become clear in Chapter 4, most of my illustra-

tions have been rendered not in pencil but in ink. In due course we shall deal with inking. Until then concern yourself only with proportions, directions of lines, and the shapes of things. There is no point at all in imitating ink effects with pencil; that's like using a wrench to hammer nails.

Caricatures exaggerate notable characteristics and are typically (but by no means necessarily) confined to faces. At first we shall limit ourselves to the head and consider the matter in terms of deviations from what is normal.

FACIAL NORMS

There are many, many systems for drawing a normally proportioned head. All of them are based on the ordinary relationships of the average human skull, relationships which do not vary nearly so much as they may seem to. It is true that human beings differ greatly in appearance. But, when all is said and done, people are more alike than they are different from one another. And the commonalities form the bases of all portraiture and figure drawing.

In Figure 11 you see my progressive drawing of a head. I have opened with an ellipse. It is almost perfect and nearly vertical. Don't attempt to draw yours as

 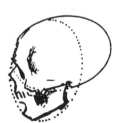

Fig. 11. Development of a human head

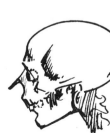 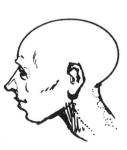

exactingly as that. Normally, I sketch the shape in rather loosely, but for purposes of clarity here I have used drafting tools for my diagrams. Having established one ellipse I then drew another connected to the first so that the ends protrude to about the same extent. This is the basis for a skull. *Observe that the top of the head is as large as the rest of the form and that, in fact, the face takes up a rather small portion of the whole.* This is very important to understand because the relatively massive size of the bony cage for the brain is an outstanding human characteristic. Skulls drawn too small and eyes too high are certain signs of amateurism. Far better to err in the opposite directions; then the deformities will be taken for some sort of perverse stylization. Successive developments from the skull to a fleshed head to a completed one pertain to academic drawing and need not detain us at this time. But you might remark that this head could have been of either sex. As it happened, I chose to go for the distaff in this particular one.

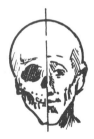 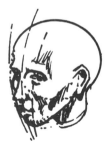

Fig. 12. The ellipse of the human skull varies according to the angle from which the head is seen

If you draw a head full-face front (Figure 12) or from directly in back, the ellipse of the skull will then become a circle. In three-quarter view it will be a slightly fatter ellipse than the one in profile. That ball of the skull will also be more prominent when seen from above and will decrease in evidence when the viewer looks at the head from below.

All of the heads so far have been based on the norms indicated in Figure 13. First, *in an adult, the eyes are approximately halfway down the face.* In some people the upper lids will be at that point, in others the pupils or lower lid, but some part of the eye will fall halfway between the crown and chin. (This is without taking head hair into account. Like chin whiskers, it is additional

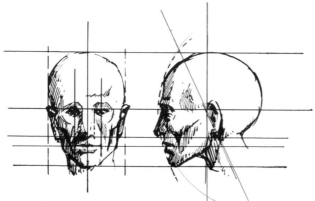

Fig. 13. The relationships of features and their sizes are quite consistent in the normal human head

material.) In much the same way, *an ear seen in a profile view will fall just behind a vertical line dividing the head into halves.* It will also have the same relationship to a line through the center of the neck following the angle of the spine. Most people's ears extend from the eyeline to the parallel touching the tip of the nose. Although lengths of noses and positions of lips vary considerably from person to person, the relations in Figure 13 approximate the average.

Relative widths of features are more consistent. The eyes, for instance, are about one eyelength apart when viewed from directly in front. (From an angle the distance from one to the other is less, just as the more distant eye will appear smaller.) More often than not, the pupils of the eyes fall directly above the corners of the mouth and the edges of the nostrils correspond to the inside corners of the eyes. This is true not only from the front but also from the side, except that in the latter case the lines of reference are curved, not straight. Notice the dotted line touching the forehead, lips, and chin, as it passes through the nose. This is the contour of a human face. Someone's face may look straight and not curved, but it never is unless the person is horribly deformed. Try drawing lines on photographs in some newspapers or magazines and you will see that faces are invariably curved. Lines that appear straight from the front will seem progressively more curved as the head turns to profile. In Figure 12 the second and third heads contain dotted lines indicating these correlations.

Practice a few heads to familiarize yourself with the proportions. And be aware that nothing will happen if you make a mistake. Move loosely and freely. Don't try

Fig. 14. Drawing ellipses as a basis for the skull

to draw as if you were tracing something. To put in the ellipses, for instance, take the HB pencil and, holding it just as you would to write your name, raise your hand slightly above the paper. Move the hand over the paper in an elliptical path, rotating it continuously (at about the rate you'd use to polish something) until you have established the size and pattern. Then let the hand touch the pencil lightly down onto the paper. Keep moving it as you do that. If the ellipse is too fat, change the motion a bit to compensate. If it's too lean, adjust your behavior accordingly. Of course, the ellipse is not going to be neat. It's going to look more or less like the ones in Figure 14. That's perfectly all right. And you don't have to erase.

Fig. 15. Even Michelangelo didn't draw every line right the first time

Michelangelo, *Studies for the Libyan Sibyl* (1510-1522). Red chalk on paper, 11³/₈'' × 8³/₈''. The Metropolitan Museum of Art, New York; purchase 1924, Joseph Pulitzer Bequest

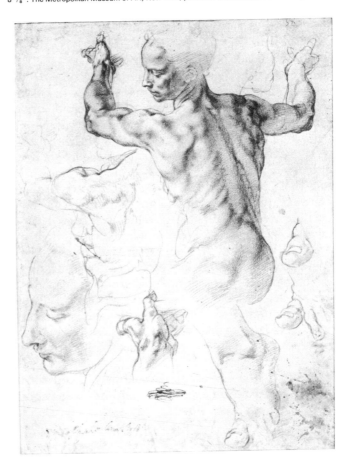

Pick out which lines you're going to use and ignore the rest of them. That's the artistic way.

Glance at Figure 15, a study for the Sistine Chapel ceiling by Michelangelo. Look at the left hand, both at the top of the page and in its disembodied form toward the bottom. There are lots of "wrong" lines. Now Michelangelo was unquestionably one of the greatest artists of all time. Yet he made marks that weren't right the first time—lots of them. And he didn't erase and correct, erase and correct, erase and correct, correct, correct. Are you better than Michelangelo? So don't worry. Be a little sloppy. Just try to keep the sketch lines a little light. Then use the 2B and 4B pencils to draw more definite forms on top of the sketchy ones.

Do at least a dozen heads, half in profile, half in full face. You will find that it's easier for you to draw profiles facing one way than another. Frequently, right-handed people find left profiles more congenial and southpaws incline toward right profiles. But don't give in to the preference too swiftly. Force a few of the others out of yourself just for practice. After all, not many pictures contain hordes of people looking only to the left or right. (*Everyone* finds the front view comparatively easy.)

We are so sensitive to customary scale relationships in faces that even slight changes will produce marked effects. The profile of the young lady at the extreme left in Figure 16 appears again in faint or broken lines within the five variations. An extension or suppression of the length of her nose and chin, along with different lengths for the mouth, diverse hair styles, and, finally, enormously raised eyes, give us a clownlike countenance, a frump, an Irish matron, a witchy crone, and a dimwitted drudge.

CARICATURE AS DEVIATION FROM THE NORM

Fig. 16. Even slight changes or exaggerations of the usual facial relationships can create many different characterizations

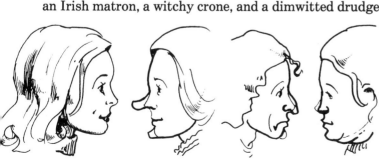

Draw your own "normal" face and try such variations for
yourself. They need not correspond to the illustrated se-
quence. Indeed, it would be better if they did not. Noses
might be round or turned up, eyes lower than average,
jaws much heavier, and so on.

As long as you are going to experiment with basic
proportions, you may as well play around at the same
time with mood and facial expressions. In Figure 17
you've a whole range of possible expressions, the mean-
ings of which are altogether obvious.

Radical deviations from ordinary proportioning will
generate the kinds of caricatures in Figure 18. Here the
faces are seen against ruled patterns based on common
correspondences. The first head is only moderately exag-
gerated; the mouth is wider than the centers of the eyes
and the jaw juts out to the sides in corresponding move-
ment. The result conveys an impression of the matinee

Fig. 17. A number of possible facial expressions

From John Adkins Richardson, *Art: The Way It Is,* p. 36 (Prentice-Hall, Inc., and Harry N.
Abrams, 1973). Reprinted by permission of Harry N. Abrams

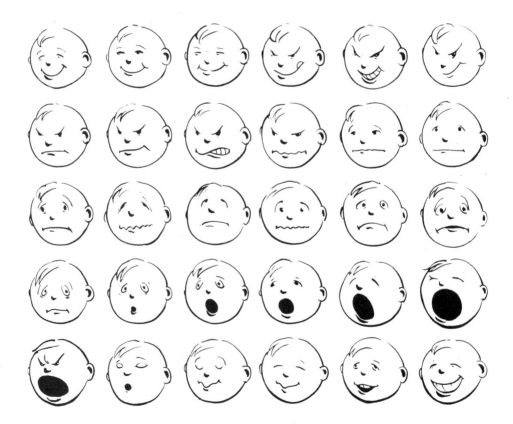

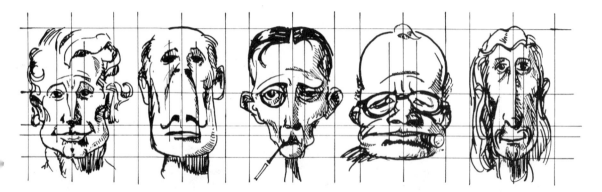

idol overblown. The other faces represent more egregious departures from nature's arrangements—enormously elevated eyes and nose, a shrunken jaw, eyes dropped low and extended along with the mouth, raised eyes and a lowered mouth along with a long, long nose. The consequences are obvious.

Work out your own inventions by means of simple variation. In doing so, however, you may wish to apply some alternative system instead of my double ellipse procedure. A common, simple one is the quartered circle (Figure 19). Again, the diagram has been devised with mechanical drawing instruments; the actual circle will be sketchy and irregular, like the one in the upper middle. And, again, the eyes lie on or near the horizontal and the ears just behind the vertical. The circle is conceived as a ball and in an angular view the lines follow an appropriate contour.

Fig. 18. Caricatures are created by deviating from the normal facial proportions

Fig. 19. The quartered-circle system can be used for caricature

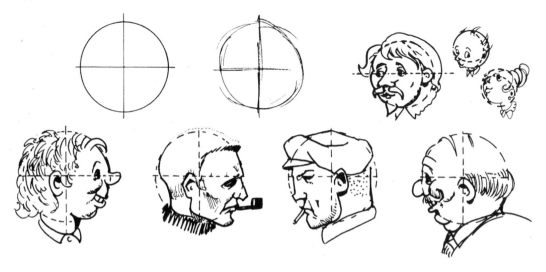

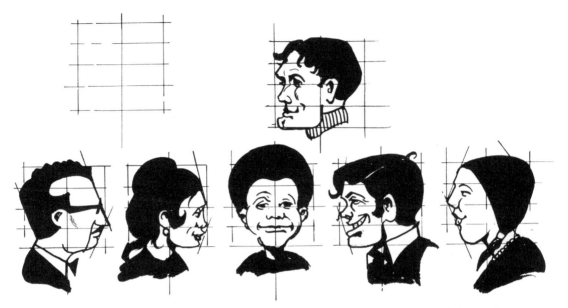

Fig. 20. The grid system, involving a four-stage box divided by a vertical, is another system used for caricaturing

Some artists prefer a grid system, involving a four-stage box divided in half by a vertical (Figure 20). It, like the circle, can be used for full-face and three-quarter views as well as for profile views. For most people the circle system seems to provide the greatest economy of means and the easiest route to some success.

Experiment with a caricature of your own device, showing the head in three positions, as if rotating from the profile through a three-quarter view to full-face confrontation.

Very few cartoonists, if any, actually lay out sketch lines for their drawings with the rigor that has been implied here. They use such systems as a mental device, to certify the relationships as they are sketched out. Thus, my caricature of actor Cary Grant (Figure 21) began in a lightly blocked suggestion of the head with reference lines for the eyes, nose, and mouth freely indicated. The

Fig. 21. Author's developmental caricature of Cary Grant

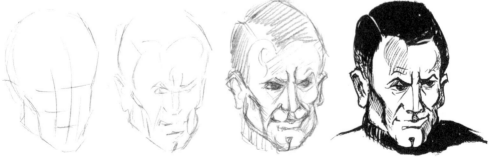

20

image was built up to a fairly complete pencil drawing and then inked. The drawings you are doing as we proceed along just now should have somewhat the character of the third one in Figure 21. As a pencil drawing it is seriously wanting; to do pencil work for exhibition you should sharpen the pencil to a special chisel-point and take far more advantage of graphite's ability to reveal delicate shades of black and gray. But we are not, in this book, concerned with the niceties of the pencil medium since our ultimate goal is to produce ink drawings from which the pencil marks will be altogether eliminated.

My picture of Cary Grant may seem to be more of a portrait than a caricature. His likeness is fairly easy to catch because it combines great perfection of feature with extraordinary muscularity. A slight exaggeration of these aspects of his visage renders up the interpretation in the upper left of Figure 22. Clark Gable, like Grant, was a motion picture star during the "golden age" of the film, when people were packaged for consumption by the public as "types" and became living caricatures of themselves. That's one reason they are useful people for a book of this type. Another is because the author can be pretty sure that everyone has seen them, either in the cinema itself or on television's late late show.

SOME CELEBRITIES

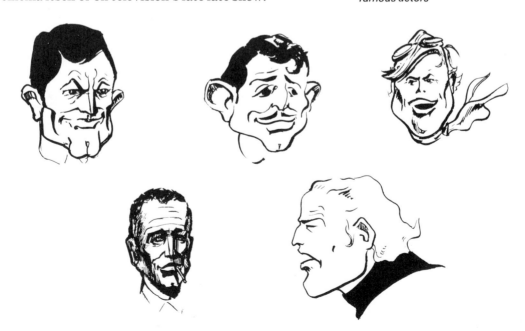

Fig. 22. Caricatures of some famous actors

Gable is one of the easiest of all handsome men to caricature. All you need is a stereotypically good-looking fellow with a slightly hooked nose, sleepy or squinty eyes, a moustache, and elephantine ears. The third face in the array is a star of the seventies and is not so recognizable. Robert Redford has a large face, small features, and a trade-mark shock of blond hair. With an angular nose he'd look just like John Kennedy's youngest brother, Edward. For me, he is far more difficult to draw than his frequent co-star, Paul Newman. Newman's face is curiously regular and his most remarkable features are a classically sensitive mouth and a gaze hooded by the shade of his brow. One of the truly unique-looking motion picture stars is Marlon Brando. His profile is easy to remember, easy to draw.

Woody Allen (see Figure 23) is a comic genius who has turned his entire persona into a stereotype of the

Fig. 23. More stars

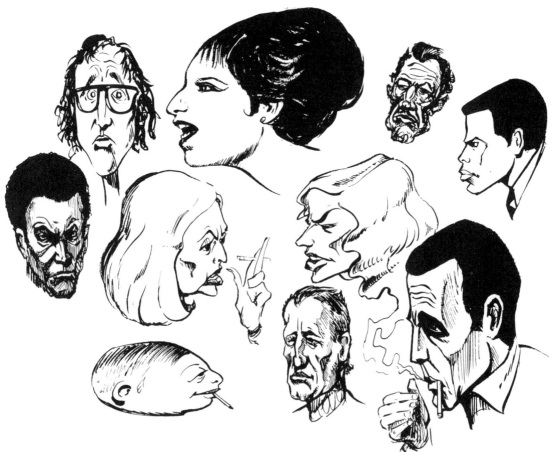

Jewish schlemiel. Long face, small mouth, droopily worried eyes, horn rims, and frazzled hair like limp nerve endings equal the Allen character. Barbra Streisand has turned a stereotypical profile into something incomparably elegant through practiced self-exhibition and exceptional talent. Richard Boone's countenance is hardly more than a long loaf of lumps. But black actor Sidney Poitier has features of such exquisite refinement and balance that caricatures of him come out resembling diagrams. His colleague Raymond St. Jacques is not so beautiful; like Newman's, his character is all in the mouth, eyes, and attitude. Bette Davis is an old standby for caricaturists and impressionists (who do a theatrical version of the same thing). The bored eyes, bitter mouth, and small, beaklike nose are brutal intensifications of elements from an extremely elegant phiz. Like Peter Lorre, directly below her, she *is* the character with these traits. All others are mere "look-alikes." Lauren Bacall, on the other hand, is one of a set, as it were, containing Ella Raines, Lizbeth Scott, and half-dozen other angular and elegant husky-voiced seductresses. But her version has been made the most memorable by the chemistry reacting between her and Bogart. He looks as though he'd be very easy to caricature, but it turns out that his distinctiveness is rather more due to mannerisms than to those hound-dog features. For his picture to metamorphose into one of the radio/TV commentator Edward R. Murrow requires only the slightest, indescribably minute changes. George C. Scott is a similarly feisty professional; his slablike mug radiates vigor and determination.

One more thing about Figure 23. Notice that Sidney Poitier does not have dark skin and that St. Jacques' lips are not thick. Both of these men have regular, finely chiseled features. In point of fact, most black people are no more black in color than whites have ever been white. And, even when they are dark-complexioned, the shape of their features will be more identifiable than their hue. The notion that all Negroes have thick features and broad, fat mouths does not reckon with the prodigious diversity of the African tribes. In any event, the standard "mushmouf" Sambo, Rastus, Pearline stereotype (Figure

STEREOTYPES TO AVOID

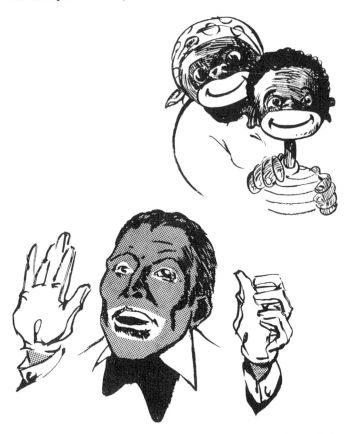

*Fig. 24. The "mushmouf" cari-
cature, which typically relied
on racist stereotypes rather than
on facts or visual observation*

*Fig. 25. Minstrel show make-
up, which provided a basis for
inaccurate caricaturing of blacks*

24) is not drawn from an Afro-American reality. It is a
caricature of a caricature based, not upon living human
beings, but upon the stage makeup of the blackface
minstrel show (Figure 25). When you caricature a person,
use your eyes and mind and heart, not your preconcep-
tions and someone else's prejudices.

**ON DOING YOUR OWN
CARICATURES
FROM PHOTOGRAPHS**

Try a few caricatures of celebrated people for yourself. Do
about five dozen of them before you show them to anyone
else. Do women, men, blacks, whites, Orientals, American
Indians, blondes, brunettes, redheads. Obviously, you'll
need photographs for your models. Where possible, com-
pare what you have done with what others have done of
the same people.

You should understand beforehand that every
caricature is also a bit of a self-portrait of the cartoonist

and that no two caricaturists will do exactly the same kind of thing with the same subject. Richard Nixon's is a very easy face to satirize. Those small, deep-set dark eyes, the scooped nose, heavy beard, and lofty brow, all would seem to predetermine every image. But just look at the differences among the portrayals of the one-time president by noted editorial cartoonists (Figure 26).

The fact that successful professionals differ in their vision is one reason that your drawings should not be expected to match up with anyone else's. But it does not mean that *whatever* you do is therefore justified as a sort of likeness. For instance, my drawing of Robert Redford is not convincing *enough*—to make just that point I have gone ahead and left it in the book. After all, the point of caricature is to convey a certain point of view to others. So check yours out with friends and family. See whether or not they can identify the subject. Most of you will be frustrated for quite a while and will shortly exhibit hitherto unrecognized impatience with your loved ones. Most of the time they'll not have the faintest idea of whom the person could be. Believe me, such obtusity is infuriating and you will have to keep reminding yourself that it is the job of the artist to communicate the image as well as possible. It is *not* the job of the observer to make you happy by puzzling out who might be the subject of an obscure drawing. Caricature takes practice, practice, practice.

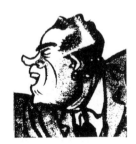 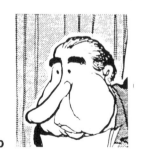 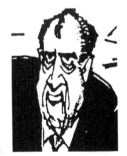

a b c

Fig. 26. Although Nixon's features lend themselves to easy caricaturing, no two cartoonists draw him in the same way

a: Detail of an editorial cartoon by Herblock (from *Herblock Special Report;* W. W. Norton & Co., Inc., 1974); *b:* Detail of an editorial cartoon by Patrick Oliphant (© 1974 Washington Star; reprinted by permission of Los Angeles Times Syndicate); *c:* Detail of an editorial cartoon by Paul Conrad, showing Nixon as an automobile salesman who is leaning on a Ford sedan, saying, "Have I got a deal for you!" (© 1974 The Los Angeles Times; reprinted by permission)

Let's confront a real possibility. Maybe, after weeks and weeks of strain, tears, fury, practice, embarrassment, more trials, successive failures, and still further practice, your caricatures remain as incomprehensible to viewers as ever. Surely this *is* going to happen to a few readers. Well, it may be that the specialized side of caricature— the grotesque portrait—is simply not your suit. That's possible, after all. But don't throw over the entire field of cartooning on that account. By the time you've proved to yourself and to all others that you're no threat to Al Hirschfeld you'll have at least gained a lot of practice in drawing heads that look like someone, somewhere. In fact, every one of you will experience that mixture of frustration and ego reinforcement that comes when everyone on hand says, "Perfect! It's Charles Laughton to a *t!*" and *you* were aiming for Winston Churchill. In such circumstances I am confident that your ethical standards are no less stringent than my own. The only way to respond is with a lofty enunciation of principle: "Yes . . . I've always enjoyed his films . . ."

ON CARICATURES OF THOSE YOU KNOW

Assuming that you have had some degree of success with celebrities done from books and magazines, you will wish to apply the acquired skills to those around you. Probably you will find this more difficult than working from snapshots and newsphotos. But you will also have already discovered that the more caricatures you do, the more naturally and easily recognizable are the next ones that spin from your pencils. Really, it's like some sort of beneficent enchantment. Still, doing caricatures of acquaintances can be a risky business indeed.

Most of us enjoy caricatures of other people but we are not usually so enthusiastic about those done of ourselves. Therefore, a subject will sometimes say: "I don't believe I look like *that!*" It's always true, of course. They don't look like that. Clark Gable did not have ears half the size of his entire head. If you ever saw people proportioned like those in Figure 18 you'd be appalled by their deformities. Usually, the aim of caricature is not to flatter; it is to deflate. If observers think the drawing captures the subject at the same time the subject himself is outraged, you've probably done a very good and

penetrating job. But be very sure of your subject's emotional balance and sense of humor before you undertake a caricature of a spouse, lover, blood relation, or lifelong friend. And if the reaction to your piece is surprisingly negative, cast artistic integrity aside. Agree that you have failed and let it go at that. No frivolous drawing is worth the sacrifice of a personal affection.

Again, too, there are many ways of seeing the same person, even when the same cartoonist is doing the watching. Although I cannot pretend to be pure of vanity, the years have inured me to insulting truths. In Figure 27 I submit a number of caricatures of me

Fig. 27. These caricatures of the author show that there are many ways of seeing one person

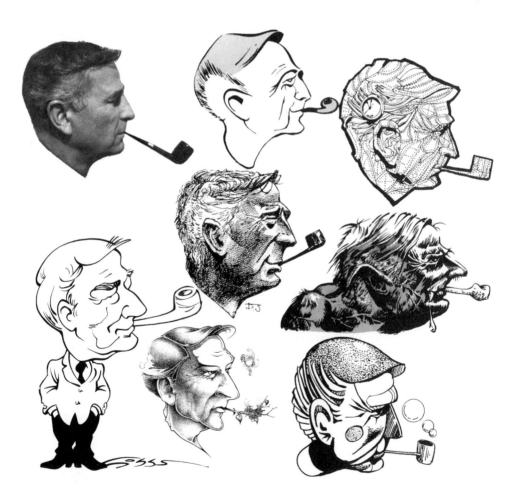

done by some who are, or have been, students of mine. Obviously, the subject has fairly regular features beginning to wrinkle, sag, and get jowly with age. The caricatures have magnified these characteristics in different ways, here stressing some at the expense of others, there playing up what someone else suppressed. One fellow sees nothing benevolent about his monstrous instructor and another considers me quite mechanical in my approach. The most successful, by nearly universal agreement, are the two on the lower left by Steve Gibbs and Tim Stambaugh. Yet, there are those who prefer the earlier one on the back cover of this book, done by R.J. Shay.

HANDS A number of observers have noted that one reason Gibbs's drawing is effective is due to the fact that he incorporated a characteristic pose. That is true, certainly, but its absence from all the others makes a point. Look back to Figure 23. Bette Davis and Humphrey Bogart are smoking cigarettes. Davis holds hers out with the sharply insouciant grace so typical of her; Bogie, in a similarly typical gesture, reaches with a cupped hand for his. Cigarette smoking played a large role in the vocabulary of cinematic movements during the thirties and forties, but the social significance of this is of no moment to us as cartoonists. The main weight of the smoking habit is carried by hand movement, and hands are as important to characterization as anything except the face itself.

Hands are also larger than most people think. Always, they are about the length of their owners' faces. That seems too large, I know, but you can check it out right now by placing your hand to your face and looking in a mirror. If the wrist is at your chin the fingertips will be near the hairline or, in cases like mine, where that line used to be.

"Everyone" seems to know that hands are difficult to draw. Well, there is something in this folk wisdom, but not terribly much. Hands pose problems in drawing because they are very complicated structures, with opposed thumbs, finger segments of constantly varied

scale, and a seeming infinity of postures. Unfortunately, their absence from a figure is almost certain proof of insecurity and ineptitude. Beginners will put their drawn figures into the most tortuously affected poses just to avoid drawing hands. And, even where the picture looks plausible in spite of this ploy, its expressiveness is apt to suffer from the curious self-constraint of those portrayed. Most of us do talk with our hands to some degree; at any rate we don't hide them. The drawing of hands is an essential. Fortunately, cartoonists—as opposed to portrait painters and illustrators—have lots and lots of leeway. Their hands don't have to be any more realistic than are the faces they draw.

Still, although a cartoonist may be able to get away with hands that look like paws, or flippers, or bundles of sticks, the movements and gestures of those hands will not be effective unless they derive to some extent from prosaic reality. Therefore, let us consider the simplest possible model for a modestly realistic hand. It appears at the far left in Figure 28 and could be either a right from the back or a left seen in palmar view. The dotted lines indicate where the fingers might fall, but for the moment think of the thing as nothing more than a solid wedge with a hinged thumb attached to its side.

We will presume that this is a right hand. If seen on edge it would look as you see it in the first place in the top row, fingers connected to the palm where the dotted line occurs. Now, to draw a pretty convincing hand all you have to do is leave out the hinge area of the thumb and take out the dotted line. Put a thumbnail on the thumb. And, to really finish it off, add the fingers as I have: the edge of the wedge becomes the index finger; the middle

Fig. 28. Knowing how to draw hands is important in cartoon characterization

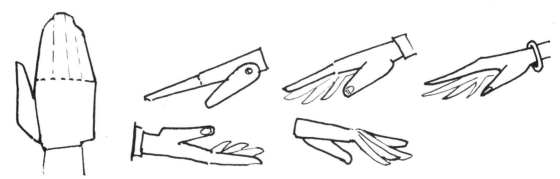

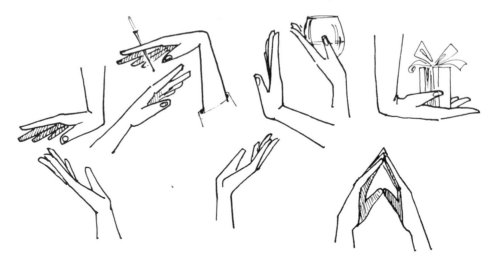

Fig. 29. A single hand posture at different angles to the wrist

finger is just like it except a bit longer; then a ring finger and little finger, each trifle shorter than the previous digit. If you want a definitely "feminine" hand simply make the fingers pointed instead of blunt. Our palm-up view is nothing but the palm-down view turned over. The right hand seen from the other side differs only in that the drooping fingers and the edge of the palm now overlap the thumb and index finger. A left hand is, of course, nothing more than the reverse of the right-hand pattern.

Our model is very useful and I have not chosen this particular pose arbitrarily. Of hand postures, this is the most common and most flexible. There is, however, another important element involved in making good use of the simple hand we have learned to do—an element too seldom stressed in books of this sort. It is the wrist.

On the top row of Figure 29 our model hand appears over and over with only one essential variation. It is poised differently on the wrist. That is, its angle to the forearm is different in each case. And see what a tremendous difference in effect it gives. Of course, the objects it holds also influence the impressions we receive. But you should try drawing similar poses with different objects. Substitute a pencil for the cigarette holder, a rose for the glass, a highball for the gift. In the second row there are two pairs of hands in a gesture of helplessness (or welcome) and thoughtfulness or possibly prayer. Here,

besides the strategic attitude of the hands to wrists I have made a tiny change in the positions of the fingers. But the change is not something you could not have accomplished for yourself.

Before you do any more drawing of hands you might study Figure 30. The arrows on the first hand point to the joints along the tops of the fingers. *Each finger (excepting the thumb) is proportioned in the same way; going out from the palm, each segment is two-thirds of the one nearest the palm.* This is true of the bone elements whether seen from above or below, but in a hand covered with flesh it does not appear to be. Then the segments appear to be equal on the bottom of the fingers, as I have indicated with the arrows in the second drawing.

This hand, now, is going to close. And its various states on the way to a fist reveal a reliable principle of how to draw hands in a variety of positions. *Normally, a hand closes with the little finger folding into the palm first, then the ring finger following, the middle next, and the index last of all.* Try it. Close your hand naturally and slowly. Aha! Hadn't noticed that before, had you? As it happens, virtually every hand gesture or posture is nothing more than a step from openness to closure. (Thus, in my sequence I have interrupted it to show a hand pointing. That is merely the loose fist with the index finger extended.) When you combine these finger positions with the variations of the wrist you have a battery of possibilities. In fact, it would be good to try some out. Take the last hand on the top row and try relating it to the arm at various angles. Like our original model, it will evoke all sorts of impressions.

Fig. 30. A hand closing

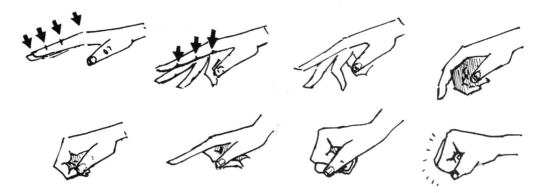

Drawing hands as if seen from the edge can achieve so much that one might be tempted to go no farther. But the time soon arrives when the simple model will not suffice. To cover all of the intricacies of the hand would be quite impossible for us—the bibliography contains books that deal at length with specifics—but one other bit of information is vital for the cartoonist. It will also clear up something that may have puzzled you but is almost never discussed.

Have you ever noticed the hands of the Walt Disney characters and most other "funny animals"? They are short a finger! That is, they've only three fingers and a thumb. This convention stems from the facts of animal anatomy only in small part; more important is the fact that such hands are more easily animated for film than realistic ones. But the ubiquity of three fingers (which even comical human beings such as the Seven Dwarfs and Elmer Fudd have) derives from a principle of hand movement.

Fig. 31. The principle of the three-fingered hand

In Figure 31 we see, at the top, the funny animal extremity. Proceeding across from left to right, the hand is

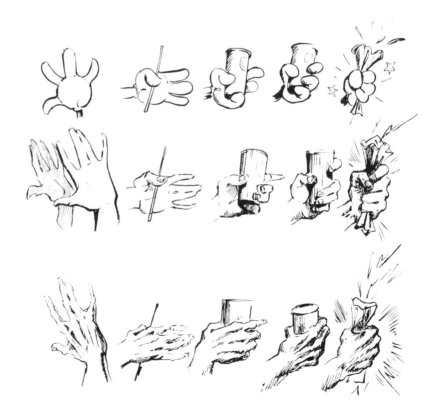

shown closing. First, the thumb moves against the palm. Then, with the thumb out a bit, the hand shifts in the expected fashion, little finger first into the palm and so on until at last the fist clenches shut. In this instance it holds a container but different kinds of things could have been substituted at each point. If you compare your own hand closing with the states of the three-fingered one, you will see that the stair-step-like slant of the fingers is common to both at every point up to the final sealing of the fist. But there is also something else to see. It is revealed in the parallel between the three-fingered hand and the five-fingered one below which follows the first's movements in serial order. *In most gestures the middle finger tends to pair up with either the ring finger or the index finger.* In other words, usually two fingers are operating like one big one and one of the two fingers is always the middle finger. On the far left in the second row both probabilities appear, with the most likely one to the fore and the less common one shaded.

The third row of hands is, of course, a back-hand view of a right hand doing precisely what the left was doing just above.

Figure 32 shows hands that are not authentic-looking in the way of the realistic ones in Figure 31; they are more "cartoony." But these, too, are emanations of the principles outlines above. They are simpler in appearance but artful all the same.

Fig. 32. Varied cartoon hands showing the principles of hand movements

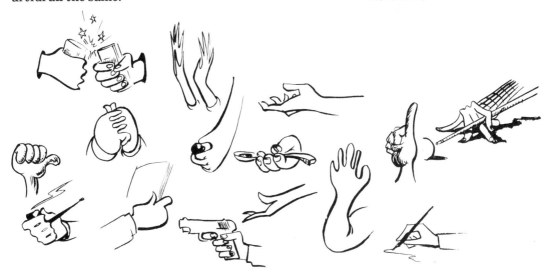

FEET Feet are not nearly so complicated to draw. But they tend to be rather awkward to handle without knowing a few particulars. In the first place they are about three palmlengths long (i.e., one-third longer than a hand) and the extra space is heel. For some reason people seem to neglect the fact that the heel extends behind the ankle. But it does, and that is what the pattern in Figure 33 is designed to counteract.

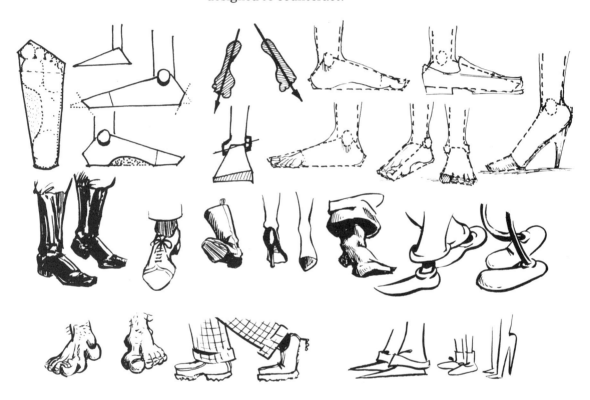

Fig. 33. Principles and proportions involved in drawing feet

As with the hand, the system is based on a sort of carpenter's model. From above the shape is an irregular pentagon and from the side a scalene triangle with the apex covered by the end of a rod hinge and the other two points chopped off. There is a flexible joint just behind the little toe and across the ball of the foot. The ankle hinge is, in reality, the end of the lower leg reduced to absurd simplicity. Note that from front or back the two protuberances are on an angle, with the lower of the two bumps on the outside of the ankle. One other point: In vir-

tually any posture, the foot will be at an angle to the axis of the lower leg, toes pointing outward, away from the body.

Most human feet are seen shod in leather, but you may want to draw a bare foot or one clad in a tight fabric. Notice, then, that the big toe turns up and that the other toes curve downward.

Figure 33 reveals much of what you, as a cartoonist, will need to know of proportions and principles. So draw a bunch of feet to go with your hands. And, no matter how far your figures are from the mundanely naturalistic, keep in mind the existence of that heel protrusion.

We seem, perhaps, to have strayed quite far from caricature. But we haven't, really. The connection is quite obvious in the series of panels in Figure 34. Each panel shows the same figure running toward and away from the viewer. The feet become progressively less true to life as we move to the right. The initial panel is the most realistic; I have indicated the way the axis of the foot diverges from the tibia. The second panel is similar to the first except that the feet are in opposite positions and the figure is clad in a sort of superhero gear. With the third set of feet a new situation emerges. This stride is very common in adventure comics but it is not a genuine part of running. We can see the sole of this man's boot, mak-

Fig. 34. Knowing about movement and posture is as important to caricature as are proportion and position

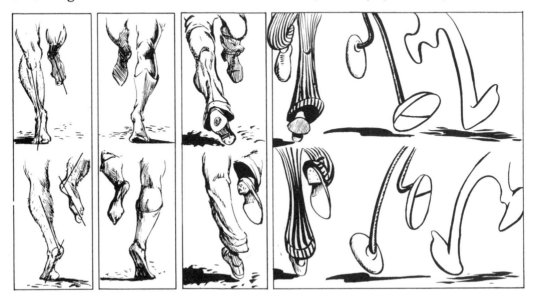

ing it seem to us that he is running much faster than the superhero. But no one runs like that. The only time you can actually observe the bottom of a runner's foot from the front is when he or she is hurdling something. What the cartoonist does is exaggerate the stride so that it becomes a phase of leaping. Such release from the earth conveys to the viewer—in a very basic and spontaneous way—that the figure is "flying" down the street. As it happens, the more unreal-looking the figure the more easily can one accept this defiance of gravity's law, even when no mad dash is hinted at. Thus, in the final panel the legs seem first to be loping along, then trotting, and finally just hastening. Movement and posture is, you see, as much a part of caricature as are proportion and position.

By now you are somewhat familiar with heads, hands, and feet. It remains for us only to fill in the spaces between.

WHOLE FIGURES AND HALF ANIMALS 3

As before, we shall begin by considering a norm and then describe deviations from it.

There are a great many canons of proportion for human figures. Some are very ancient and most of them are worked out in terms of *heads*. In this connection the term "head" refers to a module and not to a specific dimension; that is, a very short person with a small head might be 8 heads tall and a 6'6" man with a large head be only 6½ heads tall. My diagrams inevitably imply that more heads equal a taller person, but that is not their point. We are concerned with proportions and not with scale.

THE MALE FIGURE

The average man or woman is about 7½ heads tall, in a proportion first noted by the Greek sculptor Polycleitus (active c. 450–420 B.C.) who worked out a canon of ideal proportions of which only rudiments have come down to

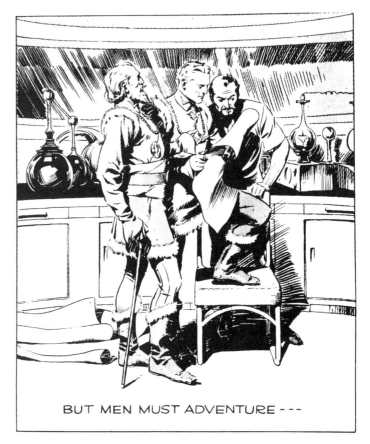

BUT MEN MUST ADVENTURE - - -

Fig. 35. Most adventure heroes in cartoons are 8½ heads high

Alex Raymond, *Flash Gordon.* © 1939 King Features Syndicate, Inc.

us. Later Greek sculptors, notably Praxiteles (active c. 370–330 B.C.) and his near contemporary Lysippus, lightened the proportion to 8 heads. By the time of Michelangelo (1475–1564) the ideal proportion for a male figure was 8½ heads, a proportion rare among living men but extremely impressive in statuary. Because of its applications it came to be known as the "heroic proportion." You will find that most adventure heroes in the comic pages are 8 or 8½ heads tall (see Figures 35 and 36). Granted, this is not true of every one of them. Prince Valiant (Figure 37) is normally proportioned. But one finds more heroically proportioned protagonists in the adventure stories than one finds ordinary men. Caniff's

Steve Canyon is 8 heads tall and so are Overgard's Steve Roper and Mike Nomad. For our proportion, then, we shall take the heroic exaggeration instead of the everyday reality.

The character who stands at the extreme left of the lineup in Figure 38 is 8½ heads tall. Although he is abnormally well-formed, he does exhibit some of the attributes that are standard for all regularly formed human beings. Arrows point out three important ones.

First, *in a standing, stable figure the head will be above the ball of one of the feet when seen from some vantage point or other.* (That is, if a figure stands with his feet spread and you observe him from the front, his head

Fig. 36. Another 8½-head-tall hero

Neal Adams, *Green Lantern.* © 1970 National Periodical Publications, Inc.

Fig. 37. This familiar cartoon hero is proportioned much like average men and women—about 7½ heads tall

Harold Foster, *Prince Valiant.* © 1943 King Features Syndicate, Inc.

IN THE COOL, CLEAR DAWN, THE YOUNG KNIGHT STANDS OUTSIDE THE UNWHOLESOME DEN....A LONELY, UNHAPPY FIGURE. NEXT WEEK- **Homesick.**

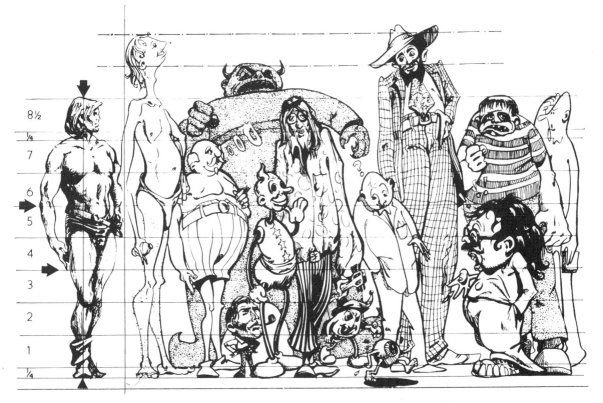

8½
¼
7
6
5
4
3
2
1
¼

Fig. 38. The arrows at the first figure point out some of the attributes that are standard for normal human beings. These three correct relationships are retained in most of the other figures, even though there are gross distortions at other points.

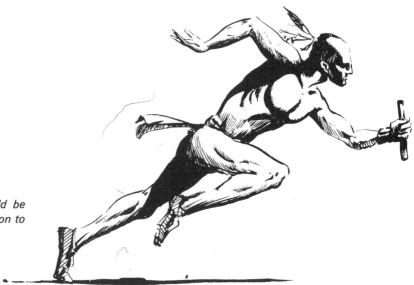

Fig. 39. This pose would be impossible for a real person to achieve

is directly above a point between the feet. But when observed from the side it will be clear that his head is at a point over the foot.) In action poses, the farther the head is from the vertical through the foot, the more unbalanced the person is. In point of fact, no one could lean as far forward in a sprint as the figure is doing in Figure 39. This degree of imbalance, coupled with the running posture, indicates tremendous momentum.

The second point is that *the elbows are at the waist,* much lower than laymen tend to draw them.

Third, just as the elbow is lower than it seems to be, the arms are far longer. *The fingertips of a relaxed arm will be about halfway between the knee and the groin.* In the grotesque variations in the lineup I have usually retained these relationships even where others have been grossly distorted. As with faces, modification of the normal automatically produced caricature. Figure 38 is for the most part self-explanatory. Only a couple of things require any explication.

In the right foreground stands a figure in tennis shoes. He is 2¾ heads tall. (That appears to be 5¼ on the scale because the head itself is enormous—equivalent to 2 heads on the scale.) This fellow is electrified by the sight of some smaller beings running through the group. The aggressor with the knife is nothing but a bodiless head with legs and arms sprouting directly from the chin and cheeks. Such figures are of very ancient origin and even have a name. They are *grylli* (*gryllos* for singular) and, while there are more complicated and monstrous varieties passing under the same rubric, this version is the most typical. During the 1960s underground cartoonist Rich Griffin invented a particularly disquieting version of the gryllos, a disembodied eyeball on legs similar to the victim in this case.

A closely related, if far better-known reconstruction is the enormous head on the tiny figure. I've used myself as the subject here, creating a figure 2¼ heads tall. This device has been ubiquitous in advertising art almost from the onset of commerce.

ANATOMY AND MEANING

One very important physical connection, as far as artistic expression is concerned, is the neck. In Figure 38 two brutish types appear, one a horned monster looming in

the background, the other the gruesome beast in the striped T-shirt. Their heads are crunched down into their shoulders. They are neckless, not because of fat (like the third man from the left) nor because of posture and viewpoint (as the fourth and fifth men from the right) but because they have no necks.

In Western culture we associate long necks with detachment from the worldly appetites of the body and associate short ones with subjugation of the soul to base animal needs. So saints and others of high spirituality are distinguished in art by long necks whereas the coarse and vulgar are usually characterized by thick, short, or nonexistent necks. Not that a long neck necessarily causes us to infer that its owner is admirable. The second man from the left in Figure 38 seems altogether too detached from reality; his self-confidence is fatuous because it is based on nothing but self-indulgence and vanity.

Consider Senor Martinez's twin daughters, Ramona and Juanita (Figure 40), both of them disappointments to him and one no less criminal than the other. Ramona, though, is promiscuous, dissolute, and a passion-driven murderess whereas Juanita is a cynical and cold confidence-game trickster who drinks only to befuddle her "marks," uses sex to inveigle them, and contracts the deaths of enemies in a businesslike manner. Which one is which? I needn't tell you that; you'll know them by their necks.

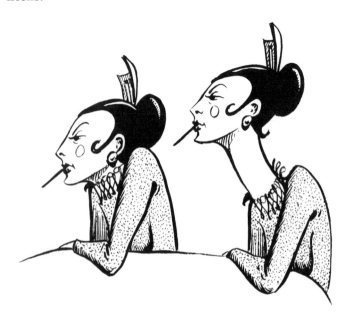

Fig. 40. Ramona and Juanita Martinez reveal their personalities in the lengths of their necks

In fact, of course, there is no association between the length of a neck and the character of a person. But cartoons rely on stereotypes, which communicate effectively whether they've much to do with reality or not. And, while one should avoid the prejudicial and hackneyed to the extent possible, the demands of the medium make it almost impossible to shun stereotypes completely. That is one of the reasons so many of the women in comic strips and gag cartoons are hardly more than sexual symbols of one sort or another.

The extreme prominence of secondary sexual characteristics in the form of breasts and buttocks in cartoons of women is partly the result of sheerest sexism. Males are the principal readers and producers of the comics and, almost without exception, women appear in them as ploys, as interest added to the straight adventure, as normal housewives married to bumbling males, as vicious shrews victimizing men, or as impractical fluffheads victimizing everyone. An unsexy heroine is as unlikely as a thoughtful adventurer. Characters like Little Orphan Annie and her female imitators (such as the incomparably superior Little Annie Roonie) were *a*sexual. They could just as well have been little boys except that innocent girls seemed more vulnerable in the old days than did little boys.

THE FEMALE FIGURE

There is, however, another reason for the emphasis on sexually distinctive prominences. The sex of the figures must be immediately evident; therefore, breasts and hips, rouged lips and long eyelashes are employed for the sake of identifiability. When men's hair was worn short and women's long that difference was sufficient for most circumstances. Some of the old heroines, like Popeye's Olive Oyl or Andy Gump's Min, were as flat as the doughboards of their day. But hair and dress will no longer do to distinguish men from women. Curiously, the unisex look in life has produced its very opposite in the cartoons.

Figure 41 presents a lineup of females similar to the one for males except that in this case I have used a more normal proportion for the rule. Our nude is about 7½ heads tall. Apart from that, what has been said of the

male figure will stand for this one. There are, surely, some differences. Breasts, of course, are the most apparent. Obviously, there is no "standard" for them except the (almost universal) one that holds that the most beautiful breasts are high-nippled and above the fifth rib. In realistic drawing it is good, despite our strange fantasies, to bear in mind that a breast is merely a gland surrounded by soft, fatty tissue. On such a form gravity exercises considerable effect and, in a normal uncorsetted state, breasts are not shaped like missile nose-cones, halves of a grapefruit, or powderhorns.

The most obvious distinction of the female silhouette is the width of the hips, usually at least as wide as the shoulders and often broader than that. A related but less often noted feature of the feminine form is the characteristic tilt of the pelvis which brings the buttocks

Fig. 41. Secondary sexual characteristics (breasts and bottoms) are "played up" in most cartoons of women, particularly in contemporary times, when the unisex look has made it even more important to distinguish the men from the women in cartoons

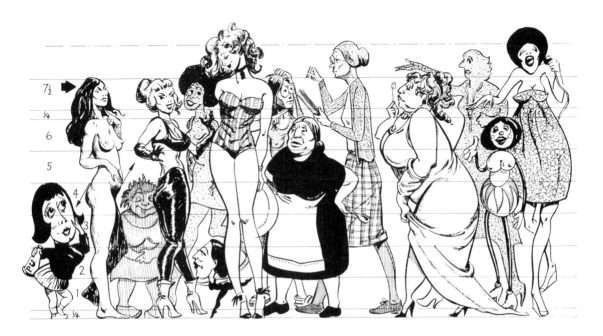

into prominence and shifts the lower part of the torso back along about the same slant (which is indicated in Figure 41 by the small arrows). The buttocks themselves are not only relatively wider and more evident than those of the average male, the peak of their curve is lower, too.

To the right of the nude is superstrumpet, whose form just exaggerates the ordinary characteristics of a healthy young woman. The breasts are enormous, really, and the bottom is extremely conspicuous from nearly any angle. Too, this girl's head is large relative to her height; she is only 6 heads tall. This is a childlike proportion and is familiar in cuties of this type, perhaps because a heroically or even normally proportioned woman as an aggressive sexpot is too threatening for a male audience. We do, though, have in our lineup of women a girl who is 8½ heads tall—the coy glamour girl in the striped costume. This kind of young lady occurs in many gag cartoons as a foil to very little and/or middle-aged men who are obviously making fools of themselves. Standing to her immediate left (our right) is an older woman, perhaps her mother. This lady is short and squat (being only 6½ heads tall) while the other heavy-set woman—the society matron with the lorgnette—is big and fat (since she is 7½ heads tall and overweight).

Children (Figure 42) require special consideration. A **CHILDREN** newborn baby is about 4 heads long. By the end of his first year he will be 4½ heads tall; at four years 5 heads, at eight just over 6 heads, and at eleven will have attained a proportion of about 7 heads. By twelve a person has normally reached the head-to-height ratio that will stay with him through the major part of his existence. In Figure 42 some children with these proportions stand on the left of the broken vertical line. On the right are cartoony versions of the same age steps, plus a teenage girl. Here, youngsters experience a radical setback in growth and development. It takes a cartoon child eight years to attain the proportions a real kid reaches in one! (By age eleven they are no taller than real four-year-olds. Why this should be, exactly, is not easy to determine, but you can see that it is true. Moreover, the dichotomy persists

in most of the otherwise realistic comic strips. Probably this convention has to do with much the same thing as the obviousness of the sexual differences between men and women in cartoons; the children are drawn with excessively childlike proportions in aid of legibility. That, of course, is also a form of caricature.

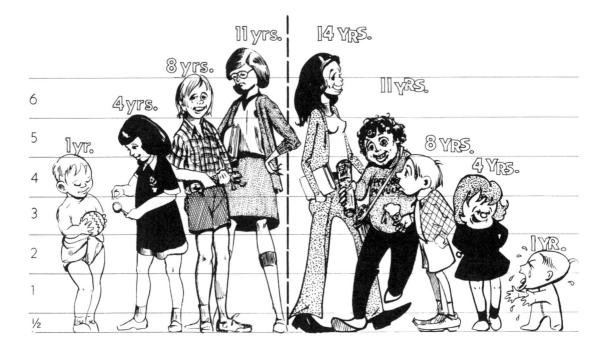

Fig. 42. It takes a cartoon child eight years to attain the proportions a real kid reaches in one—probably to make sure the viewers will be sure it is a child they are looking at

Just as a person's head and body proportion develops with maturation, other relationships also shift and change. Significantly, for our purposes, in infancy the skull is very large relative to the face and becomes progressively less prominent as the person ages. In a toddler the eyes will be almost two-thirds down the face instead of halfway, and they will remain low compared to an adult's until the youngster reaches adolescence.

Berry's World

"This is a 1930s replica — a real nostalgia item — economical, nonpolluting, quiet and good exercise!"

Figs. 43, 44, 45. Different cartoonists use many varied arrangements of proportions to achieve specific personalities for their characters

43: Jim Berry, *Berry's World* (© 1975 Newspaper Enterprise Association; reprinted by permission). *44:* Charles Schulz, *Peanuts* (© 1964 United Feature Syndicate, Inc.) *45:* Brant Parker and Johnny Hart, *The Wizard of Id* (© 1976 Field Newspaper Syndicate, Inc.

As far as the relevance of our head scale to professional activity is concerned, it is easy to see that many types can be conceived of largely in terms of them. Jim Berry's "World" (Figure 43) is full of people only 6½ heads tall but with enormously long legs, short arms, and abbreviated torsos. Charles Schulz (Figure 44) draws a world of "Peanuts" who are all about 2½ heads tall. Brant Parker's characters (Figure 45) are 3 heads tall, with trunks 1 head long and legs the same length. Andy Capp, Briton Reg Smythe's pugnacious hero, is built along the same lines as the Hart characters. The seriocomic "Spirit" (Figure 46) by Will Eisner provides us with a heroically proportioned central figure and some

SOME APPLICATIONS

Fig. 46. Eisner combines widely different figure styles and exaggerated action

Will Eisner, *The Spirit.* © 1974 Will Eisner

caricatured types in a cast of characters which also includes glamor girls and terrifically exaggerated action on the part of everyone.

DRAWING FIGURES

At this juncture you have some knowledge of heads, hands, feet, and the proportions of entire figures of both sexes and several ages. You are, therefore, prepared to draw some sort of human being in any kind of circumstance, just like Eisner, Parker, or Berry. Right? Well, not quite. Nothing in art is ever quite that simple. A few procedural guidelines are in order.

No artist begins a drawing as many laymen do, by piecemeal construction, first drawing in a head, then the torso, arms, then hands, later the legs and feet, then moving on to the next figure. Whether you are painting, doing finished drawings for gallery exhibition, or drawing illustrations and cartoons to be reproduced, you begin by sketching in the whole picture, indicating where major elements will be and how they will relate to everything else.

The most common device in figure drawing is the so-called "stick figure." There are four different types of them in Figure 47, one for each character. Any of these will do. There are literally dozens of other versions of the same thing, although the ones I've used for the two adults are the most common. In using them, the first thing to do is establish where the heads will be. Then you put in the rest, remembering where the feet will be relative to the head and the approximate proportions of arms and legs. Of course, Figure 47 is, like all such drawings, a schematic. Only a compulsive neurotic of some truly pathological sort would proceed as precisely as that. The idea is to establish the general position of the things lightly in HB pencil and then build the figures up on top of the resulting figures. The beginning should, then, resemble Figure 48, except that your pencil lines will be much lighter than these. (All of my figures in this discussion will reverse the normally desirable emphasis and make the stick figures more prominent than anything else.)

The completed drawing (Figure 49) takes advantage of the stick armatures in different ways, depending upon which one was used. The one on which the short-haired

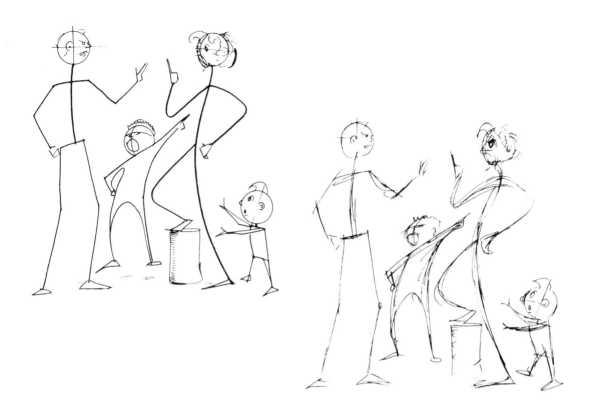

Figs. 47, 48, 49. An artist begins a drawing by sketching in the whole picture. One way to represent human beings is the stick figure, shown in Figure 47 in four common types. Figure 48 shows figures roughed in in a freehand fashion, and in Figure 49 the figures are filled out.

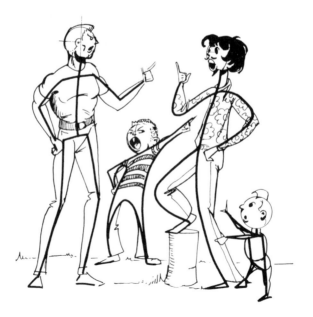

father is modeled is the kind of stick figure usually prescribed for beginners. It has the advantage of giving the clearest indications of joints. But the curvilinear stick figure underpinning the longer-haired fellow has some things to recommend it, too. Not only is it simple and quick, but it can form the edge of a figure in a way the straight, jointed stick seldom can. For beginners that has much merit.

Figure 50 utilizes a stick figure combining some of the features of the two I've just compared. It has the joints of the first and the easygoing curves of the second. Using exactly the same stick armature for all three characters I have drawn (1) a man-about-Paris, (2) a busy housewife, and (3) an armed militiaman. Study these just a bit. What is most apparent about them is that the same stick skeleton provides a means to more or less realistic portrayals. In the case of the real-looking soldier, the stick figure is more deeply buried than in the others. That is usually the case with realism. Another thing worthy of note is that the stick does not dictate which hand or foot is in a given spot or what aspect of the torso will be most exposed to our gaze. The boulevardier has his back turned to us and his right hand and right foot forward; the housewife has her bosom toward us, left arm forward and right foot back. The armed man's movements match those of the woman.

Fig. 50. The more realistic the figure, the more buried the stick figure tends to be

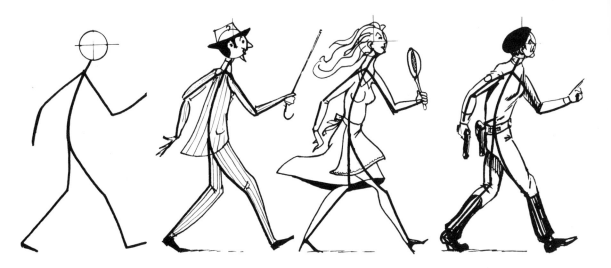

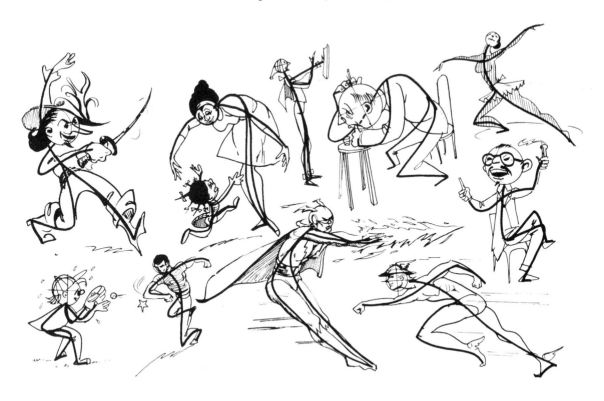

Fig. 51. Variations on stick figures

In doing Figure 51 I simply "knocked out" some sticks in different poses and then selected some for use. Try that for yourself. Do dozens of them and then build them up into completed characters in action. You will learn very quickly that what proved true of hand gestures will be true of figure poses: the same configuration may represent all sorts of different meanings, depending on the contest and specific details. When I began the figure in the upper left corner I thought it would be an overactive orchestra conductor but, as it turned out, the front foot was out too far to work. So I turned him into Cyrano, master swordsman and poet of the long proboscis. Obviously, all of the people shown in this illustration could have been other kinds of people doing other things. For instance, the three figures in the bottom right-hand corner represent an Oriental scientist, some sort of super-being who rides around on lightning bolts, and Mercury,

messenger to the Olympian deities. But they could have been, respectively: a pretty girl brushing her hair and holding a mirror, a trapeze performer, and Superman. The possibilities are endless.

Try to take as much advantage as possible of the coincidence between the line of the stick and the edge of the body or limbs. And don't get fixated on one kind of proportion or category of cartoon figures. Do some of normal or heroic stature and some only two or three heads in height.

Clearly, all stick figures are based in principle on that bony armature, the human skeleton. For that reason they are highly versatile and can be used as was the one in Figure 52, as the basis for the traditional academic block-and-column figure which can in turn be worked up into a completed figure. To do it as has here been done requires a little knowledge of anatomical detail. Academic

Fig. 52. All stick figures are based in principle on the human skeleton; here, they go from simple stick to block-and-column to completed figure to manikin

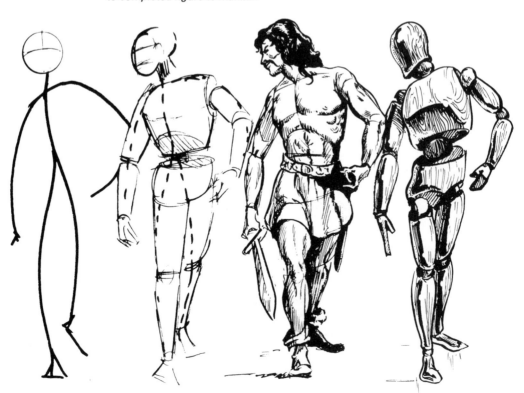

drawing and its concomitant study of the muscular architecture of the human form are not subjects we can engage ourselves with in this small book. But with what you have learned thus far you can move in that direction fairly easily by means of the bibliography.

THE BLOCK-AND-COLUMN FIGURE AND THE MANIKIN

It may occur to you, even without the comparison in the illustration, that the block-and-column system (regularly encountered in books on "straight" figure drawing) resembles the jointed dolls called *manikins* sold in art supply stores as an aid to figure composition. Manikins are not the source of the system, however. On the contrary, they derive from it. Manikins are, therefore, very useful tools for those of you interested in illustrating tales of derring-do. You can put a good one into a position that no live model could possibly hold—even if you can afford live models, an unlikely possibility at best.

DRAPERY AND CLOTHING

One thing the manikin does not provide is clothing. Nor would a dressed-up doll show you how garments of normal scale fold and wrinkle. Fortunately, a few simple rules of thumb will serve as guides for drawing what can be seen and will also furnish the means of creating apparel where it must be made up out of the whole cloth, so to speak.

It will prove far easier to draw fabric of any sort if you *think of it draping in straight lines rather than in curves.* Yes, I know it doesn't look that way to most of you. Nonetheless, nearly every kind of cloth tends to fall in angular breaks. In Figure 53 a piece of cloth supported by two tacks hangs on a wall. The rectangle described by the broken line represents the limits of that cloth were it pasted flat to the surface. It isn't, and so it droops a little. The slight folds consequent to the pull of its weight are, as you can see, radiating out from the tacks. When the tacks are moved upward and inward, the fabric moves correspondingly—the ends lift and the folds deepen. The tendency for folds to radiate from the points of support is now more obvious. When we exaggerate the relationship still more, as we have on the lower right, the drapery folds intersect one another and the effect is of triangles com-

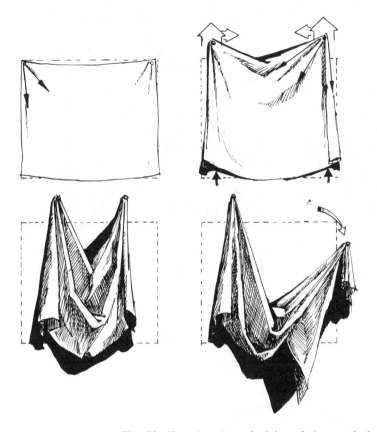

Fig. 53. Knowing the principles of drapery is important in clothing cartoon figures. This figure illustrates that drapes fall in straight lines rather than in curves

mingling. When one of the tacks is moved to another part of the cloth as well as to another portion of the wall, the drapery takes on a new configuration. But the triangularity of the folds remains. What you are observing here in terms of dents, wrinkles, and folds typifies all drapery, no matter how elaborate it may be.

The Louvre Museum in Paris owns a study of drapery by Leonardo da Vinci (1452–1519) which is of an alarming complexity (Figure 54). Parts of it contain droops and folds that are, indeed, curved. But most of the edges are relatively straight and it is quite easy to reduce the entire thing to opposed angularities (Figure 55) without sacrificing the structural character of the cloth.

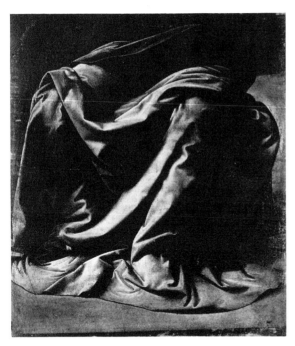

Fig. 54

Fig. 55

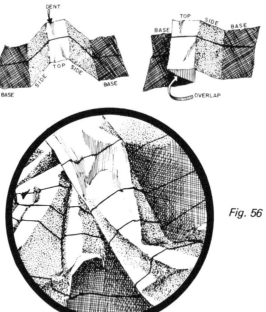

Fig. 56

Figs. 54, 55, 56, 57. The essential principles of drawing a
draping fabric are that (1) it tends to fold along diagonals
radiating from points of support and also tends to crease in
triangular patterns; and (2) each fold, crease, or wrinkle should
be conceived of as having three surfaces

54: Leonardo da Vinci, *Study of Drapery* (16th cent.). Drawing on canvas. Paris: Louvre
Museum. (Cliché des Musées Nationaux)

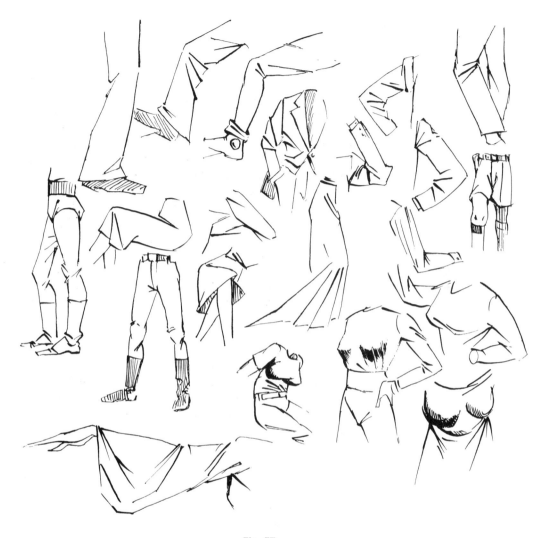

Fig. 57

If you look at a lot of drapery in Renaissance drawings and prints you will discover that it has the essential character of Figure 55; it is as though all of the artists intended a woodcarver to work from their pictures.

In a famous drawing textbook, *The Natural Way to Draw,* Kimon Nicolaides suggested that drapery should be rendered in such a way that a sculptor could work directly from it. And he devised a means of clarifying the forms in order to so render it. Figure 56 is a modification of his procedure. Always think of a given fold as having

at least three surfaces—a top and two sides—rising from a base. At times one of the sides will be hidden, as when the top overlaps in such a way that a sculptor would need to undercut the forms. In the circle I have rendered the zone marked off by the ring in Figure 55, using the technique symbolized in the diagrams above. The tonalities have nothing to do with light and shade; they merely signify which surface is which. (No two people will agree in every case as to what is the top and what the side or the base. That doesn't matter as long as the triadic principle obtains.) The lines crossing the forms show the cross-contours of the material. Just as it is not likely that one would actually draw such lines across a drapery study, it is neither necessary nor necessarily wise to shade your drawings as has been done in Figure 56. This picture merely represents a procedure for making distinct in the mind what might otherwise appear overwhelmingly complicated and visually obscure. As for light and shade, we shall deal with that later.

The essential principles, then, are: (1) Cloth tends to fold along diagonals radiating from points of support and also tends to crease and wrinkle so as to suggest triangular patterns. (2) Each fold, crease, or wrinkle can be most easily conceived of as having at least three surfaces.

Figure 57 contains a number of examples, represented diagrammatically, of these principles (more especially the first one) applied to a variety of costumes. Study them and apply the technique to garments you are in a position to observe. You will find that natural forces do not invariably concede to my systematic demands. Sometimes drapery will bend into parallel folds instead of diagonals and fall in smooth, unbroken curves. But in general the principles presented here will serve you well. And folds are more apt to look "right" when done according to the system than when they are exempted from it. Therefore, when you just "make up" a suit or dress, it will look plausible. Incidentally, in Figure 57 I have included a couple of legs in tights. Tights wrinkle, too. In actual fact such garb will always evidence a few wrinkles; no one has yet produced the stretch fabric as skin-tight as whatever the costumes of the superheroes are supposed to be made of.

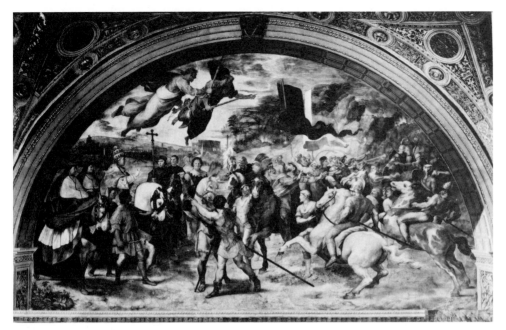

Figs. 58, 59. Raphael was a master of the principle of continuity; the figures show how he used the linking-up of the edges of forms to make his figures more coherent

58: Raphael, *Expulsion of Attila* (1513–1514). Fresco. Stanza d'Elidoro, Vatican, Rome (Alinari-Art Reference Bureau). *59:* Detail of Figure 58, with diagram of continuities

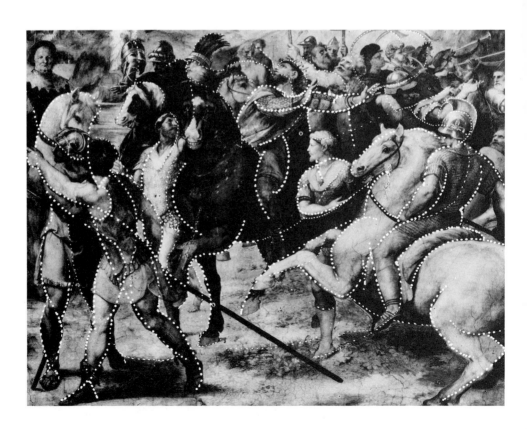

**CONTINUITY OF
LINE AND FORM**

One last thing about figure drawing. You can insure a certain internal harmony and grace by establishing continuous movements in your completed figures. The stick figure may have accomplished part of the job for you, but it's not likely to have completed it. A great master of continuity in the sense that I mean was the Renaissance master, Raphael (1483–1520). His *Expulsion of Attila* (Figure 58) in the Vatican is a figure composition of great integrity. By superimposing lines upon a detail of the work (Figure 59) we can stress the way in which edges of forms link up to make the figures more coherent than they otherwise would be. The same sort of thing occurs, if less impressively, in many skillfully finished cartoons (see Figure 60).

*Fig. 60. Diagram of continuities
in Neal Adams'* Green Lantern

Neal Adams, *Green Lantern.* © 1970 National
Periodical Publications, Inc.

Fig. 61. These "funny animals" in the inner city really represent human situations

ANIMALS

A lot of cartoons don't involve human beings. Ostensibly they are about wild and domesticated animals. Actually, these fantasy creatures are almost nothing at all like lower animals. Figure 61 tells a story of the inner city using so-called "funny animals." Here, a lady white mouse raises alarums as a black cat tries to return her mislaid purse. Her cries startle the police doggie and interrupt the thoughts of the local politician on his way to heal a ward. Obviously, what we have here are human beings in animal disguises. That is always the case. The late, great Pogo did not share any of the rather obnoxious qualities of other opossums. And where has anyone ever seen a mouse even faintly resembling the best-known mouse of them all (Figure 62)?

There are versions of the animal comic which involve creatures that do not walk around on two legs. Presumably they only think like people. But these, too, project all sorts of human physical attributes, particularly in facial expressions and movements of hands and feet. The cats in Figure 63 represent a sexpot, a ruffian, and a cool black "player." Such identification of lower animals with human characteristics is expected, surely. There is a long, long tradition of such identification; Aesop's *Fables*

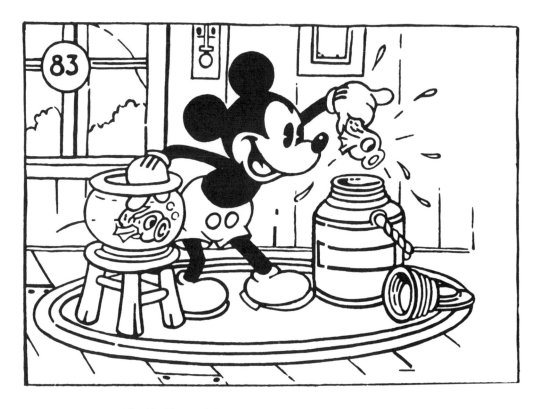

Fig. 62. The world's most famous mouse

Walt Disney, *Mickey Mouse.* © Walt Disney Productions

*Fig. 63. The feline equivalent of a sex kitten, a ''tiger,'' and a
cool cat*

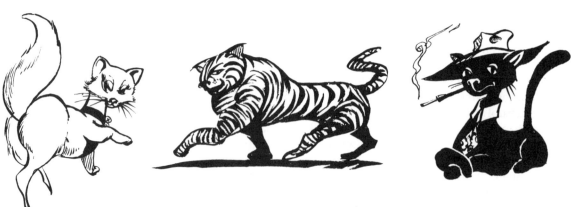

(6th century B.C.) are merely the earliest stories of the kind to have been written down. For cartooning, the animal/human hybrids have some perhaps unexpected consequences. The most interesting, or so it seems to me, are the modes of animal locomotion represented in the comics.

Quadruped motion is extremely complicated and difficult to observe with the eye unaided. Until 1878 no one knew how to draw a horse galloping the way horses actually gallop. Frederick Remington (1861–1909) was supposed to have been able to have done so on his own account, but the evidence that he did not is really quite conclusive.[1] Like everyone else who drew animals, he was overwhelmed by Edward Muybridge's stop-motion photographs of running horses first published in October 1878 by *Scientific American*. Until those pictures appeared, people drew speeding horses in a "flying gallop" (Figure 64), a posture no real horse could have attained

Fig. 64. The "flying gallop"

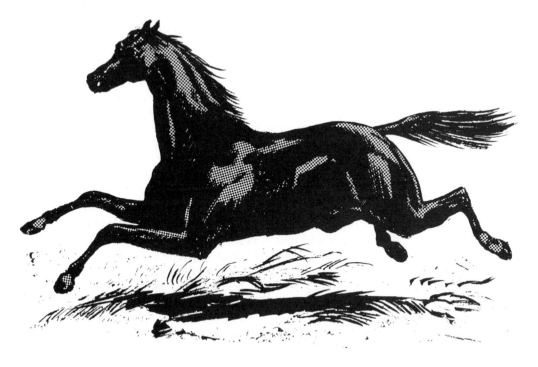

[1]See Estelle Jussim, *Visual Communication and the Graphic Arts* (New York: R. R. Bowker Co., 1974), pp. 195–236.

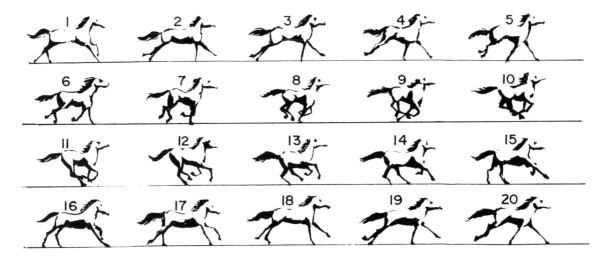

*Fig. 65. After Edward Muybridge's stop-motion photographs
of a running horse, which greatly influenced artists' represen-
tations of animals in motion*

except when stuffed and mounted. Figure 65 is a drawing based on one of Muybridge's series. At one point (frame 10) none of the four feet is quite in contact with the earth but at no time are all four legs stretched freely out to the front and rear, not even at points 2 and 19. Nor do horses leap barriers in this posture. If you want to draw horses in motion realistically you will have to rely on the camera's speed or on your memory of what it has recorded.

Dogs do not walk or run in quite the same way horses do. But neither is their gait based on human being's stride. In cartoons, however, this is the universal model for all but the most exactingly naturalistic of the animals. Figure 66 contains four canines. The first dog is strolling along with his back legs in perfect step with the forelegs. Casual insouciance is the resulting tone. With the front and back legs out of step, a bit more urgency and determination is suggested. The pampered pooch on the lower left is prancing—an effect achieved by being out of step on tiptoe. In step on tiptoe gives a similar, but slightly more martial appearance. From the front an in-step gait looks jaunty, as it does here in the case of the Scottish terrier.

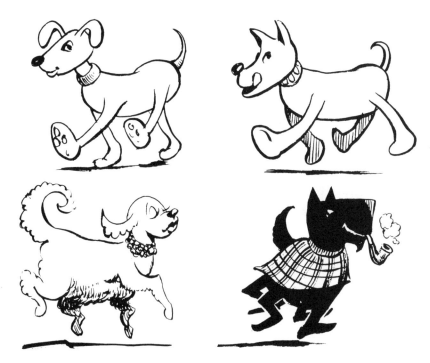

Fig. 66. Dogs are usually portrayed in cartoons as running or walking in a way that is unnatural; however, their manner of moving evokes particular moods and characterizations

Fig. 67. Although hardly realistic, these animals are moving in ways that effectively caricature many forms and moods of movement and flight

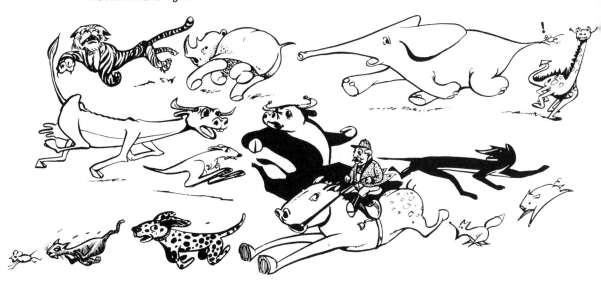

In Figure 67 we see a whole array of species and running styles. None of them corresponds to the momentary position of any real animal any more than do the attitudes and appearances. But they carry with them much more conviction and force than any photographic reproduction of motion ever could because they caricature the idea of movement and flight.

Practice drawing animals and people. Next, we are going to explore ways of rendering those images so that they will be sharp, clear, clean, and easy to reproduce.

A. What You Use

The vast majority of cartoons are drawn for reproduction. But the term "reproduction" is rather misleading because what you see printed in a newspaper, comic book, or magazine does not look like what the cartoonist drew. It's similar, of course, but the original drawings are always done two or three times the size they are going to appear in print. Comic book pages, for example, are usually laid out on paper that is 18 × 23½" although most comic book pages are only 6¾ × 10⅛". And they aren't in color until printed; up to that point everything is in black and white. Except for pencil lines that haven't been erased—those are pale blue. The artist may have painted out areas with white paint, or made corrections by pasting one thing over another. In print, however, none

67

of this is evident. There, the image will not only be smaller but will also be sharper, cleaner, and clearer. This is true of nearly all commercial artwork done for reproduction, and a special printer's jargon has grown up to describe and distinguish the various elements and phases of the process that takes a thing from the artist's studio to the printed page.

The prepared art work is known as a *mechanical*. For a cartoonist this is usually no more than the ink drawing he wishes reproduced. Any material intended for reproduction is called *copy* (whether it is manuscript to be set in type or a picture); therefore, the cartoonist's mechanical is also the printer's copy. For us, the terms are virtually interchangeable. The copy is photographed to make a film *negative* which, in turn, is used to create a printing *plate*. From the plate a press will print an image in ink onto paper *stock* of some sort. That image is known to printers as an *impression*. Most of the rest of this book is going to be concerned with the preparation of *camera-ready copy* (that is, ready for photographing) in the form of mechanicals. But in order to secure a firm grasp of what is required of the cartoonist one must understand the process that turns the mechanicals into impressions.

PHOTOMECHANICAL REPRODUCTION PROCESSES- LETTERPRESS

Except for the colorplates, all of the pictures in this book were reproduced by a process that prints solid black onto white paper. Whenever ink touched paper there is a spot of black and wherever ink did not the area remains white. Speaking in the most literal sense, there are no in-betweens—that is, no grays of any kind. Look at Figure 68 for a moment. Granted, it seems to contain zones that are gray. But if you look very closely you will observe that such grays are made up of tiny black dots distributed over areas of white and that, while the optical effect is of gray, the physical fact is black on white. This is important to understand because everything about the two most common printing processes depends upon it, and these are the processes with which a cartoonist must be concerned.

Let's suppose that we wish to reproduce a little drawing like that in *A* of Figure 70. It is a very simple mechanical posing no problems. The printer can use it as

Fig. 68. In this design, Benday
patterns and stipplings are used
to make gray areas

copy; it is what he will call "camera ready." But his camera is probably unlike any you have seen before. Figure 69 shows it in its essential detail. This is a *process camera* and any such camera will contain the same components, although not always in just this form or order. As cameras go, it is awfully large.

Our mechanical will be centered on the copyboard at the far end of the machine, pressed flat against it by a powerful vacuum, and lighted by banks of arc lamps set at 45° to eliminate any glare or shade. The camera back is a rather complicated mechanism having doors within doors and all sorts of specialized gaskets and fittings. All

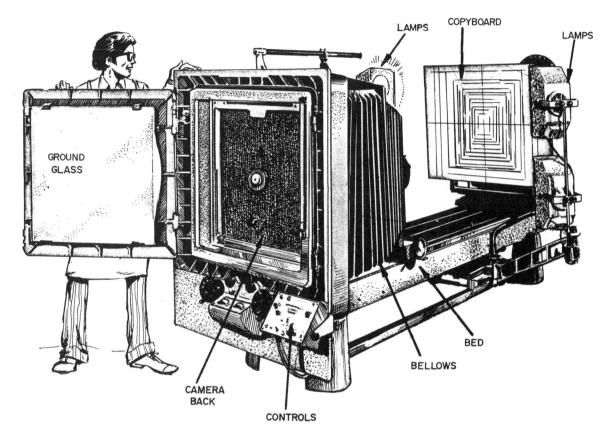

LAMPS

COPYBOARD

LAMPS

GROUND
GLASS

BED

BELLOWS

CAMERA
BACK

CONTROLS

Fig. 69. A process camera, which photographs the image of copy to the exact size of the final reproduction

we need to know here is that a sheet of photographic film can be used within, held in place like the copy by a vacuum. The photographer focuses the image of the copy onto the large ground glass in the back. By adjusting the position of the bellows along the camera bed it is possible for him to enlarge or reduce the image of the copy on the film to the exact size of the final reproduction. In this instance, we will assume that the image is to be reduced by 50 percent, so that it will be half as large as the mechanical. The photographer will pull the lens back far enough to achieve this degree of scale reduction and expose the film to the copy.

Film used for reproduction is very, very high contrast, insensible to any gradation between the two extremes of utter black and pure white. If the copy contained a pale gray it would not appear in the negative; a dark gray would produce the same effect as a dense black.

What one has when the film is developed is, of course, a negative (Figure 70B). What was black in the mechanical is transparent in the negative. Not white, but transparent.

The next step uses the negative to make a surface from which ink can be transferred to paper. In letterpress printing the procedure is as follows: The negative is *flopped*—turned over to make a mirror image[1]—and (Figure 70C) mounted on a piece of plate glass called a

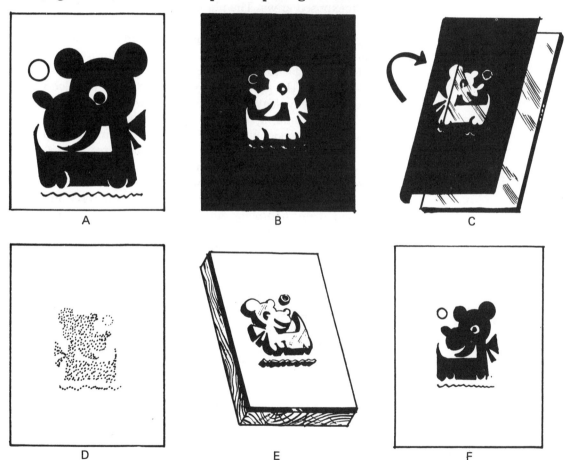

A B C

D E F

[1]With the exception of silkscreen (see glossary), all commercial printing techniques require that the printing image be the mirror image of the printed impression. In offset lithography (see below) the negative is *not* flopped because the plate is going to print onto something else which in turn imprints the image on the paper. (Thus, plate = drawing, image = mirror, impression = drawing.)

Fig. 70. The various stages in the creation of a line cut

flat. This flat is placed face down onto a sheet of zinc that has been coated with a photosensitive solution. It is then exposed to very strong arc light. Again, a vacuum frame is employed to insure perfect contact between the film and the metal. The black of the negative (white in the mechanical) blocks out the light; the clear area on the negative (black in the mechanical) permits light to pass through. Light hardens the coating on the zinc so it is insoluble in water (Figure 70D). Careful washing removes the unexposed areas. The plate is then inked and dusted with a fine, acid-resistant material called *dragon's blood* which clings only to the hardened areas and not to the remainder of the plate. The back of the plate is covered with acid-resistant lacquer. The piece of zinc is immersed in an acid bath and the parts not covered with dragon's blood are etched away, leaving the areas that were black in the mechanical standing up above those that were white. Mounted on a wooden block (Figure 70E) to bring it up to the same height as printer's type, the plate is printed exactly like type. And what it prints is a small duplicate (Figure 70F) of the original drawing.

What I have just described is the process for creating the kind of zinc *photoengraving* called a *line cut.* The kind of mechanical used in this process is an example of *line copy*—copy composed of solid blacks and whites without true grays. It is the simplest and most easily reproduced kind of copy, and 90 percent of published cartoons were in fact originally mechanicals in the form of line copy.

Photoengravings are used in *letterpress* printing, an example of the kind of printing most familiar to the layman, relief printing. In relief printing the image is printed when ink is carried to the paper from a raised surface. Fingerprinting is a commonplace example, and wet footprints at a poolside another. Stamp pads ink the relief surface of a rubber stamp. Typewriter keys strike the ribbon with the relief surface of the key and make the mark. Printer's type is another example, and, indeed, is the source of the name "letterpress."

There are various kinds of letterpresses. The *platen press* has two flat surfaces—a bed, which carries the plate or type, and the platen, which supports the paper. These surfaces open and close like a clamshell. A *flat-bed cylinder press* prints more rapidly; it has a large revolv-

ing cylinder instead of a platen. The most advanced form is the *rotary press,* which uses a plate cylinder and a printing cylinder as well. Unlike platen and flat-bed cylinder presses, which print on separate sheets of paper, the rotary press can be *web-fed* from a continuous roll of paper that is cut into sheets after printing. It is highly accurate, prints at a much greater speed than the others, and is used for jobs requiring a great number of copies.

Today, most daily newspapers and their cartoons are printed on rotary presses, but because the mechanics of letterpress are most easily understood in terms of the flat-bed cylinder press, I have chosen it for my model. In Figure 71 you see the functioning elements stripped of the protective coverings and machinery that make it possible for them to work. A sheet of blank paper is snatched by a gripper device on the impression cylinder and is taken around to be pressed against the plate resting face up on the bed of the press. The bed itself moves back and forth in such a way that in the time it takes a sheet of printed paper to whip around the cylinder and be released the bed has passed the plate beneath ink-covered rollers that transmit the sticky printer's ink to the raised surface of the plate. As the bed carries the inked plate forward again the impression cylinder turns in answering motion and brings the paper into contact

Fig. 71. The flat-bed cylinder press

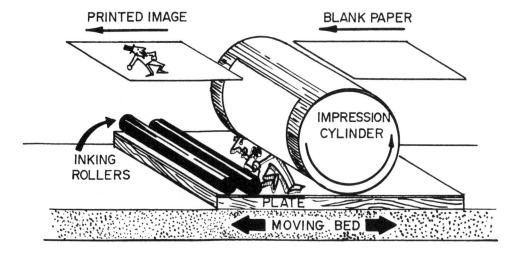

PRINTED IMAGE BLANK PAPER

IMPRESSION CYLINDER

INKING ROLLERS

PLATE

MOVING BED

with the plate, impressing the image onto it. The cylinder lifts slightly to permit the bed to move back to the inking rollers, carries the paper clear around to release it and grip a fresh sheet. By the time that sheet has started around the drum the bed has begun its forward motion and the plate will come in contact with the new sheet exactly where it did with the previous one. And so it goes, for as many impressions as the job requires.

At one time, practically all commercial printing was done by letterpress and much of it still is, especially on small production runs. But the most flexible and convenient of the printing techniques is of much more recent origin. In fact, it is the way the book you are reading was printed. It is *offset lithography.*

PHOTOMECHANICAL REPRODUCTION PROCESSES — OFFSET LITHOGRAPHY

Lithography means "stone drawing or writing" and derives from the origins of the technique in the fine arts in which the printing surface was originally (and usually is still) the smooth face of a block of Bavarian limestone. Offset lithography is a modern, commercial version of lithography, employing plates of zinc or aluminum instead of stone. Unlike the other printing techniques, which are mechanical in nature, lithography is chemical. It depends upon the fact that oil and water will not mix.

The preparation of negatives is identical to letterpress, the making of the plates very similar; it is the printing process itself that differs. The plate is a very thin sheet of zinc or aluminum (about as thick as a coffee can) so treated that after it has been exposed to light through a negative (as in photoengraving) and lightly etched, the zones where light was excluded (black in the negative but white on the mechanical) are receptive to water and the places where light hardened the surface are receptive only to grease or oil. Printing depends upon the fact that printer's inks are oil-based, greasy substances having an antipathy for water.

Once the image has been fixed in the plate, the plate is wrapped around a drum on an offset press. When the press is turned on, this plate cylinder (see Figure 72) revolves. As it does it is contacted first by a set of rollers that wet it with water and then by a set of rollers which apply the ink. The water beads up on the grease-receptive

Plate I. Benday color separations

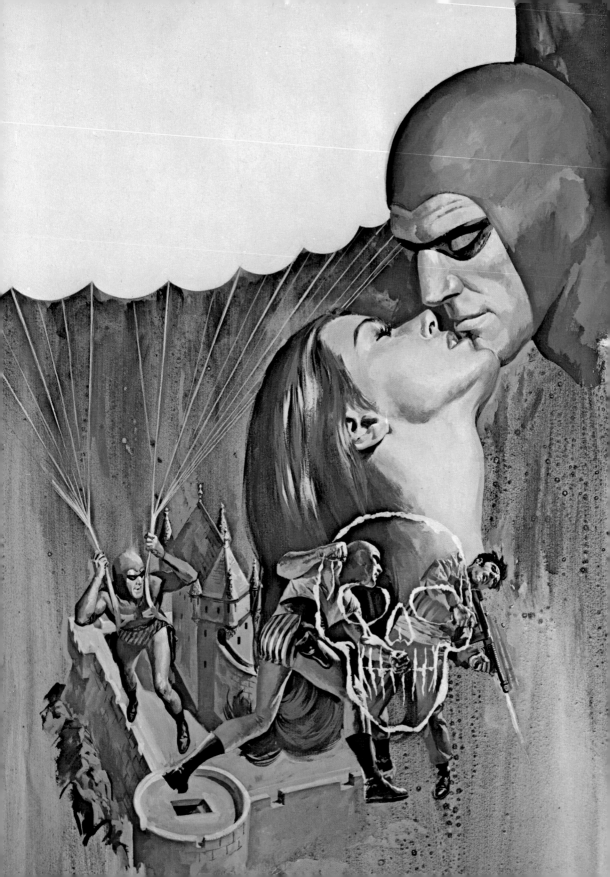

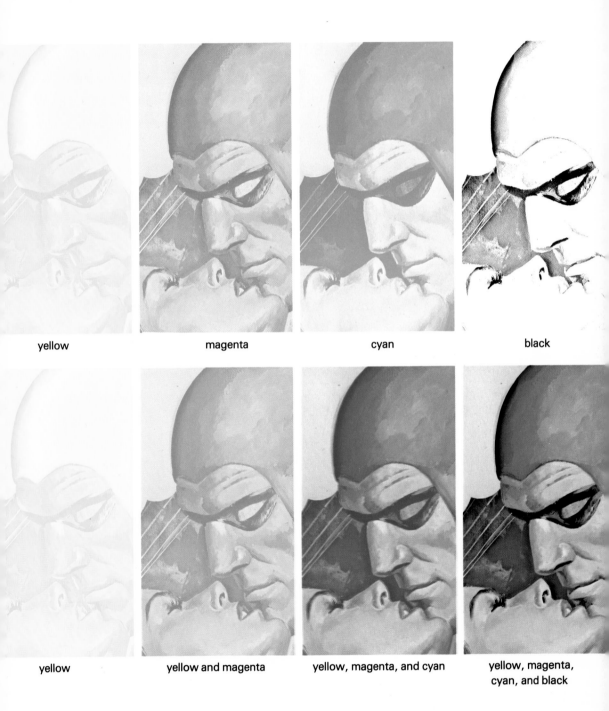

yellow magenta cyan black

yellow yellow and magenta yellow, magenta, and cyan yellow, magenta, cyan, and black

Plates II and III. Process color separations: yellow, magenta, cyan, and black plates

The Phantom. © 1975 King Features Syndicate, Inc.

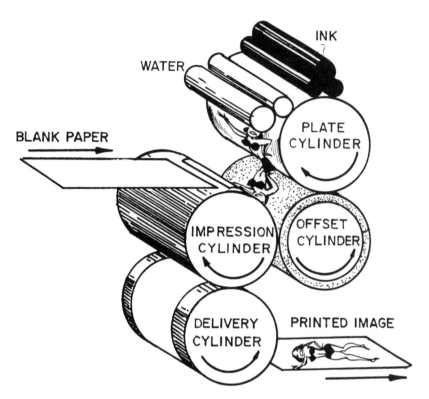

INK

WATER

BLANK PAPER

PLATE CYLINDER

IMPRESSION CYLINDER

OFFSET CYLINDER

DELIVERY CYLINDER

PRINTED IMAGE

areas but is absorbed into the others. Since the bare metal areas are wet the ink, being greasy, will not adhere to them, but in greasy areas the ink rollers push the drops of water out of the way and oil ink is attracted to the oily surface. Next, the inked plate contacts another drum, this one wrapped in a rubber blanket, and the inky image is "offset" from the plate onto the blanket. Blank paper is brought against the blanket by an impression cylinder, is printed and then removed and deposited by the delivery cylinder.

Offset lithography permits finer printing on rougher grades of paper than letterpress and has such other advantages as higher speed and longer-lasting plates. Practically all magazines, brochures, and illustrated books are printed by this method. The images are not, however, quite as clean and sharp as good letterpress work.

There are other modes of photomechanical printing in the graphic arts. Currency, stock certificates, and many fine books are printed by a process called *gravure*, whose subtlety and fineness would be wasted on the cartoonist's

Fig. 72. Offset lithography, a modern and flexible printing technique

Plate IV. John Adkins Richardson and Richard Corben, Fever Dreams

Fever Dreams © 1972 by Richard Corben, John Richardson, and Jan Strnad

75

art. Similarly, the *collotype* process, which prints from gelatine plates, is useful only for the most expensive and exquisitely complicated kinds of reproduction. Bus placards, theater posters, and similar advertisements are often printed by *silk-screen*. Although this last medium is peripheral to our interests here, it does afford some opportunities for the comic artist, so you may wish to consult the glossary and bibliography for further information.

EQUIPMENT, TOOLS, MATERIALS

It is possible to do artwork, even for color reproduction, with nearly anything that will make a mark on paper, if you are sufficiently clever and have enough time. One of the most beautiful magazine illustrations I have ever seen was a representation of an ice cave. The medium? Fingerpaint! For that, no equipment was needed except a kitchen table. The materials were from the nursery, the tool was an artist's hand. But this case is unique. Normally, anyone who does graphic art for printing will need special supplies. Now, as commercial artists go, the cartoonist can get by with the least of all. His is a very basic craft; it rarely involves typefaces, combinations of different kinds and sizes of copy, intricate calculations, or elaborate instructions to the printer. Cartooning equipment is no more than the essential equipage of the graphic artist. By the same token, it will be in constant use. Here, as in so many cases, the higher initial cost of quality will far outweigh the false economy of a lower price for inferior instruments that will not hold up or will produce less than satisfactory results. Of course, there is no sense in paying great sums for superb equipment having capacities you will never use. A good drafting machine is invaluable for precise work in such exacting fields as cartography and technical illustration, but for the cartoonist's work, a T-square and triangles will suffice. Moreover, excellent ones are relatively inexpensive.

Figure 73 shows the basic things you will require for ordinary work. Most of them are available in any store selling drafting or surveying equipment. The first need is, certainly, a drawing surface of some sort. A *drawing table* (A) is the obvious choice. Many artists use the table as a base for a second surface, a *drawing board*, a practice

that permits them to switch to different-size surfaces, replace a worn surface, and alternate among various jobs simultaneously in progress. In any case, the surface on which you work should be adjustable and used in a slightly tilted position. Too, it would be best if it had a metal edge embedded in the left and right sides to insure continued straightness. The *lamp* (B) shown here is a two-tube adjustable fluorescent and is the kind most commonly used for illumination. As far as other lighting is concerned, if at all possible, windows should be to your left just as for reading. Because north light is more constant than any other throughout the day, it is always preferred by the artist, but is by no means essential. *Tabourets* (C) are nothing but cabinets used to hold tools and materials. They are usually available through art supply stores and often come with glass tops intended to be used as painters' palettes. We will use the top mostly for keeping tools in use at hand. A *chair* (D) of almost any sort will do, surely. But the kind shown here, with a swivel seat, adjustable height, and a compensating back support is almost essential if you intend to spend hours at the board. Because all cartoonists and illustrators have recourse to pictures of things you will need a place to file photographic magazines, pictures, and personal sketches, as well as the books in your professional (or avocational) library. Therefore, a *bookcase* (L) and perhaps a filing cabinet are commonly found in studios.

Tools

Of tools, one of the most important is a good *T-square* (E), designed to establish horizontal straight lines in parallel. Buy a steel one or one of wood sheathed in plastic with a blade about as long as the drawing board is wide. In use, the head of the T-square is held against the left edge of the drawing board and lines are drawn along the top edge of the blade. (Obviously, a left-handed person may wish to work with the T-square against the right edge of the board.) You put the higher lines in first and, maintaining pressure with the hand on the head, slide the T-square downward after each stroke is finished. Lines at angles or perpendicular to the horizontal are usually described against one of the three edges of a *triangle* (F). For your work you will need two 12" or 14" triangles of clear plastic. One of them should be a 45°-45°-90° triangle, the

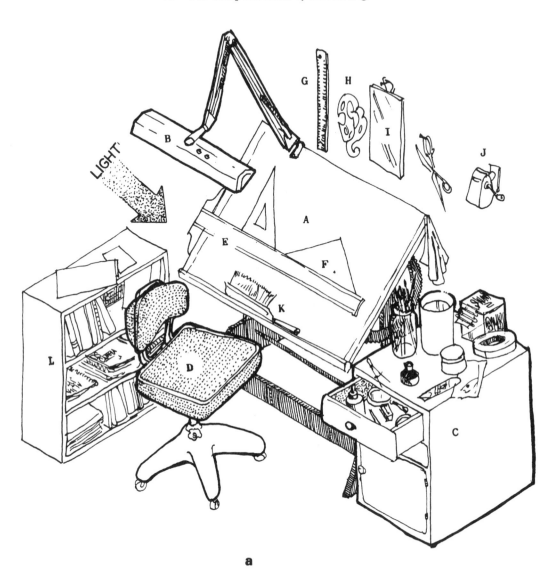

a

Fig. 73. a: *Basic equipment for a cartoonist's studio;* b: *Bow compass, drop compass, dividers, beam compass;* c: *Ruling pen from above, ruling pen from side, lettering pen, crowquill pen, technical fountain pen, technical fountain pen (different style), fibre-tip pen, ballpoint pen;* d: *Mat knife, frisket knife, swivel knife, single-edge razor blade, pin vise;* e: *Flat-ended tweezers;* f: *Push pin*

b

c

d

e

f

other a 30°-60°-90° triangle. By combining these in different ways you can create angles besides the obvious ones. Adjustable triangles are also made for artists' use.

One should never cut against a plastic edge. For this use a *steel straight-edge* (G). You may as well buy an 18" one with graduated scales for inches, pica, and agate measure since much work beyond simple illustration will require all three.

Unlikely though it may seem, sooner or later you are bound to need a set of *French curves* (H). These are used to draw continuous curves that are not simple segments of circles or ellipses. They are tricky to use properly and it requires practice to combine segments derived from the varying edges into apparently unbroken curves. A fairly satisfactory substitute is an *adjustable curve*, a ruling edge made of flexible plastic or metal that can be bent into nearly any shape.

Because so much of a cartoonist's work is concerned with human expression and gesture, a helpful item for many of us is a simple *mirror* (I). You can use this to check out expressions. (Cartoonists seem always to be making faces as they draw—as if they all suffered from some bizarre nervous affliction. Usually it is just an unconscious reflection of the exaggerated behavior of the characters they are putting in action on a piece of paper.) Mirrors are also useful for working out hand postures since one can pose one's own hand and draw it from nearly any angle.

Necessity for a *pencil sharpener* (J) goes without saying. A mechanical sharpener that will accept more than the standard-size pencil is desirable. You will also need a *dusting brush* (K) of some sort to sweep eraser rubbings and so on from your work.

Upon and inside the tabouret in Figure 73 are other necessities. There are *pencils*, of course. Apart from the usual range of drawing pencils some of these should be blue drafting pencils. Lines drawn lightly in blue do not photograph and therefore need not be erased from mechanicals. On the other hand, red pencil photographs like densest black and is useful for making marginal instructions to platemakers and printers, so a red pencil ought to be on hand.

Pens are of all sorts and kinds. You will need a

number of them. Some of these will be the ruling pens included in a basic *mechanical drawing set* containing, as well, 2 small bow compasses, a beam compass, dividers, and perhaps a drop compass (for drawing *tiny* circles). Ruling pens are always moved from left to right (unless the artist is a southpaw) and tilted slightly away from the edge of the straight-edge. Never dipped into ink, they are always filled from the squeeze stopper of the ink bottle. This is sometimes true also of your *lettering pens*, which are fitted with a reservoir attachment. The most commonly available brand of lettering pen point in the U.S. is the Speedball line. Hunt makes equally good ones. Buy several pen points and an instruction booklet. You will definitely need some round or oval nibs, for those are the ones used to do the kind of lettering that usually appears in the comic pages. A Hunt "Globe" 513 and Speedball B-6 and D-5 will suffice for nearly all comic strip lettering. To use the nibs you must have a pen holder, naturally. (Another brand of lettering pen, the Coit, has a nib that can readily accept paint as well as ink—unlike Speedball or Hunt—but the nibs are not detachable from the pens themselves.) The varieties of drawing pens are endless, but you ought to have in your array of them a few *crow-quill pens* and proper holders. Crow-quills imitate the true quill pen of Colonial days. They are tiny metal tubes shaped to a point and slit. They are capable of making very fine lines and also of making variable, thick–thin strokes, depending upon the pressure exerted by the artist's hand. The brands and subcategories differ in degree of elasticity (and holder size) and you will have to experiment to see which seem most useful for your purposes. I prefer the rather stiff Hunt 107 for cartoon work but use the Esterbrook "Lithographic" for fine arts renderings.

Another useful tool is the so-called *technical fountain pen* of which the best known variety is Rapidograph. Such pens draw lines of constant width and can be used continuously for long periods without needing refilling. They are especially well-adapted to use with French curves and templates but are also good for freehand drawing, particularly where a very free but unbroken line is desired. *Fiber-tip pens* such as Flair are good for the same purposes but do raise some problems, the most com-

mon being their tendency to produce lines of steadily increasing thickness and fuzziness as the tips soften with use. Too, the ink used in them contains a coal-tar dye that will bleed through any white pigment used to make corrections, in the form of bluish stains. Although these stains will not photograph, they do look very messy on mechanicals. There are also certain *ballpoint pens* which contain an India ink medium sufficiently dark for graphic reproduction and so are marketed for this purpose. Pelikan makes a technical fountain pen called "Pelikan Graphos," which takes a variety of lettering nibs. Its 0-0,6 is good for comic strip lettering.

Of all the items in the cartoonist's tabouret, the *red sable watercolor brush* is the most important. Virtually all cartooning is done with this extremely versatile tool. And it *must* be red sable; a substitute really won't do the job. Sable brushes, fully loaded with moisture, do not "flop"—they flex. Only sable brushes can maintain sharp points and spring back to their original shapes after completion of a stroke. Unfortunately, sable is rather expensive and even a small brush may seem shockingly expensive at two or three dollars. That's the bad news. Here's worse: Any brush used with drawing ink will eventually deteriorate no matter how you baby it, so it's a good idea to keep more than one on hand. Both Windsor Newton and Grumbacher make fine red sable brushes. Professional cartoonists seem almost universally to prefer a number 4 for general use. When you finish using the brush wash it out with warm water and mild hand soap. (Hot water softens the glue that holds the hairs to the handle.) Form the brush into a point when you are done by twirling it between your lips or against the palm of your hand.

Normally, one would be told to buy some larger, less expensive brushes to paint in large zones of black where finesse is unnecessary. You may do so, of course. But I have found that the common *cotton swab* used for cleaning babies' ears is an ideal and highly economical substitute which does a better job than a brush. A cotton swab can be dipped right into the bottle, it spreads India ink smoothly, like a felt marker, and makes it go farther than a brush would. Moreover, the swabs are cheap, disposable, biodegradable. I recommend them.

In some cases, particularly if you are interested in

political or sports cartooning, a few *lithographic crayon pencils* are advisable for working on special textured boards (coquille and Ross) that are familiar to the editorial pages.

Inevitably, you will need to cut paper and film. Most such cutting is done with *single-edge razor blades* that are thrown out as soon as they dull. A couple of knives should be in your supplies, too: a *mat knife*, called by hardware stores a "utility knife," and a swivel *frisket knife*. The former is used for cutting heavy cardboards, the latter for delicate materials. If the frisket knife has a swivel-blade mount it is ideal for cutting intricate shapes. The blade of such a knife can be locked in place or let ride free as the job requires. (Handling a swivel knife is tricky and requires practice. Always hold the handle vertically and let the L-shaped blade cut as it trails, as if it were a brush tracing over the form.) Another cutting tool useful for cutting very thin materials is a *sharp needle* clamped into a suitable handle. Most graphic art supply stores will carry such handles, called *pin vises*, usually designed to hold either frisket knife blades or etching needles. Last, because most predictable, own a good pair of *scissors*.

Earlier, when you were doing pencil caricatures, I suggested that you buy an *art gum* or *pink pearl eraser*. You should now have both of these and also a *kneaded eraser*. This last is so soft that it can be manipulated into any shape you like, and when used does not mar paper. Very delicate in effect, kneaded erasers are used more for cleaning surfaces than for elimination of lines.

To hold paper onto the drawing board either *push pins* or *masking tape* will do. Generally, masking tape is the more desirable. Push pins are valuable to have on hand but it is a waste of time to buy the cheap, albeit colorful, ones on sale in supermarkets and drugstores. They look "sharp" but they are not sharp enough for real work. This is another case of having to pay to get a really functional item.

Because you will have to handle lots of tiny pieces of paper cutouts (to correct individual words by pasting new ones over misspellings, for example) you will need a pair of *tweezers*. Most common to art studios are the flat-ended type sold at cosmetic counters.

Inessential, but helpful, are a *magnifying glass* and a *reducing glass*. Everyone knows what the former does. A

reducing glass looks the same but contains a concave rather than convex lens and so operates in the opposite way. It can assist one in gaining a clearer conception of what work will look like when it is reduced. A reducing glass is more important to own than a magnifying glass and is quite inexpensive.

Finally, you will need some *jars* to hold water for rinsing out brushes. You may also do as many of us do and store your brushes and pencils in such containers although special cylindrical rotating trays are available for this purpose.

Materials Two things are universal in the commercial art field: India ink and bristol board. *India ink* is a waterproof, opaque, intensely black ink usually sold in ¾-oz bottles capped with a squeeze-bulb pen-filler. The three most popular brands of India ink are Higgins (which is rather thin but doesn't clog pens easily), Artone (which is incredibly dense but does tend to clog), and Pelikan, a German product (which is thicker than Higgins' standard but less opaque than Artone's). Each of these products is subjected to excellent quality control and each has its uses. Also, my characterizations here are of the standard India ink produced by a given company. Each makes other varieties for special purposes. Higgins, for example, has a particularly opaque India ink marketed as "Black Magic" that is similar to Artone's standard. Pelikan is a good all-around India ink since it represents a more or less "happy medium." Higgins products, however, are more widely available.

Bristol board is the paper most frequently used in doing comic art and other mechanicals for reproduction. Bristol is not a trade name. It is a generic term for a wide range of art papers. Strathmore bristol has become the standard for the industry and is available in two surfaces, kid (matte and faintly rough) and plate (slick and smooth), both of which come in 1-, 2-, and 3-ply. One-ply is like very heavy typing paper or formal note paper, 2-ply is about the weight of a good playing card, and 3-ply is the thickness of commercial packaging materials used to box retail merchandise. For some reason or other, inexpert suppliers tend to sell the plate stock when asked for "bristol." But the matte surface of the kid finish is what

is wanted for most cartooning. And 1-ply is adequate for most comic art; 2-ply is entirely acceptable. ("Illustration board" is nothing but kid bristol applied to heavy cardboard.) A poor grade of bristol will lead to imperfect results and, to estimate quality, use the Strathmore as your measure.

A 19 × 24" pad of *tracing paper* will prove very useful. (If you undertake cartooning very seriously and intend to do anything with color you will eventually need a roll of *frost-surfaced plastic overlay film.*)

The best way to make routine corrections in ink work intended for reproduction is with *opaque white*, available in art shops under various brand names. If you have a massive change to make, like an entire panel in a comic strip, the simplest thing to do is simply redraw it on another sheet of paper that has been cut to size and glued to the mechanical over the error. For that you need a special glue.

Rubber cement is used by all commercial artists. It can be used freely and liberally and is easily removed without any damage to paper or ink drawings. For a permanent bond, both sheets of paper are painted with the liquified rubber, let dry, and pressed together; for a temporary "positioning" bond, only the piece to be applied receives a coating. Any excess cement is removed with a pick-up or (colloquially) "goober." This may be purchased but it's easy and free to make your own. Just peel up some of the residue around the jar opening or rub some up from the drawing paper by pushing fingers against the dried cement. This will roll up into a little ball. Then use the ball to wipe away the other dried cement. Rubber cement clings to rubber cement and, eventually, the goober will grow into a fairly large lump. You can tear it in half and then you'll have two. The blasted things tend to multiply, like amoebae—or coathangers.

Rubber cement is very volatile and evaporates rapidly, so it is best to use a small jar for applying it and to keep a large can in reserve. You should also have some *rubber cement thinner* on hand because the cement itself is apt to thicken over a period of time. Too, the little brush built into the lid of small jars of rubber cement is good for applying the cement.

B. How You Use It

Fig. 74. The diagonal line method of scaling

When preparing a mechanical for reproduction in any form, the first consideration is geometric similarity at different scales. That is, the mechanical must be exactly the same proportion as the space intended for its reproduction, although you are going to draw it quite a lot larger. Many comic strips appearing in daily newspapers today measure 6 ⅞" long by 2 ⁵⁄₁₆" tall. Let us say that you are going to draw the mechanical about twice as large as that—a fairly common practice—so you decide to make your drawing six inches longer than the strip will appear in print. That means the length of the mechanical will be 12 ⅞". How tall will it be? You can't simply add another six inches to the height, making an 8 ⁵⁄₁₆ × 12 ⅞" rectangle, because that is a very different shape from what you want. You could work it out algebraically with an elementary ratio formula, but that is tedious and subject to miscalculation. You could purchase a *proportion calculator* of some sort which will scale things for you automatically. But the simplest way to do it is by the *diagonal line method*. This is very simple to do, is entirely

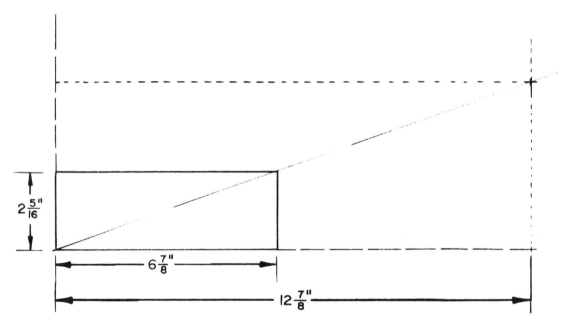

flexible, costs nothing whatever, and insures complete accuracy. Figure 74 describes the procedure.

In blue pencil, mark off the limits of the reproduction on the lower left-hand part of your bristol board. Then, strike a diagonal line through the rectangle so that it connects the bottom left and upper right corners and extends on out into the space of the paper. Next, use the T-square to continue the bottom line of the rectangle out as far as you want the drawing to be long—in this case $12\frac{7}{8}$." With T-square and one of the triangles, draw two vertical lines, one straight up from the left end of the rectangle and another straight up from the $12\frac{7}{8}$" mark on the right. Wherever the right-hand vertical intersects the diagonal is the corner of your mechanical. Set your T-square just under that point and draw a horizontal line through it, beginning at the left margin. The resulting large rectangle is the exact proportion your comic strip should be. This same procedure will work if you know only the height you want in the reproduction. And, of course, by reversing the procedure, you can always tell exactly what the proportions of any rectangle will be when it is reduced. All rectangles based on a common diagonal will have precisely the same proportions (see Figure 75). The diagonal line method may also be used to scale irregular shapes such as, for example, the figure in Figure 75. Simply construct a rectangle so that it just touches the outermost parts of the enclosed image. It is, after all, the extreme limits with which we are concerned.

The standard length of the comics in the daily newspaper is dictated by customary page makeup, so everyone knows that the usual strip is three columns wide. For other kinds of cartoons you may have to indicate the degree of reduction required. This can be done in terms of column width, picas, inches, or percentage of reduction. The simplest way is to draw two arrows (see Figure 75) far enough down to be well clear of the image itself. In the break, note the exact size for the reproduction.

Once you know what shape the mechanical must be you can begin to pencil in the cartoon. Since blue will not photograph, it is wise to sketch in the first components with a blue pencil, lightly. Then you may want to "tighten up" the drawing with a graphite pencil. I prefer

Run your thumbnail along the edge of the pages and see the Masked Marvel perform! (See "Animated Cartoons," p. 182)

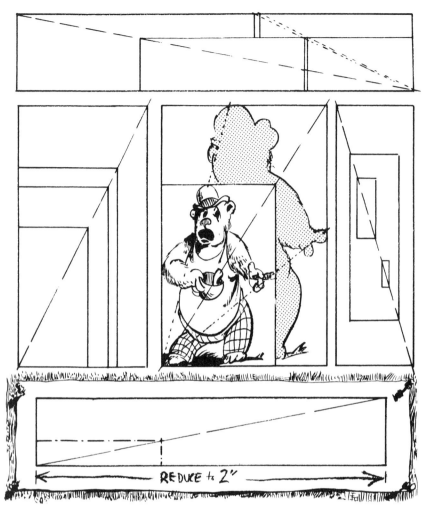

Fig. 75. Variations with the diagonal scaling method

Fig. 76. With the brush held upright, the drybrush technique creates varied lines

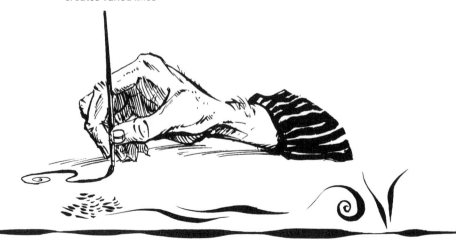

an HB or B for this work, but tastes vary. Too hard a lead will indent the paper and cause problems when the areas are inked, whereas leads too soft and crumbly result in blurry effects.

However you draw and whatever branch of cartooning you practice, it is almost certain that a good deal of your work will be done with a red sable brush. So now is the time to begin practicing *drybrush*, the name for ink drawings done with such brushes and without water. (When water is used to thin the ink and make grays, the artwork is called a *wash drawing*.)

For drybrush the brush should be held, not like a pencil, but very nearly upright, as in Figure 76. And, to the extent possible, movements ought to be made by the hand and arm rather than the fingers. All the fingers should do, really, is increase or decrease pressure of the brush tip against the paper, determining whether the mark made is thick or thin. Because sable is so flexible it is quite easy to produce a varied line like those below the hand in Figure 76. Indeed, to produce a relatively unvarying stroke you will need the help of a straight-edge. In Figure 77 I've shown the way I drew the lines that occur beneath. The trick is to keep the brush upright and at the same height above the paper at all times. A straight-edge can be held steady in this way for a few seconds longer than most of you will suppose. And, if some infirmity prevents that, it can always be propped against a rigid support. By allowing the thumb of the brush hand to ride along the upper edge of the blade you can keep the line fairly constant. But to produce an unwavering stroke you must move swiftly. The more slowly you go, the more apt you are to produce irregularities. (If you tremble once every second and it takes you five seconds to draw the line you will have a line with at least five bumps in it. But if you take only a half-second not even one tremor will appear.)

When you first begin using a brush the experience will be frustrating. Probably, you'll clench it as hard as you can and that is certain to produce disaster. If you try to draw with your fingers and not by hand and arm movement, you will produce cramped-looking work and become soon exhausted from unnecessary effort. Brush

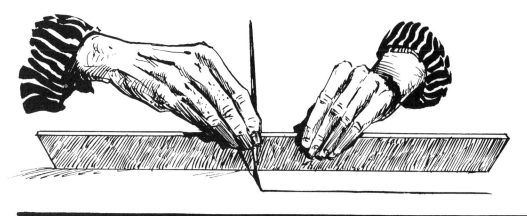

Fig. 77. Using a straight-edge and working quickly, the artist can produce an unvarying stroke of the desired width

Fig. 78. "Pointing" a sable brush to make it sharp-tipped and easier to use

drawing is like anything else. Beginning drivers are hesitant, jerky, hold the wheel too tightly, and oversteer. Novice skiers can't relax and are, therefore, all the more apt to fall. The same is true of lovemaking; tension is friend to neither pleasure nor proficiency. Easy does it, is the rule. But of course, one must be wise enough to understand that only practice brings familiarity and nothing less than familiarity can promise ease. And there's nothing "natural" about drybrush rendering. It will require practice—and lots of it.

Here are some suggestions that will make the brush a bit less obstinate. The first trick becomes a habitual mannerism among all who draw with a red sable brush. Immediately after you dip it into the ink, shape the brush to a point by bringing it toward you on a piece of drawing paper while at the same time twirling the handle between your thumb and index finger (see Figure 78). Keep a strip of bristol board tacked to your drawing table just for this purpose. About half of every bottle of ink will end up in chaotic squiggles on those little scraps, but unless you follow this procedure the brush will be too charged with ink and the tip won't be sharp.

Secondly, I should like to suggest that when you begin drawing figures with the brush you follow some sort of consistent pattern with respect to the thickness

and thinness of lines. Al Capp's *Li'l Abner*, whether rendered by Capp or by Frank Frazetta or other Capp assistants, has always made very effective use of a varied brush line. There, the tendency has been for the line to become lighter at high points and thicker on down-strokes, beneath curves, and in indentations. I have employed that technique in Figure 79. Study other artists for clues to their systems.

Finally, a caution: Partly for easier handling and partly for the sake of the brush, don't dip it in ink up to

Fig. 79. This cartoon makes systematic use of a varied brush line

the ferrule (the metal part). To do so will make the tool deteriorate more rapidly.

A sable brush can do practically anything a pen can. In fact, it can make lines that are much thinner than a pen line. But it is important in doing art for reproduction that the elements not be so fine as to disappear in printing. As a cartoonist you have always to bear in mind that everything you do is going to be reduced in scale and printed by presses. This means that lines must be clear and that ink must be black, and when you depart from distinctness it must be in order to convey something obscure with still greater clarity. Thus, in the adventure strip panel reproduced as Figure 80, opaque white has

Fig. 80. Here the author-artist has applied opaque white in a rather dry "scumble" technique to produce a speckled effect suggesting "blurred" air

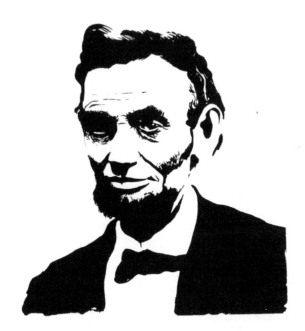

Fig. 81. The face of Lincoln, reduced to harsh black-and-white contrasts

From John Adkins Richardson, *Art: The Way It Is* (Prentice-Hall, Inc., and Harry N. Abrams, 1973). Reprinted by permission of Harry N. Abrams

been applied in relatively dry "scumble" so that it produces a broken, speckled effect to suggest air blurred by the slashing blade.

RENDERING FOR REPRODUCTION IN LINE CUT

Everything drawn for line-cut reproduction must be in black and white. But this needn't mean all light and shade is precluded. In point of fact, one can achieve virtually photographic effects by careful placement of solid blacks against pure white. My reduction of Lincoln to such harsh contrasts (Figure 81) shows how little variation is needed if shadows are placed strategically. Milton Caniff (Figure 82) is a master of the technique. And Stan Drake, the creator of *Juliet Jones,* has developed a clever "gimmick" for rendering intricate cityscapes (see Figure 83) in terms of extremely high contrast. They are astonishingly accurate in terms of perspective and shaded detail but require very little working up. Drake

Fig. 82. Caniff makes good use of strategically placed blacks and whites

Milton Caniff, *Steve Canyon.* ©1976 Field Newspaper Syndicate, Inc.

Fig. 83. Drake has developed a technique that allows him to use photocopy as a basis for an ink drawing

Stan Drake, *Juliet Jones.* ©1975 King Features Syndicate, Inc.

simply makes a photocopy on a Xerox machine of a picture in a magazine or travel brochure. The resultant image tends to be a very pale version of the original—so pale that it will remain invisible to a process camera. Pasted onto the mechanical, it does wonderful service as the basis for an ink drawing. One has only to paint in the shadow areas with ink to produce an impressively

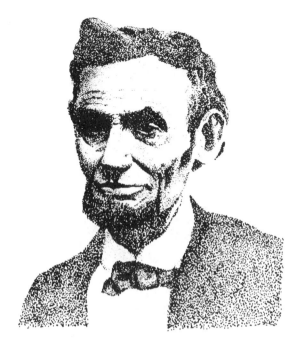

Fig. 84. *Stippling is a way to produce a grainy copy of reality by reducing light and shade to the relative density of the dots made by the pen*

From John Adkins Richardson, *Art: The Way It Is* (Prentice-Hall, Inc., and Harry N. Abrams, 1973). Reprinted by permission of Harry N. Abrams

realistic drawing. Obviously, the same technique can be applied to nearly anything: planes, cars, room interiors, landscapes, etc.

Stippling—that is, making dots with a pen, can produce a grainy copy of reality (see Figure 84). This technique reduces light and shade to relative density of marks. The more dots per square inch the darker, the fewer the lighter. Of course, making all those dots is rather tedious work. *Cross-hatching* is more direct.

Fig. 85. *Cross-hatching can be used to indicate light and dark areas*

DALE'S LOVE FOR FLASH
IS TOO UNSELFISH - - -
"DON'T GO ON THIS EXPEDITION WITH
ZARKOV AND KORRO," SHE BEGS, "I
KNOW IT'S FAR MORE DANGEROUS
THAN THEY SAY!"

Fig. 86. Raymond used "feathering" to shape his forms

Alex Raymond, *Flash Gordon.* © 1939 King Features Syndicate, Inc.

When you cross-hatch you simply draw lines more or less parallel to and across one another. But in doing so, it is wise to use a rather systematic procedure, like that shown in Figure 85. In the work of a professional you will rarely see scratchy, back-and-forth effects. Normally, an artist will cross-hatch by going from light to dark, building up the darks by adding new lines at different angles from the ones he puts down first. This may be done by either pen or brush. Frequently, the brush is used to shade edges in realistic illustrations by "feathering" an outline with small strokes that follow the contour of the edge, beginning rather fat on the outside and tapering off toward the inside. Alex Raymond, creator of *Flash Gordon* (Figure 86), enhanced his invented world this way. When it came to pen cross-hatching one of the greatest was Frank Miller, whose *Barney Baxter* (Figure 87) of the thirties and forties shows a truly virtuoso handling of textured grays.

96

The commonest way to produce gray areas in the comics is through application of prefabricated patterns, called *benday* after Benjamin Day (1838–1916), who invented them. Consisting of dots and lines of different sizes and in varying densities from extremely light to almost solid black as well as graduated patterns, white versions of all these, and exotic textures, they produce a uniform tone wherever desired. Figure 88 shows only a few of the most common benday screens. Originally, these zones of dots and lines had to be incorporated into the reproduction by a printer during the platemaking process. Today they are available to artists for direct use on *shading sheets* where they have been applied to clear plastic sheets with a pressure-sensitive backing. Zipatone and Chartpak are two familiar brands. In use, the film is placed over the ink drawing and a section cut to fit with a frisket knife or sharp needle. The film is then rubbed to insure adhesion with the bristol. The grays in Figure 68 as well as elsewhere in this book were achieved in this way. Benday patterns are also available in a slightly different form as pressure-sensitive impressions on the back of a waxy film; these are transferred to the drawing by rubbing the front of the film and offsetting the dots onto the drawing paper. The problem with transfer dots is that it is almost impossible to keep them in line and the film from crawling.

Many advertising cartoonists and a few comic strip artists have made extensive use of a special kind of paper called *doubletone*, of which the most famous brand is Craftint Doubletone. This technique was made famous in comic strips by Roy Crane, the cartoonist who created *Capt. Easy* (entitled *Wash Tubbs* until 1932). Crane drew it until 1943, when his associate, Leslie Turner, took over; Turner retired in 1970, and the strip is now drawn by Bill Crooks and written by Jim Lawrence. Crooks still uses the same general technique begun by Crane. Crane himself now draws and writes *Buz Sawyer* (Figure 89). The strip is extremely sophisticated in many respects, but the Craftint Doubletone board still serves as the artist's mainstay. Notice that the shading consists of three values: medium gray made up of parallel diagonal lines, dark gray resulting from a mechanical cross-hatching of such lines, and solid black. The black is India ink. The

Fig. 87. This artist used pen cross-hatching to produce even-textured grays

Frank Miller, *Barney Baxter*. ©1939 King Features Syndicate, Inc.

white is blank paper. The two grays are barely visible in that paper as faint blue lines, invisible to the camera until they have been developed by chemicals sold for use with the doubletone board. The solutions brush on just like water, but one causes one set of lines to turn black wherever it is applied, the second brings out the other set. Crane's ability to render anything imaginable, in any atmosphere or time of day, with three values and white is nothing short of uncanny. Craftint manufactures doubletone boards with dot patterns as well as parallel line designs, in assorted densities. But the virtuosity of Crane, Turner, and Crooks has given the parallel line design a considerable edge among cartoonists. Singletone boards with only one pattern are also available.

There are other drawing boards with special properties ideally suited to graphic production. Among the most widely employed by cartoonists are the *textured boards*, of which the primary examples are Ross board and coquille board. These are hot-pressed bristols (i.e., "plate") embossed with very definite pebbly, ridged, and grainy textures. A pencil or crayon can mark the high

Fig. 88. Benday patterns consist of zones of dots and lines that produce gray areas

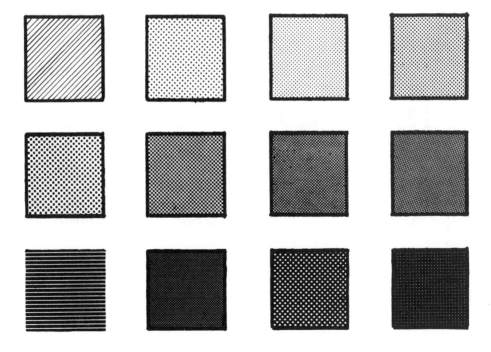

☙ KING FEATURES SYNDICATE ☙

Buz Sawyer ® **By Roy Crane**

Fig. 89. Crane's use of doubletone board allows a sophis-ticated use of shading

Roy Crane, *Buz Sawyer.* © 1972 King Features Syndicate, Inc.

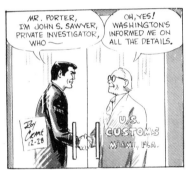

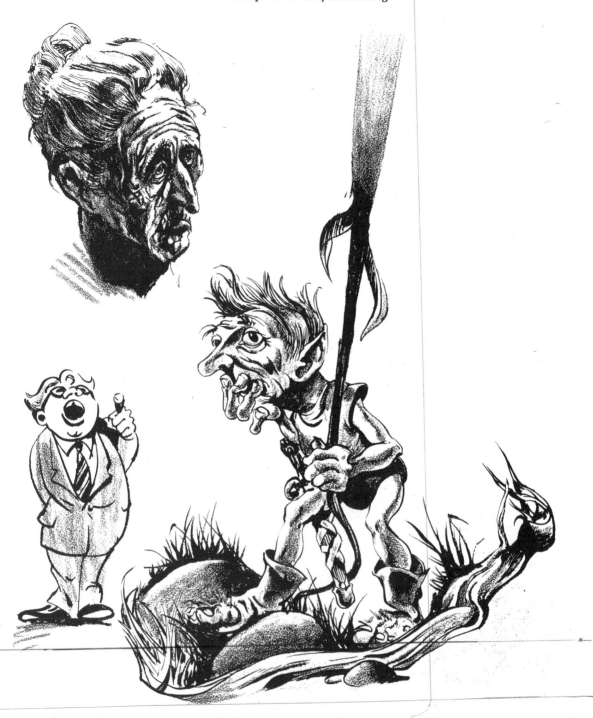

Fig. 90. Textured paper allows the use of crayons in elaborately shaded drawings that can be reproduced easily

points but will not usually get down into the spaces or "valleys" between. A black crayon rubbed over the surface produces a pattern of black speckles on a white background. The particular pattern produced is, of course, determined by the specific texture impressed into the board. The peculiar merit of these boards for cartoonists or illustrators is that they make it possible to draw up elaborately shaded crayon drawings (Figure 90) that will reproduce in black and white as easily as if they had been done with pen and ink. The characters in Figure 91 were done on coquille board in the following way: I drew the principal outlines lightly, with blue pencil, and added some detail with an HB drawing pencil. Next, the most critical edges, wrinkles, folds, and solid blacks were inked in with a sable brush and crow-quill pen. The shading itself was done (in the case of the old woman) with a number 4 Korn's lithographic pencil and (for the politician and the Hobbit) a number 2 conté crayon that had been sharpened to a point. Light pressure deposited the crayon on the uppermost peaks of the ridges, additional pressure drove the crayon deeper down into the valleys. Pressure should, in any case, be applied gradually and delicately—more by repeated stroking and consequent buildup of crayon than by bearing down to grind the stuff into the paper. A great deal of editorial cartooning is done on coquille or Ross boards and they are also often used for illustration in magazines devoted to fiction in the Western, science-fantasy, and mystery genres. There is no reason that comic strips can't be done on the textured boards. Gag cartoons have been.

Finally, there is another special drawing board which, although of limited use, deserves mention. This is *scratchboard*, which is cardboard coated with a uniform thickness of white clay. A few, very few, gag cartoonists have used it, usually to evoke an "antique" look. As far as I know I am the only one ever to have applied it to the adventure strip (Figure 91) where, of course, it approximated the appearance of wood engraving. In this medium, again, the sketch is done on the white surface with a blue pencil, then the entire picture rendered in India ink with a brush and pen. Once the ink has dried (almost instantaneously), one can scratch parts of it away with needles, knives, and special tools that cut parallel

Fig. 91. Done on a scratchboard, this cartoon resembles a wood engraving

John Adkins Richardson, *Maxor of Cirod.* ©1971 John Adkins Richardson

grooves, thus revealing the white clay beneath the black ink. Never cut more deeply than necessary. The most common error—or so it seems to me—is to overdo the black on white and leave too little white. Although the sparkling clarity of a scratchboard drawing makes it seem like something that needs fine art papers for printing, it is excellent for reproduction on newsprint and many renderings of automobiles and liquor bottles in the ads are done in this medium. I include mention of it here, however, because some greeting card motifs are eminently well-suited to the technique. Too, I have always thought that one could do tremendously powerful political cartoons in the scratchboard medium. (In fact I experimented with the idea during the late 1960s for a "free press" printed by some radical college students. But the cartoons were rejected for content, indicted as "counterrevolutionary versions of Trotskyite Deviationism.")

RENDERING FOR REPRODUCTION IN HALFTONE

Earlier, I said that *all* of the reproductions in this book were done by a process that reduced everything to black or white without grays. That is true. It is, for instance, true of the rendering by Richard Corben in Figure 92. The original photograph and the actual painting are examples of what graphic artists call *continuous-tone copy* as opposed to the line copy we have been discussing up to this point. That is, the painting actually does contain a full range of grays between white and black, unlike line copy, which merely may appear to contain grays. Line copy is used to create a line cut. Continuous-tone copy, on the other hand, ends up in what is called a *halftone*. And what a halftone does is to reduce all of those grays down into minute dots so that it can be printed in exactly the way a line cut is. The sole difference is in the way the copy is exposed to the process camera.

There are several ways of making halftones. But the principle is always essentially the same. Here is one method: A halftone *screen* is placed in the process camera between the lens and the film (see Figure 93). A halftone screen is a sheet of glass or plastic engraved with very

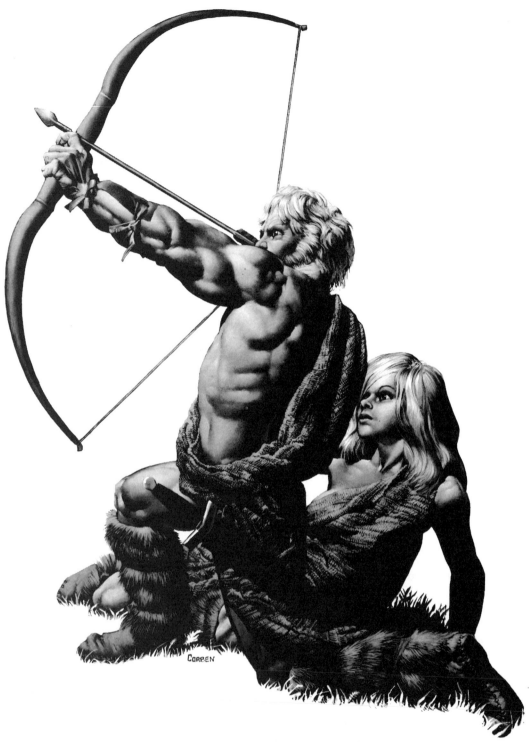

Fig. 92. This has been reproduced by the halftone process from a painting containing true grays

fine diagonal lines that have been filled with black pigment. A diagram of one vastly enlarged is shown in Figure 93. Because the film used in reproduction is incapable of discriminating anything except black or white, it "sees" the copy in terms of those extremes. Without a screen in the camera the image would be reduced down into blotches, like image *A* in Figure 94. But when a screen of 100 lines per square inch is interposed, these gross patches are broken up into tiny points of light or dark. As it happens, optical law dictates that a light area the same size as a relatively darker area will look relatively larger—to a camera no less than to the human eye. Therefore, the high-contrast film reads white areas of the copy as made of large dots; gray areas, of slightly smaller ones; darker gray areas, of still smaller ones; very dark areas, of tiny dots; and black areas, as having almost no dots at all, producing a negative like the enlarged detail in B. A plate made from that sort of negative, in the same way a line cut is made, prints the kind of image you see in C. Enlarged to the same degree as B, it will have a lot of little dots standing up in relief; there are many dots close together where the image is to be black and very few where it is to be highlighted. If you look at a newspaper

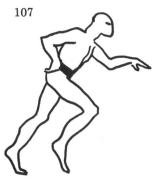

Fig. 93. This drawing illustrates one way to make halftones

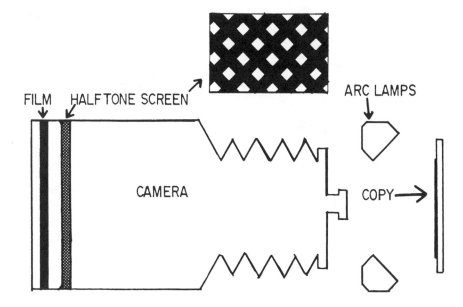

FILM HALFTONE SCREEN

ARC LAMPS

CAMERA

COPY→

you will see that reproductions of photographs answer to this description. Newspapers use very coarse, 65-line halftone screens for their work. Screens of 100 are standard for the kind of paper you are reading from right now. Finer screens (120–150) are suitable only for coated papers.

Anything that can be photographed can be reproduced in halftone. Pencil drawings, oil paintings, watercolors, paper sculptures, puppets—the possibilities are limitless. But the most common medium in the field of cartooning is the *wash drawing*. Wash drawings are done with water and India ink, black watercolor pigment, or some similar substitute. In principle, the medium is a

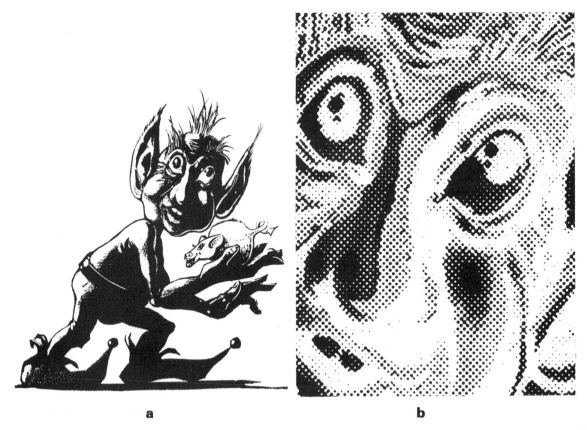

a b

Fig. 94. a: *Continuous-tone copy shot without a screen;* b: *Enlargement of section of negative made with halftone screen, five times;* c: *Continuous-tone copy shot with 100-line screen and reproduced;* d: *Enlargement of section of halftone reproduction* (c) *by 5 times*

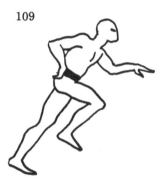

simple one, but considerable practice is required to handle wash fluently. For the most part it is a matter of working from light to dark through a series of grays. The materials and tools are those of the watercolorist: watercolor paper or illustration board, sable brushes (numbers 4, 6, and 12 at least, and flat as well as round), jars to hold water for thinning and for cleaning, and something in which to mix the different values you need. Transparent plastic egg trays are practical for holding the mixtures of water and ink. Wash drawing is easier to do if you mix up solutions before beginning to paint, putting the darkest black (pure ink) in one cup, dark gray in another, medium gray in a third, and light gray in a fourth. Normally,

c

d

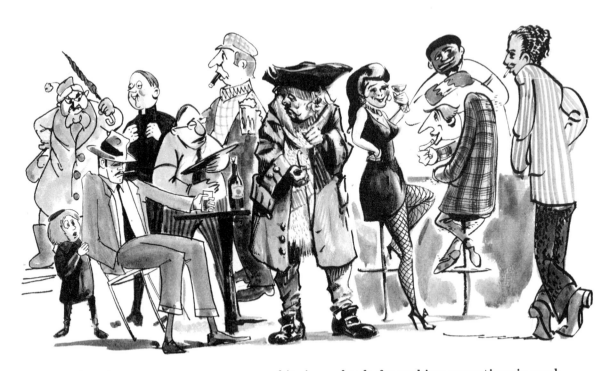

Fig. 95. There are many ways of doing wash drawings

opaque white is used only for making corrections in wash drawing; as in ordinary drybrush, the paper serves for the lighted areas. The main difference is that here, instead of cross-hatching, stippling, or using benday patterns, you paint grays in directly. There are as many ways of doing that as there are artists, and I have described a few of them in Figure 95. A simple approach for beginners is to use the washes very boldly, making no attempt to modulate shadows or create detailed effects, clarifying the image with the drybrush or pen line. Such a line is easier to control when the wash areas have dried, but pen lines in damp areas are often much more interesting than the hard contour of ink on dry paper. Too, a casual look is usually more effective than a very neat, outlined appearance. Whatever manner you adopt, avoid excessive subtlety. Keep the number of values limited to two or three apart from black and white. Cartoons, by their nature, require impact—and that presumes contrast. Also, don't try to go over a wash once it is down to smooth it out or model it. Put it down and leave it alone. If it is completely wrong, do it over.

If you wish to wash drawings, you would be well-advised to study watercolor painting, since all of its many techniques are directly applicable to this ink medium. And watercolor is very difficult to learn for oneself; it would be best to take a class taught by a professional. Like the other techniques, it requires practice.

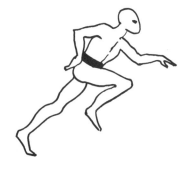

The practice required to do wash drawings is still more essential for work in the other continuous-tone medium I wish to discuss—*airbrush*. An airbrush (Figure 96) is nothing but a spraygun about the size of a fountain pen. It can yield the most delicate gradations of tone or can be used to produce flat, even tones. Often used for retouching photographs, the airbrush is unequaled in the attainment of extremely realistic effects. To become really good with an airbrush requires a lot of time and patience, and its masters are pretty much restricted to specialized areas of technical illustration. The tool has, however, been employed to great advantage by animation cartoonists and by at least one comic strip artist, Richard Corben. Corben (Figure 97) combines the airbrush with

Fig. 96. An airbrush is simply a small spraygun that can produce delicate gradations of tone

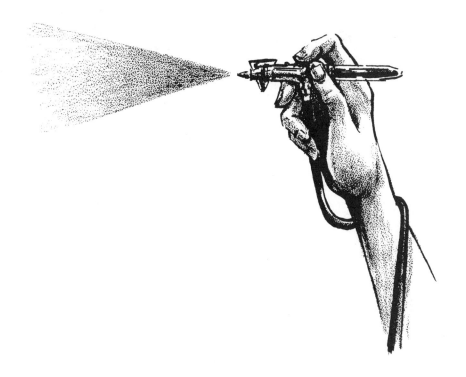

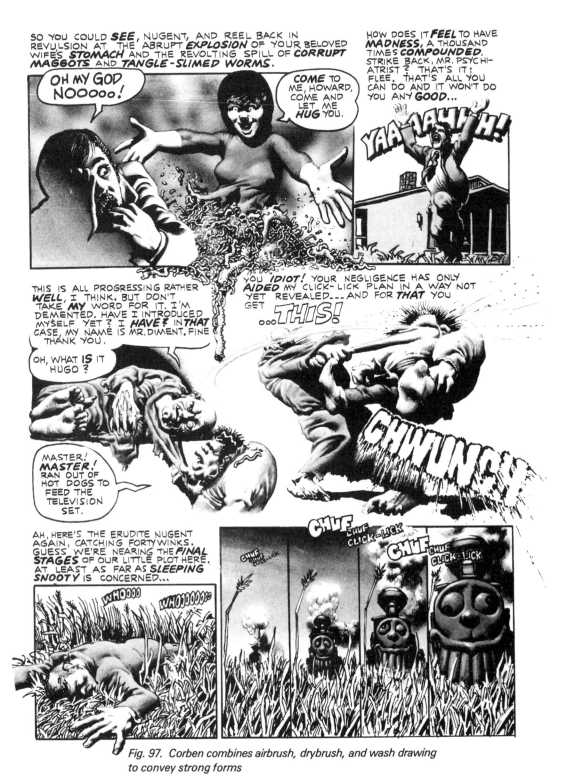

Fig. 97. Corben combines airbrush, drybrush, and wash drawing
to convey strong forms

drybrush and wash drawing to convey remarkably strong forms in his science-fantasy-horror comics.

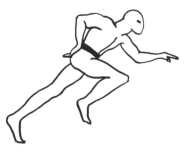

The airbrush works like any other atomizer; a stream of air passes through a channel to the nozzle across a tube, creating suction to draw paint or ink from a container up the tube and into the airstream. The paint is then expelled through the nozzle as a spray of fine droplets. The fineness of the spray depends upon the size and character of the nozzle opening and the position of a needle that controls the amount of fluid released through that nozzle.

Either a CO_2 tank or a mechanical compressor can be used to power an airbrush. Generally, a mechanical compressor with a storage tank that can maintain a constant pressure range is the best investment.

For black and white illustration, India ink may be used in the airbrush after being diluted with a couple of drops of clear (*not* soapy) ammonia in order to slow up the drying time. Since the spray itself is very diffuse, you must cover whatever is to remain white or is to be airbrushed in a contrasting tone later. Friskets are usually used to block out those zones. Frisket material can be bought in sheets or in rolls or can be made by covering tracing paper with a thin coating of rubber cement so that the paper will stick closely to the work surface while being struck by the spray but will not be too hard to remove. (Friskets are made by placing the frisket material over the pencil or pen drawing and lightly cutting out the areas you want open with a frisket knife. Then you peel away the cut area to expose the paper. It is not nearly as difficult as it may seem to cut through the frisket without damaging the drawing surface.)

Richard Corben writes me that "the actual painting with an airbrush is accomplished very quickly. It's the preparation of friskets, changing of colors, and cleaning up that takes the most time." His words on procedure are worth quoting here:

When doing an airbrush drawing that is to be black and white, there is a possible shortcut. One frisket is overlaid on the drawing and all contour lines are cut but not

removed. First, just the parts that are to be darkest are removed and the area sprayed using diluted ink. Then the second darkest areas are removed and sprayed without worrying about covering the darkest areas. Then the third darkest areas are done, progressing towards the lightest areas. In this way a full tonal range drawing can be made with a single frisket.

An airbrush is held lightly in the hand, in the way shown in Figure 96. The button on the top releases air through the nozzle when it is depressed by the index finger; when the button is pulled backwards, ink or paint is drawn from the cup or jar up into the airstream. The thumb, in position just behind the control button, serves as a support for the index finger and makes for greater control and steadiness. The paint cup ought to be only about half full to prevent spillage.

For the sort of work you might want to do in cartooning, either a Paasche Model VI or a Thayer and Chandler Model A will do. They are, however, the easiest to clog and hardest to clean of the airbrushes. Corben says that his Paasche Model AB is useful for small passages needing an extremely fine spray and is easy to clean. Airbrushes cost between $50 and $200 and compressors run from about $100 to $300.

The Corben strip reproduced here actually combines two kinds of copy—continuous-tone copy for the drawings and line copy for the lettering in the balloons. Had he wished, Corben could have incorporated line drawings among the airbrushed ones, not as halftone lines the way he did here, but in the same way the lettering has been reproduced. In either case, the mechanical would consist of a base mechanical on bristol and an airbrushed overlay done on tracing film. The artist merely indicated in writing on the margin of the mechanical that the overlay is a "double burn" and the platemaker then knew he had to expose the plate twice—once for the line copy, once for the halftone—thus creating a single plate combining both pieces of artwork. (This is economical only in offset lithography, though; it is expensive and rare in photoengraving.)

Fig. 98. Registration mark

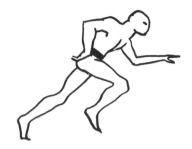

Any time overlays are used, *registration marks* must be used. These are cross-hairs, frequently centered in circles (see Figure 98), used by platemakers and printers to insure the proper positioning of art throughout the reproduction process. They are provided by the artist, who may draw them or may use already prepared registration marks printed on transparent plastic tape. Whichever the case, at least two registration marks must be applied to each sheet of the mechanical so that they are directly and precisely on top of those on the bottom sheet. Normally, they will occur at the top and bottom centers of the sheets.

COLOR

Color is seldom a major consideration for the cartoonist, but we should at least touch upon it before going on. Essentially, there are two kinds of approaches to color in reproduction: *mechanical separation* and *process separation*. There are, of course, all sorts of subsidiary categories, such as "double halftone," direct and indirect process, etc. We shall consider only four-color work and discuss it in simple terms.

Comic books and the Sunday "funnies" are usually printed in four colors from mechanical separations done in the studio. "Separation" can be taken quite literally; it is any process whereby colors such as green, violet, brown, orange, pink, tan, whatever are broken down into their four component elements of yellow, red, blue, and black. In a comic book the black is what the artist's original line copy consisted of. Using it as a key for the zones of color that are to be added, the colorist can use benday dot patterns and solid overlays to create any of the standard hues and tones. For instance, blue dots on top of a yellow field will produce a yellow-green or green, depending on how close together the dots are. Red dots on the same yellow would give yellow-orange or red-orange. Red and green together over yellow in about equal densities give a tan. Usually, the cartoonist himself does not have to understand very much about how this is done; he just indicates the colors desired by coloring in a photograph of the line copy with inks or transparent

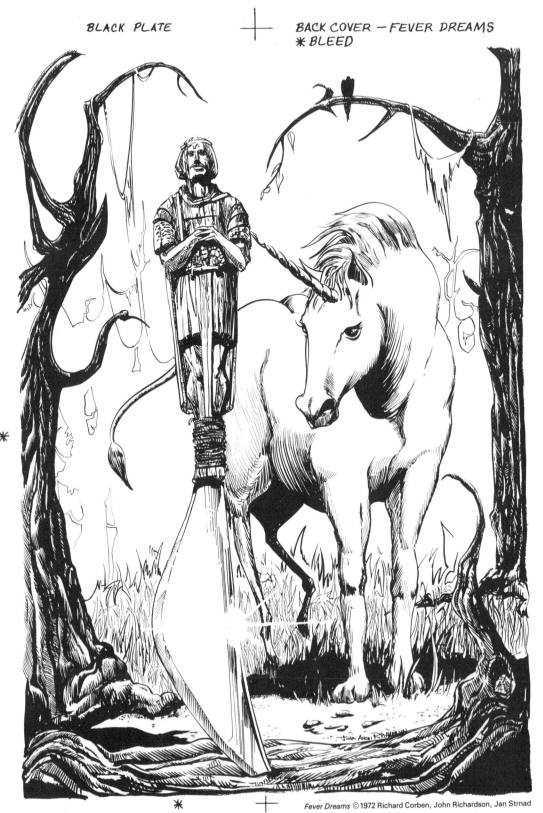

Fig. 99. Color separations for Fever Dreams *back cover: black plate*

paints. Following this legend, the colorist can produce a set of three overlays which will be used to produce three separate printing plates. When these are run through a press, inked with transparent process inks (yellow for one plate, red for another, blue for a third, and black for the fourth), and their impressions superimposed on one another, you have the "full color" of the Sunday comic page or typical comic book (Colorplate I).

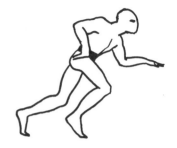

Most of us have been taught that the three primary colors in pigment are yellow, red, and blue—that is, that all the other colors (except black and white) can be mixed from them. That is almost, but not quite, true. The real primaries are yellow, magenta, and cyan (turquoise)—or, in shop-talk: process yellow, process red, and process blue. The hue you'd call "truly red" in fabric can be evoked by a combination of magenta and a little yellow. Similarly, a touch of magenta in the cyan brings into being the kind of blue that is not blue-greenish. The results of intermixtures of the process colors and black on white paper are well-understood and are, therefore, predictable. From this fact have grown a number of products of value to the commercial artist and cartoonist.

Bourges graphic art mediums are based on the use of transparent color sheets matched to standard printing inks. The sheets come in (among others) the three process hues and black, printed with dot patterns in the following densities: 10%, 30%, 50%, 70%, 100%. With these sheets it is possible for anyone to produce mechanical separations that will correspond exactly to the final printed impressions as far as color is concerned. Bourges sells a color guide of 3 × 5" swatches that can be overlapped to see the effect of overprinted inks.

Coloron is another color guide that predicts the results of color combinations and tints and also indicates the legibility of type and other effects against each color. It consists of eleven transparent plastic sheets printed in a 110-line screen with a series of panels graduating from a 10 to 100% density. Using it, even an inexperienced (if sufficiently fastidious) artist can produce color separations by means of black and white overlays. (He'll have to use a magnifying glass though, because 110-line screen is far, far too fine for most of our purposes.)

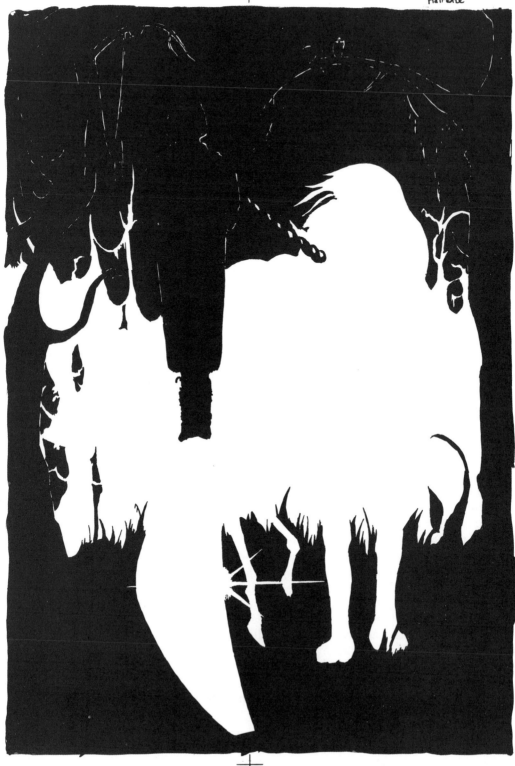

Fig. 99 (cont.). Yellow plate

In doing mechanical color separations (or other kinds of combinations such as line copy and halftone double burns), the work should be prepared on tracing film, which is resistant to shrinkage. Leave margins of several inches around the work because it is here you will add the registration marks and any instructions to the printer.

Colorplate IV is a reproduction of my back cover on an underground comic book entitled *Fever Dreams*, a collaborative venture by Richard Corben and myself. Pay particular attention to the exquisite wonderfulness of that color which, as comic book color goes, is really quite extraordinary. Unfortunately, the author cannot take credit for it. It's all a product of Corben's virtuoso airbrush and the mechanical separations shown in Figure 99 facing pages 119, 121, and 123. The separations were done in black and white on tracing film and the plates run in the colors Rich designated on the top margin. Note the instructions respecting size, process, color, and so on. The remark in red pen, saying "bleed" with stars on the three sides means that the image should be printed to extend off those three edges of the page after it is trimmed. When your design involves an image that "bleeds off" you should allow between 1/8" and 1/4" beyond the trim size of the *printed page* for trimming.

The kind of work that went into this separation is not only onerous; it also demands a great deal of experience and fine judgment regarding the ultimate effect of black and white overlays that will be printed in color and superimposed. But it produced an effect that would have been very costly had the cover been done as a painting in full color and printed as a color halftone after process separation. That is the way Colorplate II was produced and is the way most book jackets and four-color gag cartoons are done.

Process separation is done by the platemaker from original art or from high-quality color transparencies. It involves very close tolerances and real understanding of it requires at least a little knowledge of color theory. But here's how it's done (see Colorplate III). The process camera shoots color copy four times through four differently colored filters. These filters are exact complements (i.e., opposites) of the process color primaries,

Fig. 99 (cont.) Red plate

yellow, magenta, and cyan, plus one yellow filter. What this means is that when the copy is photographed onto black and white high-contrast film through a violet filter, the yellow components of the full-color image are translated into dense blacks and dark grays, while all other colors are so bleached out that the film doesn't see them at all. A green filter turns the reds to black, but drops out yellows and blues. An orange filter brings out the cyan blue but suppresses the reds and yellows. Finally, the yellow filter is used to balance the black and white values throughout the image. All of the actual film images are black and clear, just like any other halftone image on reproduction film. When four separate plates have been made, they can be run inked with the appropriate hues and the superimposition of all four will give a close approximation of the color range in the original copy. Because process separation is expensive and because the halftone screens used must be quite fine, requiring a coated stock for clear printing, this process is uncommon in cartooning except for such special cartoons as those appearing in mass-circulation men's magazines, greeting cards, comic book covers, book jackets, and so on.

Any of the standard painting media can be used for producing artwork for color process separation. But it is wise to avoid certain kinds of color combinations. In particular, intensely red forms painted into black areas are difficult for the camera to discriminate and may entail special work by the platemaker, thereby increasing costs.

BLUE
Halftone

Fig. 99 (cont.) Blue plate

SINGLE-PANEL AND LIMITED-SEQUENCE CARTOONS 5

Most of us, upon hearing the term "cartoon," summon to mind a single picture, either humorous in nature or made so by a caption printed beneath it. The word itself, however, derives (like "carton") from the Italian *cartone,* meaning heavy paper. Originally, the reference was to a full-size preliminary drawing for a painting, a usage today retained only within fine arts circles. The word seems to have secured its popular connotations during the eighteenth century when caricature was imported into England from Italy as an aristocratic diversion, becoming a sort of "in joke" hobby. From this period comes the modern cartoon. And although from the very first, stories made up of sequences of pictures have been part of the tradition, the single panel has predominated. Cartoons telling jokes are the most enjoyable, the political statements more memorable. We shall begin with jokes.

GAG CARTOONS At one time the field of gag cartooning was quite accessible to new talent. Twenty-five years ago the appetite of mass-circulation magazines for column filler in the form of visual puns and illustrated jokes was enormous. If you couldn't sell a gag to *The New Yorker* then *The Saturday Evening Post, Esquire,* or *Colliers* might buy it. If not one of these, perhaps the *Farmers' Weekly* or *True,* or *Woman's Home Companion.* There were dozens of others besides. If all rejected the cartoon—as might well happen, competition being what it was—there were still trade journals, specialty magazines, the pulps. In the United States today there are only two reliable markets for gag cartoons: *The New Yorker* and *Playboy.* They pay well and they take only the best.

Of course, there are plenty of other magazines on the stands, and many of them publish gag cartoons. But where there were once a thousand magazines there are now less than a hundred regularly published. Most use far fewer cartoons in any given issue than they did years ago. Humor magazines—like *Mad* and *National Lampoon*—rely pretty much upon regular stables of artists who work more or less exclusively for them. *The New Yorker* seems genuinely dedicated to preserving the gag cartoon as a vital graphic form in the face of practically nonexistent competition and has published some remarkable new talent. But the George Booths and William Hamiltons are two exceptions among literally thousands of gifted cartoonists who've yet to see their work in print. Still, because *The New Yorker* is rightly considered the ultimate measure of success in American gag cartooning, we shall rely heavily upon its sense of humor here. That should not, however, mislead you.

The first thing to be considered when one is trying to place a gag cartoon is the audience. What appeals to a *Playboy* subscriber will not necessarily amuse a reader of *The New Yorker.* And the latter is unlikely to be impressed by the gag saved for posting on the plant bulletin board by a devotee of *The American Rifleman.* Clearly, anything reaching the pages of *Parade* or *National Weekly,* supplements distributed with Sunday newspapers, is aimed at a highly commonplace sense of humor. *New Yorker* humor is aimed at well-educated middle-class people who are highly sensitive to the pretensions and

ironies of modern life. Sophisticated rather than intellectual, they are elitist (or at least cliquish in attitude) but at the same time archly self-deprecating. They sense the hypocrisies of their liberalism as well as the ultimate futility of conservative integrity. And that sort of schizophrenia makes fertile ground for satirical wit. By contrast, the *Playboy* mentality is comparatively sophomoric, highly materialistic, and self-congratulatory in a somewhat shaky way. Though sexual relations form a mainstay for the humor, the far more constant characteristic of *Playboy* cartoons is irreverent exaggeration.

Both *The New Yorker* and *Playboy* take what has come to be called a "liberal" view of minorities. Alternative lifestyles are dealt with tenderly or wryly; they are very seldom ridiculed. Quite the contrary is true of lesser men's magazines like *True* or of most of the "homemaker" periodicals. There, of course, freaks and dissenters are fair game. Among women's magazines, *Cosmopolitan* will accept female versions of the male magazines' sexual humor. *Ms.* is far more earnest about sex; its editors find libertinism less funny than pathetic. They prefer jokes in which sexpots get deflated and male chauvinists their comeuppance.

Despite the tremendous variety of tastes, however, the range of gag cartoons can be broken down into a few categorical groupings according to principles hiding behind the jokes. Too, they share certain attributes in terms of appearance no matter where the gags are published. Also, there are certain things they demand of the reader. Let us examine these things in reverse order: viewer behavior, appearance, and type of gag.

The first thing any cartoonist has a right to expect of readers is that the latter realize that what they're seeing is a joke. A famous instance of confusion on this point occurred when one of Charles Addams' cartoons from 1940 was republished in Germany after World War II. Captionless, it consisted of nothing more than a wash drawing depicting two skiers on a forest slope. The man is halted in his climb to the summit, bug-eyed and stock still, as a girl sweeps downhill beyond him. Her ski tracks have passed on either side of a large evergreen tree! (This gag has since been repeated with numerous variations,

even in movies, but Addams seems to have originated it.) A large number of Germans wrote in with their solutions to the "puzzle." Obviously, many people must have spotted it as a joke and, therefore, saw no reason to comment. But Americans were stunned by the number who did submit letters and by the apparent literal-mindedness of their recent enemies. This "humorlessness" was, as I recall, widely accepted as evidence of the type of mind required to follow Hitler into the holocaust. Of course, it was nothing of the sort; it was just a question of the cartoon being out of context and of some culturally distinct notions about what kinds of impossible situations are funny and which are simply puzzling. Such differences are as fundamental as those of language. In a French comic strip the rooster who sounds "cock-a-doodle-do" to me will say "kocorico!" In Germany it cries "kikeriki!" In Chinese the characters signifying this crowing are pronounced: "Kiao, kiao." That's the way a rooster sounds to native speakers. But none of those renditions look right to the Spaniard, Thai, or Norwegian. And, where noises don't sound the same, you can hardly expect the same kinds of jokes to produce, universally, the sound of laughter.

Assuming that the viewer knows the thing before him is a joke, there is still the matter of knowing *how* to read gag cartoons. That's right. Oddly, most people are not aware that a specific sequence is expected from them. You look at the picture first, then read the caption. Most cartoons will be funny even if you do the opposite, but normally they will work better going from picture to caption. An example of how this is apt to work appears in Figure 100. It produces a "double take." But the effect would be less startling if someone read the caption first and then simply noted that what it says is true.

It is far more difficult than one might at first suppose to render a cartoon idea so that it is funny. Often, a drawing style that seems crude and inept is the very thing that makes the joke seem funny. James Thurber's mannerisms turned a situation like that in Figure 101 into a hilarious event. Had I drawn it, it wouldn't even be droll.

The way things appear in Thurber's world is in perfect harmony with the behavior of his people whose emotional reactions are bizarrely, yet ever so slightly

Fig. 100. *"My God, Sugar, I just counted five pairs of legs!"*

Fig. 101. *"What have you done with Dr. Millmoss?"*

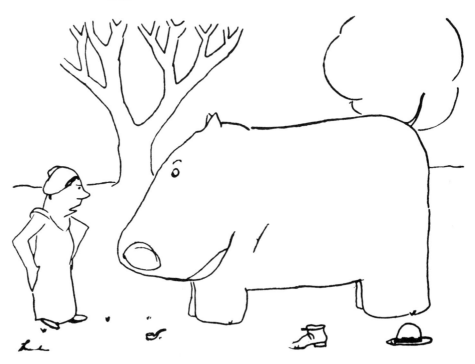

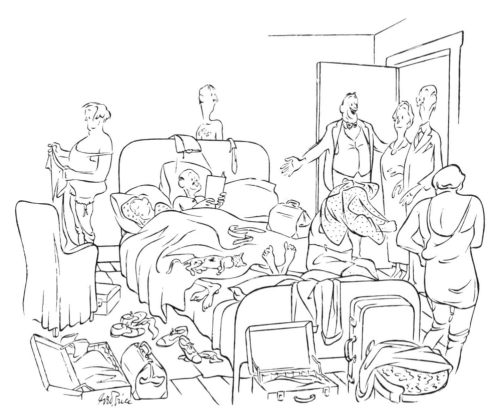

Fig. 102. "Here's the guest room. Just make yourselves at home."

misdirected. And George Price (Figure 102), whose subjects are more often than not seedy characters on the edge of disaster, uses a line combining flimsiness with rigidity. Drawn with a split-haired brush, it evokes the kind of shabby tentativeness suffered by the population of his cartoons. Everyone he draws is either rumpled or stiff. Since his men and women tend to be bony-looking, gristly, even when they are fleshy, hints of hunger linger there. The threat of deprivation is constant.

Development of a style as congruous with one's humor as is true of Price or Thurber is not something that can be achieved by deliberate learning. Rather, it is instinct in one's sense of things and emerges as one practices. If you see humanity as a lump of barely sensitized

protoplasm you are apt to evolve a different kind of joke and style than if you think people are curiously robotlike. But in either case the picture is going to exhibit similarities with many other gag cartoons.

When composing any anecdotal or story-telling picture, one must bear in mind that the principal aim is to convey a message and not to design a thing of beauty. In nearly every case a gag cartoon will have what used to be called a "center of interest." That is, the viewer's attention has to be focused on a specific area of the drawing. The ways of doing this are, literally, innumerable. The most common, however, involve contrast and line directions. To wit, invert Thurber's cartoon. Although apparently very simple, it is quite cleverly designed,

Fig. 103. Diagram of some of the linear movements in Figure 102.

employing great economy of means to direct us beyond the large animal to the annoyed woman who utters the caption. Notice that the hippo's face is parallel to, and virtually duplicates, the line of the adjacent tree limb. This directs our attention along the pathway leading to the woman whose left forearm continues the same angle. The side of the tree nearest to her curves around with a little hook below the horizon, again pointing to the

Fig. 104. "Still, did you ever stop to think where you and I would be if it weren't for evil?"

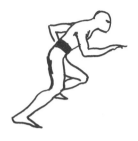

his hat, shoe, and pipe—are not scattered but march resolutely toward his champion. Her relatively small scale and abrupt angularity contrast quite sharply with anything else in the picture.

The Price cartoon focuses attention on the speaker by posing him against a rectangle in a sea of curves and diagonals. Also, the elements right behind him are the tallest things in the room. His posture is expansive, both things in contrast with the white compactness of the other figures. Moreover, things tend to be lined up so that they point at him. Figure 103 is a diagram of some of the linear movements; actual edges and palpable connections are indicated by solid arrow lines and alignments or compelling forces (such as the direction of a glance) indicated with broken and dotted lines. Such movements in pictures form pathways, as it were, for our eyes.

Experience tells me that the diagram will raise eyebrows and questions. After all, lines do run both ways. How can I say that these point to the speaker instead of away from him? Because the majority of the diagonals converge on him. Did Price do this deliberately, though? It is deliberate, unequivocally. That such a pattern could occur by accident is far beyond the realm of chance; besides, it is fairly common pictorial composition. Now, if you were to ask whether or not George Price was *conscious* of every alignment I have found, I would have to say that he probably was not. Artists often do things by instinct, habit, or custom of which they are not aware. About 80 percent of the work done by teachers of composition and design in art schools consists of pointing out to students things they have done without thinking, so as to reinforce the positive and eliminate the negative.

The Price and also the Thurber are quite sophisticated. A more readily imitated way of providing contrast is used in Alain's famous gag about the vested interests of clergymen (Figure 104). Solid blacks set against openwork lines are further emphasized by eliminating any distraction near the faces by creating a hiatus around them.

If you study the composition of gag cartoons closely you will soon remark the rarity of closeups. It is uncommon to have less than a whole figure, rare to see a figure

less than half-length, and extremely unusual to see nothing but faces. Probably, this is an unconscious ploy we and the artists use to maintain psychological detachment through illusory distance. We are never so far from the characters that we have a hard time "reading" them. (If the figure is so distant that he or she is featureless, the point of the joke will be related to scale and not to expression.) Even when people are relatively near we are not allowed to become intimately identified with them or their circumstances. Humor usually depends to some extent on feeling superior to the butt of the joke without feeling sorry for him. The classic example is the pratfall. It's funny when a pompous character turns and strides off into a swimming pool or slips on a banana peel; pity rather than laughter is apt to be evoked when the victim is feebleminded or elderly. Habitually, we laugh at such events when they are set apart from our normal human sympathy for underdogs and fools. After all, those who actually get a kick out of others' misfortunes and embarrassments are despicable. Typically, humor entails emotional distance. In cartoons the distance is literal.

You may notice, too, that cartoonists work as if in obedience to the famous modern painter, Henri Matisse (1869—1954), who once wrote: "All that is not useful in the picture is detrimental." Although Thurber, Price, and Alain all use full-length figures and fill up the entire space with pictorial material, there is nothing that does not in some way contribute to the total effect. Thurber's is the least detailed cartoon, Price's the most. But where additional landscape detail would have detracted from the impact of Thurber's fantasy, Price needed to itemize the contents of the "guest room" quite explicitly in order to convey the curious ambience of this lower-middle-class milieu. Still, even he did not tell us more than is absolutely necessary. Similarly, Alain tells us only what we must know in order to have a pretty good sense of just how cozily insular the comforts of religion can be.

Composition, like anatomy or perspective rendering, must be studied in a wider context than cartooning. One of the best ways to learn it is through serious study of what has been done by others. And one of the best ways to learn how to observe what artists have done is to analyze their pictures *upside down*. Then you will be able

to think about the lines and forms without being distracted by the apparent plausibility of the arrangements.

As with caricatures, you should check out the quality of your cartoons with friends and family. And, again, unless you are a very rare exception, you will experience maddening frustration. What you hoped would produce hilarity will bring forth polite, puzzled chuckles or groans. Most of us are not very witty. Even when someone is, it is unlikely that he or she has an instinct for the gag cartoon. People who write and perform outrageously funny skits seldom come up with good ideas for gag cartoons. I cannot recall the number of times truly clever people have approached me with amusing ideas that simply would not be funny as cartoons. The gags were too labored, too specialized, too naive, or too subtle. When unquestionably comic they were frequently too derivative—ideas that might have been funny drawn up by Thurber or Addams or Price, but not by me or some other hack. (Of course, the layperson is usually quite ignorant of the skill required to create a good comic drawing and tends to think that any artist can draw a simple little picture to get across a funny idea.)

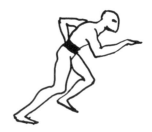

Here's an idea that at least ten people have suggested to me over the last twenty years: "Okay, there's an office, see? And a guy at a desk. He's a 'straight' type with a grim look. About five or six others are standing around, listening to him. They're really diverse. Like there's a lion tamer, a ballerina, a black physician, a lady wrestler, a little kid in a turban, and a Japanese Kabuki dancer. Here's the caption: *No doubt you wonder why I have called you together here* . . . Great, huh?" Could be. I have seen a similar gag somewhere or other and I thought it was funny. But not just everyone can draw that up so that it works. A Thurber of that type wouldn't be funny at all. Price could do it. But Hamilton would turn out something that looked too much like an illustration for the kind of team adventure story the gag is spoofing. There is no art in the world so dependent upon content fitting the form than the gag cartoon.

Obviously, there's no way to teach people what is funny, let along communicate how to be funny. But it is possible to categorize the kinds of things people find

humorous in the pages of magazines. For instance, a whole genre of humor depends upon *unusual people doing ordinary things in an unusual way*. The most famous of these are the members of the "Addams Family," whose appearance and attitudes are at odds with their otherwise routine behavior. A guest, whose bag is being carried into a cobweb-festooned room by Frankenstein's monster, is told by his hostess: "This is your room. If you should need anything, just scream." This wraithlike young witch appears with a cup at the half-door of an old hag, asking: "May I borrow a cup of cyanide?" The entire family is about to reward some carolers with the contents of a boiling cauldron they are pouring down from the roof. There are other examples of the same sort of thing. Jim Berry once did a cartoon in which a counterculture couple walk into their burglarized flat and the outraged male says: "We've been ripped off! Call the pigs!" He reacts just like any middle-class husband but phrases his response in the disrespectful language of the underground.[1]

Charles Addams has also done the obvious with the device and switched it around. A conventionally prosperous homeowner is raking autumn leaves into a pile for burning at the foot of a tree. His wife is watching and everything is perfectly normal. Except that she is tied to the tree! *Ordinary people doing something unusual in an ordinary way*. Edward Koren applied the same principle. His grinning butcher holds up an item for inspection by a worried-looking lady customer, saying: "It's mighty fine eating for the pennies it costs." The only odd thing about the situation is the hideous creature for sale; it's a scaly, saurian-headed fowl that looks as though it had been fattened on decaying carrion.

Hyperbole is always good for a laugh. Figure 105 employs a hyperbolic device, taking the figurative literally. The possibilities of such exaggeration are endless. A kink in a man's leg is a *real* kink. A "dogleg" in a street suggests a number of possibilities. A piece of one's mind,

[1]The philosopher Henri Bergson would have said that the humor here depends, like most humor, upon a mechanical rigidity that "dehumanizes" the speaker so that anyone can feel superior to him. Although true, such generalizations need not concern us because they've too little utility from the point of view of a humorist.

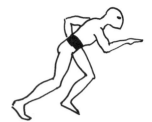

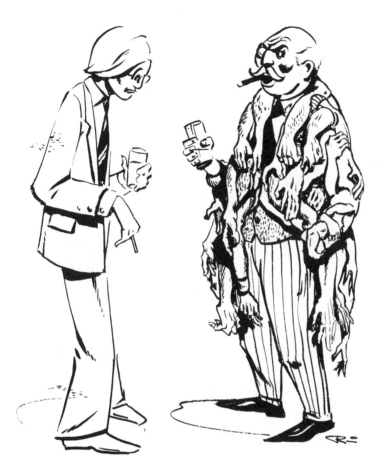

Fig. 105. "Unique? Of course it's unique, you bloody fool! All coats of arms are unique!"

lending one's ear, knocking off blocks, putting money where one's mouth is, and so on and on. Any dictionary of phrase and fable is full of potential. The reverse of exaggeration—understatement—is itself a form of hyperbole.

Incongruity is another familiar resource of comedy. Mike Williams' werewolf (Figure 106), from Britain's *Punch*, employs a number of stratagems to get a laugh. The monster doesn't behave the way we've been taught to expect; he's playful instead of vicious and his obsession is with fetching from men rather than preying upon

them. Yet he is not just a weredoggy; he is somewhat threatening in appearance. If that chap doesn't throw the ball he'll be in deep trouble. Finally, the cliché the werewolf uses to express himself wraps the gag in *irony*.

Some jokes consist of nothing but an ironic remark that would be funny in any circumstances. For example, one bum (or hippy, or royal degenerate, or tycoon) says to another: "I find that lacking a sense of responsibility has

Fig. 106. "It's the same old story, a few rotten werewolves and we all get a bad name, Throw the ball, pal, throw the ball."

Drawing by Mike Williams. © 1970 Punch (Rothco)

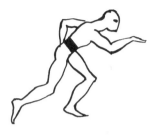

heightened all my other senses." Two tycoons chatting in the club is a standard situation. The depiction of an archeological team translating a prophetic or incongruous inscription is another of a number of traditional cartoon situations to which hundreds of captions have been applied. The most famous of these standbys are the two-people-on-a-desert-island picture and the bums on the park bench. Another concerns one or two men crawling on desert sands. Here the gag usually depends upon either hyperbole or irony.

Very close to irony is *paradox*. But to employ paradox to humorous effect requires a very ingenious artist and also an astute audience. Saul Steinberg needs bow to none when it comes to sheer wit; his visual puns and fantastical situations lift his cartoons from the level of graphic fancy to that of fine art. Not nearly so adroit, but astonishingly shrewd within his self-imposed limits, is Kliban. What he has found to say about cats, for instance, is unbelievably inventive (Figure 107). Although impossibly incongruous, definitely full of paradox, and ridiculously exaggerated, the *Cat* cartoons will contain something that will be hilariously funny to anyone who

Fig. 107.

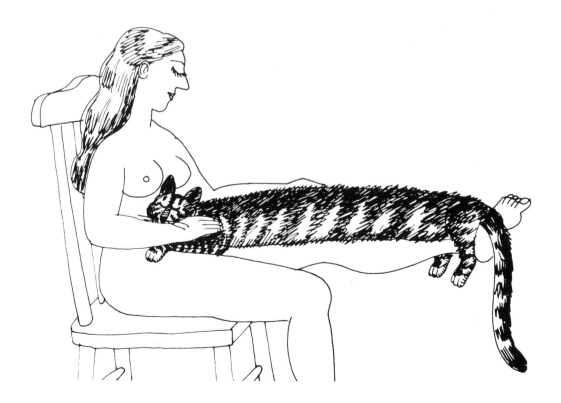

Fig. 108. "Well, for once it looks as if Papa Mars does not intend to cut the grass from under my feet." (The reference is to an unexpected reprieve from the threat of war during a period of great political tension in nineteenth-century Europe)

Honoré Daumier (1866). Lithograph. Private collection.

has owned a cat. Some of Kliban's humor depends on nothing more than the shock of recognition. You know— "That's *just* the way Tiger used to sit on the sill!"

Cartoonists who specialize in social comment rely upon that same *shock of recognition.* Sometimes their humor is so close to actuality that a pedestrian mind will not find it particularly amusing. Hamilton's upper-middle-class subjects mouth the sort of empty confessions and weary insights one overhears through tinkling crystal and other evening sounds at cocktail parties on genuine patios in affluent suburbs in San Francisco, New York, St. Louis, Chicago, New Orleans. At the other extreme stood cartoonists like Art Young and Denys Wortman, who sympathetically delineated the lives of those cut off from the benefits of modern capitalism.

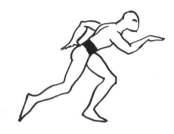

EDITORIAL CARTOONS

That gag cartoons based in social commentary share a great deal with their more openly political brethren, the editorial cartoons, is readily seen in Reginald Marsh's powerful statement published as a gag by *The New Yorker* in 1934. Here, a crowd of poorly dressed people are intent on some sort of spectacle out of the picture on the left. A woman holds her awe-struck child up to see better, explaining to the young woman beside her: "This is her first lynching." Marsh, a fine painter as well as cartoonist, modeled his manner on that of the greatest political cartoonist of all time, Honoré Daumier (1808–1879). Daumier's cartoons (Figure 108) are impressions of honest-to-God, hand-made lithographs. That is, Daumier actually drew the image in reverse onto a slab of limestone which was then processed and used to print the image that appeared in the left-wing gazette, *Charivari.* They are not, however, invariably political in any obvious way; often they are intended to deflate the pretensions of the Parisian middle classes, as in Figure 109. In modern times cartoonists rely on textured boards and crayons to imitate the Daumier style. Few are so adept at figure drawing as Marsh, let alone Daumier— one of the great names in the history of draftsmanship. But then, one looks to the work of a Mauldin (Figure 110) or an Engelhardt (Figure 111) for revelations of social ironies and not for sheer artistic power. Fitzpatrick, who

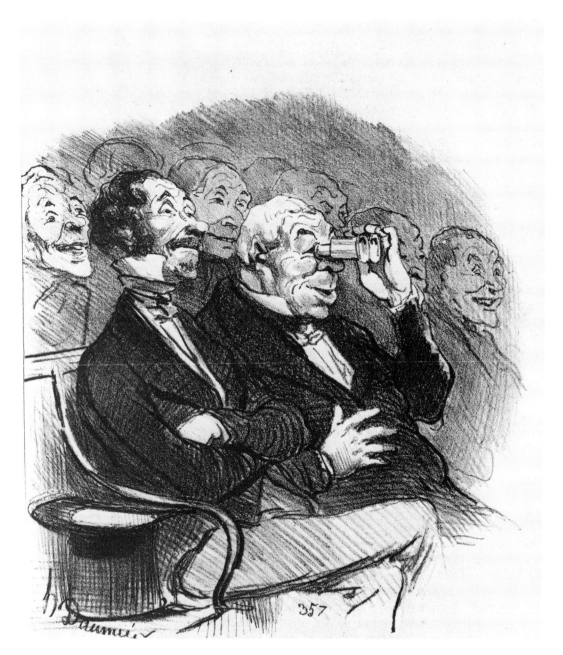

Fig. 109. "Parisians in 1852: The enthusiasts' section—a sight at the opera"

Honoré Daumier (1852). Lithograph. Private collection.

Fig. 110. "It's been the greatest century ever."

Bill Mauldin. Copyright ©1976 The Chicago Sun-Times. Reproduced by courtesy of Wil-Jo
Associates, Inc., and Bill Mauldin

141

Fig. 111. *"OK, He Hasn't Buckled Yet—Now Lower The Next One."*

Tom Engelhardt. © 1976 *St. Louis Post-Dispatch*

drew for the *St. Louis Post-Dispatch* in the 1930s and '40s, did invent symbols (Figure 112) nearly as compelling as Daumier's, if not so beautifully rendered.

One of the most hard-hitting of the editorial artists is the man whose cartoons Richard Nixon found especially distasteful, Herbert Block, commonly known as "Herblock." That is to be expected, since Mr. Block detested Mr. Nixon (see Figure 113), and what we actually look for in our political cartoons is a position we can share. Fitzpatrick, Mauldin, and Engelhardt have all

Fig. 112. "Toward the Low Countries and France."

Fitzpatrick. © 1940 *St. Louis Post-Dispatch*

been with the *St. Louis Post-Dispatch,* in the order here named. That newspaper has a liberal bias and, inevitably, its cartoonists incline toward the left rather than the right. Similarly, the readers—at least of the editorial page—share the viewpoint of the editors and can be counted on to concur with a given position most of the time. Editors, readers, and cartoonists think the same things are of fundamental importance. Ranking high

Fig. 113. "Of Course, If I Had the Top Job I'd Act Differently"

From *Herblock Special Report* (W.W. Norton & Co., Inc., 1974)

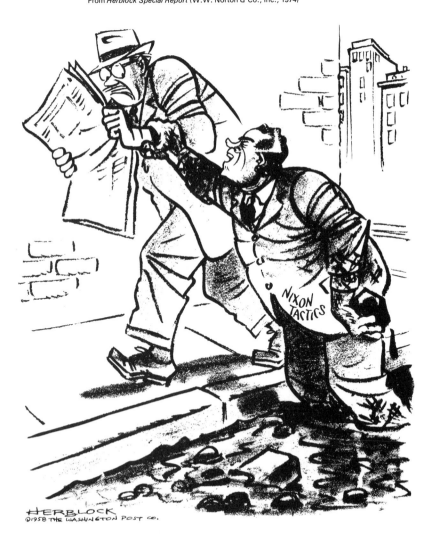

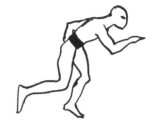

Fig. 114. "Riding Shotgun"

Editorial cartoon by Don Hesse. Copyright, St. Louis Globe Democrat. Reprinted with permission of Los Angeles Times Syndicate

would be civil liberties, minority rights, ecological justice, and social reform. The St. Louis morning paper, *The St. Louis Globe-Democrat*, on the other hand, is a conservative organ. Oh, a lot of liberals read it on the way to work. But their collective blood pressure is surely raised by exposure to editorial opinions that give top priority to self-reliance, fiscal responsibility, freedom from government regulation and interference, majority will, conventional morality, old-fashioned patriotism, and harsh treatment of scofflaws. The *Globe-Democrat* cartoonist Don Hesse (Figure 114) expresses an appropriate-

145

ly conservative view of the world. He'll pillory the welfare cheaters (who simply don't exist for Engelhardt) while tolerating the exploitation of taxpayers and consumers by gigantic corporations (a target to which Engelhardt responds with the conditioned reflex of the "do-gooder").

For reasons not altogether clear, the best of the editorial cartoonists have been, with rare exceptions, the liberals. It is not prejudice speaking through the author, here. I am not, by any means, invariably in ideological accord with American liberalism. But the fact is that, beginning with Daumier, the most memorable satirists of the political scene have been leftists rather than rightists. There are exceptions, certainly. For instance, Nast— although a champion of racial equality—was violently chauvinistic, anti-Catholic, and opposed to labor unions. But, as there was a lot for a good Lincoln-Roosevelt Republican to oppose in those days, he could excel. As Bill Mauldin has said, opposition is where cartoonists do their best. They are not so good at defending convention, the "Establishment," or pure moral rectitude. Since the only power committed liberals (as opposed to Democrats) have ever held is in the allied fields of education, mass communication, and the arts, it is hardly surprising to find them supporting freedom of speech with a passion that is every bit as hysterical as the conservatives' hatred of "government interference." Liberals are in a position to mold public opinion, but whatever changes they effect occur at rates no less than glacial. Therefore, they find themselves continually opposing the status quo which, since it is a reality rather than a dream, has all sorts of flaws and vast need of reform. Such a need is grist for the cartoonist's satirical mill and, so, the liberals tend to become most prominent.

The only reason this is important enough to mention in a manual of instruction is because no political indifferent has yet become a successful editorial cartoonist. To succeed in the profession requires a serious commitment to a viewpoint. If your heart's not in it, you'll never be able to hack it. On major newspapers the editorial cartoonist participates in the daily editorial conferences where the news is discussed and page makeup decided. Normally, he will draw up four or five ideas on diverse

topics for the day's issue. These cartoons will not necessarily be camera-ready, but they will be sufficiently finished to require only minutes for completion. Deadline pressure in a newsroom is intense. Today it is quite rare for one cartoonist to do all the editorial cartoons for a whole week; very often one or two issues will use material from another paper which holds a congenial viewpoint, or will substitute syndicated material.

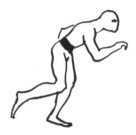

As newspapers become fewer and fewer in every city, owing to declining readership and enormously inflated costs, and as more and more dailies across the country become local editions of a "newspaper" produced by an incorporated chain, a smaller number of editorial cartoonists find work. And many of them who are working are not associated with a newspaper staff. They slave away for a syndicate "bull pen" that produces political cartoons the way advertising agencies produce commercials. The routine work of these pools concerns such non-controversial subjects as oppression of the little guy by bigness in government, business, and labor, the burden of taxation, the desire for world peace, the way red tape strangles us all, and so on.

Before he got his big chance to replace Mauldin, who had moved to *The Chicago Sun-Times*, Engelhardt was free-lancing. Before that he worked for a syndicate during a presidential election year. The demand for cartoons gave a clear picture of whose political position actually counted in a press supposedly dominated by liberals. In effect, Engelhardt was hired to draw pro-Stevenson cartoons and he says the syndicate assigned approximately one of these for every six pro-Eisenhower spots. Engelhardt couldn't take it; he was infinitely more serious about his chosen occupation and about the real need of social reform. On the day after Mother's Day in May 1961 some civil rights "Freedom Riders" were hauled from interstate buses in the South and beaten as the buses burned. On Monday Engelhardt submitted ten ideas for cartoons about the event. The one selected was so bland that even he can't recall it. He and the syndicate had a mutual falling-out. For him it meant free-lancing and odd jobs. But his is the kind of integrity that pays off in eventual success and personal satisfaction.

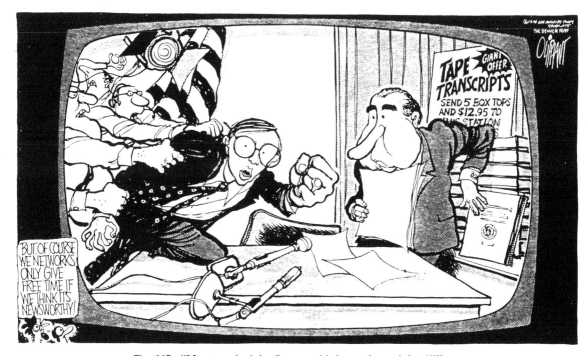

Fig. 115. "My name is John Dean and I demand equal time!!!"

Editorial cartoon by Patrick Oliphant. Copyright, Washington Star. Reprinted with permission of Los Angeles Times Syndicate

A number of other superb cartoon commentators have appeared since the Kennedy years. Oliphant (Figure 115) is among the most talented. Auth is similar but a bit more middle-of-the-road. Levine, definitely a member of the intellectual left, brought cross-hatching back to the editorial pages.

People like Engelhardt, Herblock, Oliphant, et al. are the elite corps of the cartoon staffs of daily newspapers. For the man whose cartoon is regularly featured on the page of editorial comment in a newspaper of international repute will be only one of several cartoonist-illustrators employed by that paper. Thus, Engelhardt sometimes shares the editorial section with a younger colleague, R. J. Shay. Here (Figure 116) Shay illustrated an article on California with a medley of his alternative styles. There are four or five other illustrators regularly employed by the *Post-Dispatch* and all of them occasionally turn their hands to cartooning. But, since Shay

was once a student of mine, I choose to give him pro-
minence. Not that he learned much about cartooning for
the feature pages from me.

The only kind of editorial cartooning I have done was
a highly specialized version—sports cartooning. At one
time every major daily in a city with a major league ball
club carried a sports cartoonist. The subject of the car-
toon was usually a player of local or national importance;
sometimes the panel was devoted to an event or par-
ticularly newsworthy achievement. Well, that seems to

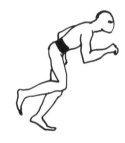

Fig. 116. "California or bust"

Robert Shay. © 1975 St. Louis Post-Dispatch

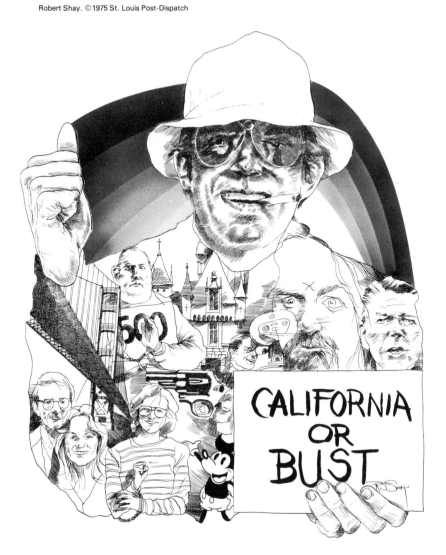

be a thing of the past. For reasons I cannot explain, sports cartoons have virtually disappeared from newspaper columns. They appear fitfully and only a handful of papers use anything but photographs to decorate their sports pages.

In editorial cartooning the importance of freshness and legibility is paramount. Reapplication of the same old symbols in the same old ways, over and over and over, is deadly. Some off the symbols (such as Hesse's gigantic money bag) are part of the political cartoonist's idiom and may be safely used as a kind of shorthand. But exclusive reliance on stereotypes will gain you nothing. Too many fledgling cartoonists attempt to get a point across by using such symbols and by ignoring the most necessary ingredient for a good editorial piece—a dramatic event. One should try to build the cartoon around a theme in such a way that the reader understands the basic idea at a glance. Herblock's anti-Nixon panel (Figure 113) drives its point home with immediate impact. Instantly, one knows that the unheroic man on the street both disapproves of and fears the conspiratorial ruffian who reaches for him from the gutter. The caption serves only to confirm one's impression.

Herblock's work is unusually vigorous and this particular cartoon is even more powerful in retrospect than it was when it appeared, inasmuch as it turned out to be a very accurate prediction. But all of the cartoonists included here strive for similar impact. Given other political convictions, Hesse's angry citizen might have been labeled "Consumer Action" and the treasure he has commandeered called "Public Utility Profits." What gets across, regardless of the lettering, is that an outraged citizenry is taking measures against the profligate.

As with gag cartoons, whatever isn't necessary is detrimental.

GREETING CARDS The title of this chapter is "Single-Panel and Limited-Sequence Cartoons." *Limited sequence* simply means that more than one panel or element is involved in the presentation but that the form is not that of the comic strip. There are a few gag cartoonists who specialize in sequence jokes that would be indistinguishable from a comic strip except that the action isn't set off in ruled boxes

and the cartoon is not among the "funnies." But the best example of limited-sequence cartoons is also an entirely different field—one that is frequently overlooked by tyro cartoonists. I refer, of course, to the market for funny greeting cards.

Almost all humorous greeting cards are based on the principle of *bathos*—that is, anticlimax. Figure 117 is an instance. The recipient is set up to expect a gift certificate for a super-luxury car and then is hit with a pun. In the same way, the sexually titilating card in Figure 118 leads the birthday boy to hope for something quite different from what he gets. The anniversary card (Figure 119), though, prompts mixed feelings about the sender, until the punch line turns out to be a compliment for the husband. Finally, in Figure 120 we have a couple of "insult cards." The first of these is of the "toothless" type; it's all in good fun. The other is a deliberately merciless put-down and few could laugh at it. The fun in any of the cards is playing a joke on someone. And when we are amused by them it is because we enjoy the trick and the surprise. But the last card shows us how very close to tears the techniques of laughter may bring us. It would be a "bomb" in terms of sales.

Not all cartoons drawn for cards are done with a joke

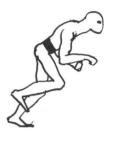

Fig. 117. All humorous cards are based on the principle of bathos—anticlimax

Fig. 118. Birthday card

in mind. Sometimes the card is just decorated with an illustration in cartoon form. Of those, among the most popular are the exquisitely delicate renderings of children drawn for American Greetings Corporation by Holly Hobby (Figure 121). She is imitated at other companies by people working under various trademarked pseudonyms. (Mrs. Hobby, incidentally, is a real person whose first name *is* Holly. She is exactly what you might expect from her work; an intelligent, talented, self-effacing young matron of great sensitivity and enormous

Fig. 119. Anniversary card

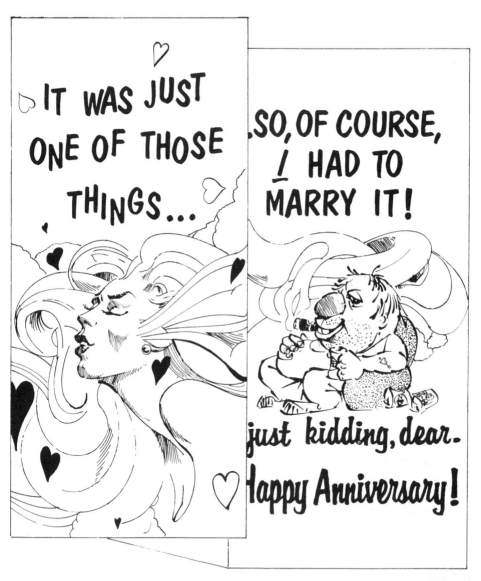

Fig. 120. "Insult" cards

tenderness.) None of her imitators' drawings project the same authenticity of sentiment that her own do. Like Norman Rockwell, she depicts an earlier America which never existed but which, nonetheless, retains intact a kind of reality because its innocence measures the contemptibility of so much contemporary life.

Greeting cards are usually done by artists employed by the design studios of large companies which market

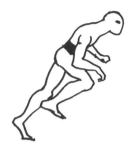

AFTER PONDERING WHICH OF YOUR ATTRIBUTES IS *MOST APPEALING,* WE'VE DECIDED IT'S

YOUR

FOUL

BREATH!

them through various wholesale and retail outlets. Typically, payment is made for the finished piece that will be copyrighted by the company. Unless you are already highly successful you will not be able to contract for royalties instead of selling the ideas outright. Most of the companies use work submitted from outside if they think it will sell and if it meets the requirements of their lines.[2]

Fig. 121. Mrs. Hobby's drawings are done with a sensitivity that takes them beyond "cartooning" as we usually think of it.

Holly Hobby. © American Greetings Corp

[2]The addresses and requirements of the major greeting card companies, as well as of all outlets for cartoons, can be found in an annually updated directory called *Writers' Market*, available in most public and university or college libraries.

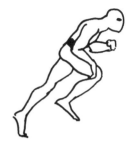

THE GRAPHIC STORY (NÉE "COMIC STRIP") 6

In principle, the sole difference between a gag cartoon and a humorous comic strip is that the latter's joke appears in a slightly prolonged form. Similar conditions apply to both gags and strips with regard to economy of means, classification of situation, and appropriateness for the audience. Apart from extension of the gag into several panels, the major difference in appearance is that in the comic strip the lettering is internal; that is, it is part of the artist's mechanical rather than a typeset caption.

Lettering is the first thing most cartoonists shunt off onto an assistant as soon as they can affort to. Stan Drake was once driven to consult IBM about building a custom typewriter with letters modeled after his pen work. That proving too costly, Drake tried substituting the nearest IBM typeface available. Its mechanically regulated look offended his aesthetic sensibilities so he

157

resumed the drudgery of hand lettering. Lettering is the least interesting and most tedious part of cartooning, but it is very important and nearly anyone wishing to draw comic strips is going to have to practice it. Well, not everyone. If you are wealthy there is an alternative; you can hire someone to do it for you.

The comic strip medium has its specialists. There are, for example, those who do backgrounds for other people. Philip "Tex" Blaisdell did backgrounds for dozens of strips. And there are those who specialize in lettering. Frank Engli does lettering on Milton Caniff's strips. Ben Oda has lettered hundreds of comic books and dozens of newspaper strips. But this kind of expertise comes high. So we'll assume that you are going to have to do your own lettering.

In comic strips the lettering must be neat and legible without seeming to be stiff. The ordinary variety falls somewhere between very, *very* clear handwriting and a draftsman's lettering. In Figure 122 I have provided a few examples and in each one mentioned the kind of tool used to do it. Notice that, while the variations are considerable, certain things are constant throughout. Given a specific pen, the letters are all the same height and the lines of text the same distance apart. The words have been arranged as balanced lines with plenty of "breathing space" between them and the edges of their balloons.

Fig. 122. Examples of comic-strip lettering and balloon styles

These balloons—technically, the word for them is phylacteries—have been drawn with different implements. From upper left, going clockwise, they were done with a technical fountain pen and French curves; the same thing as the lettering; a Hunt 513 pen point; a fiber-tip pen and circle template; the same thing as the lettering; a number 4 sable brush; a technical fountain pen. The balloons are all different, as you can see. But two of them suggest special effects: the second one an electronically reproduced voice, the last a "thought balloon," revealing the unvoiced ideas of a character. Cartoonists have also devised "whisper balloons"—usually done with a wavering, wispy sort of line—"shout balloons," and so on. Published comic strips are a voluminous textbook of such conventions and hold plenty of examples of lettering styles and of balloons.

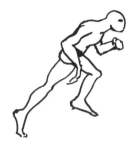

Standard lettering in the comics is rarely done smaller than 1/8" (the original size of that in the top left balloon in Figure 122) or larger than 1/4". To do it you will need, besides the pens noted in Figure 122 and elsewhere in this book, a *lettering triangle*. This is a transparent plastic draftsman's triangle that can be used for ruling parallel, horizontal guidelines in pencil by means of a network of regularly spaced holes designed to accommodate a pencil point. The pencil is inserted and used to pull the triangle along the T-square across the paper, drawing a perfectly straight line. Then, the pencil is put into the next hole down, the process repeated, and so forth, until enough guidelines have been made. There are a number of similar devices for drawing lettering guidelines. Most are inexpensive and all of them are far, far quicker to use and more exact than measuring with a ruler and marking with a straight-edge would be.

A good place to pick up the basics about lettering for very little outlay of money is through study of Speedball's standard manuals. But be aware that much cartoonists' lettering is not quite like regular poster lettering. The most radical deviation from standard practice is the use of an "I" with little crossbars for first person singular (as in "I did this" in Figure 122) in an otherwise sans-serif alphabet. *Serifs* are the short lines stemming from the upper and lower ends of strokes in lettering such as the typeface you are now reading. *Sans-serif* means "without serifs" and is one of two major categories of

letter form: serif and sans-serif. This line of type and the "Leroy" lettering in Figure 122 is sans-serif. To mix serif and sans-serif letters is usually a sign of rankest amateurism—except in the comics. Still, not even cartoonists doing comic strips put serifs on any "I" except the pronoun. Thus, everything in the first balloon in Figure 122 is sans-serif except the pronoun "I." There it is permitted. But there is no real reason to employ serifs at all and many artists do not. (Every once in awhile you will also see an initial "J" with a serif. This is the only exception besides "I.") Study and practice lettering, trying out different styles and tools.

HUMOROUS STRIPS Apart from lettering, there is not much difference between the single-panel gag and a comic strip except that in comic strips the joke unfolds like a story. Usually, too, the comic strip involves continuing characters from one issue to another. The episodes may be self-contained as they are in *Blondie, Archie,* and *BC* or they may be part of an overall plot, as in *Lil' Abner.* But there will nearly always be a certain amount of continuity in terms of settings, characters, and so on. Because of this, the comic strip artist has an opportunity to develop subtleties in his persona and an entire universe of relationships among them and between them and their environment. Thus, Garry Trudeau lets us become aware that Mark Slackmeyer's left-wing protests are sponsored less by doctrine than by his exasperation with injustice.

Fig. 123. In Doonesbury, *the cartoonist has developed continuity in his situation and characters*

Garry Trudeau, *Doonesbury.* ©1971 G. B. Trudeau / Distributed by Universal Press Syndicate

DOONESBURY by Garry Trudeau

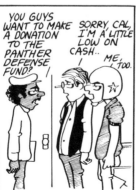

Doonesbury's knee-jerk liberals—the radical priest and the professors pandering to youthful fashion—are teased because of the combinations of smug pomposity and terror of age hiding behind the poses. Zonker's not really a drug addict; he's a free spirit. And Mike's perpetually disappointing attempts to treat all people as if they were as amiably repressed as he is himself (see Figure 123) are a sort of futility gauge against which all of the political activity of the strip can be measured. Nothing is *really* going to work out—not so much because of corruption as because of the sheer klutzedness of humanity.

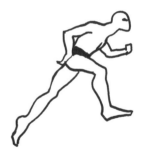

Stylistically, humor strips have other things in common with gag cartoons. The distance factor is operative still. There are occasional closeups, but they are uncommon. *Doonesbury's* action rarely takes place any closer than an apparent six feet from the viewer. The drawing style employed by Trudeau is somewhat rudimentary in appearance but, like Thurber's, is highly effective and original. Trudeau has a standard technique for rendering features. Everyone has odd, inverted-looking eyes and a faintly dissipated air. It all fits the character of the strip.

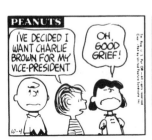 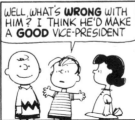 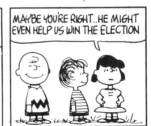 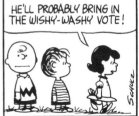

Fig. 124. Schulz's drawing style in Peanuts matches the mood of the strip

Charles Schulz, *Peanuts.* ©1964 United Feature Syndicate, Inc.

Charles Schulz developed *Peanuts* (Figure 124) from a too-slick, geometric kind of drawing style to the manner he now uses. The figures and backgrounds are still sort of geometric, but in an irregular, carefree way that matches the mood of the strip. The "Peanuts" are always striving for absolute order and facing frustration. The balloons and lettering have, generally, the same characteristics as the rest of the cartoon. Schulz couldn't get away without balloons as Trudeau does, and carefully ruled balloons drawn with french curves wouldn't fit in either. The need

for such harmony among parts is essential to the attainment of quality in any strip, but it is especially important to a humorous one in which the artist must create a world of fantasy that can stand on its own, apart from the world of ordinary visual reality.

The writing of a strip may not be something you will ever do. Quite a number of professional and amateur comics are collaborative efforts of a writer and a cartoonist. Even so, you really have to understand some of a writer's problems in order to put a joke or story into effective graphic form.

In comic strips the development of the joke is terribly important. It follows an inevitable, even inexorable rhythm that moves from opening to close in three distinct stages, no matter how many panels may be involved. A good example of how this works is Glenda Washington's *Diggin's Block,* in which we have two aspects of male chauvinism simultaneously represented as a joke. In this case (Figure 125) the three phases of the joke are coincident with the panels. First there is (1) a *situation,* then (2) the *setup,* and finally (3) the *punch line.*

Fig. 125. This cartoon shows the situation, *the* setup, *and the* punch line *in three panels*

Glenda Washington, *Diggin's Block. Chix Comix* No. 1

In the example the situation involves the detached observation of a worker by one of the leisured. In this case, the nonworker realizes his advantage and is sympathetic to the worker. The second panel is the setup, a transition that both intensifies the situation and also introduces a hidden, ambiguous note to provide for the punch line. Diggin's punch line reveals the true opportunism that initially had been disguised by a seeming sentimentality.

In *Doonesbury* (Figure 123) Trudeau established the situation in the first two panels, set up the viewer in the second and third, and delivered his punch in the final one. Schulz's *Peanuts* (Figure 124) is similarly wry. The situation in panel one is established as Linus' enthusiasm versus Lucy's skepticism producing Charlie Brown's anxiety. In panel two it is intensified as Charlie is being set up along with the reader. In panel three the ambiguous element is introduced and further intensification occurs. Finally, the fourth panel delivers the inevitable put-down for good Ol' Charlie Brown.

Sir Rodney, the ignoble knight in *The Wizard of Id* (Figure 126) is, on this particular Sunday, thrown into a ping-pong game of reason and unreason. The situation seems normal enough as comic strip situations go. But in panel three the response seems irrational. The setup has begun. Rodney's reaction is perfectly rational. The counter-response—a panel containing the word *FLUMP!*—is puzzling. But the punch-line panel rationalizes the whole sequence of events. One of the funniest things about Id, incidentally, is the stolidly dubious resignation with which soldiers and peasants greet outrageous events.

The studio name for the segmentation of a story line into individual pictures is *breakdown.* Not only the pacing of the strip but also its visual fluency are connected with the breakdown. Since a comic strip consists of a series of pictures, the relationship of each to the next is important. Most cartoonists organize their sequence of images by preserving certain constants from panel to

Fig. 126.

Brant Parker and Johnny Hart, *The Wizard of Id.* ©1976 Field Newspaper Syndicate, Inc.

THE WIZARD OF ID by parker and hart

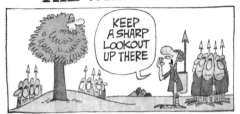

Fig. 127. Diagram of visual pathways in The Wizard of Id (Figure 126)

Fig. 128. Loomis's "formal subdivisions" applied to cartooning

panel. In a strip like *Doonesbury* this is fairly simple because the background is usually as unchanging as the distance from the viewer. Graphically, *The Wizard of Id* is much more complicated because there are many shifts of level, proximity, and points of view. Take a straight edge of some kind, slide it slowly down from top to bottom of our reproduction, and compare some horizontal relationships from panel to panel. Notice that Rodney's head in panel one is on a line with the tree (which is the principal focus of the action) in panels two and three, about through the panel center. A central horizontal connects the main elements of the remaining panels, too. Also, the horizon in panel one is in line with the bottom of the tree and with Rod and his men in panels two and three. A similar relationship appears at the bottom of the strip—that is, the last three panels.

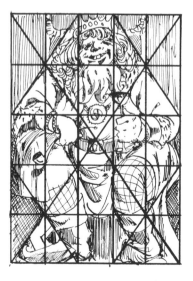
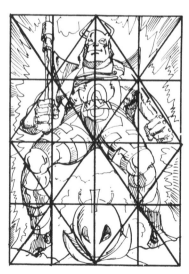
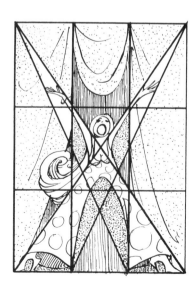

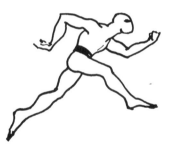

A strip cartoonist faces the problem not only of maintaining continuity in the sense of some overall harmony but also of confronting the unusual tactical problems growing from the necessity to guide the reader through the strip. Merely the question of what gets across first, words or image, can be quite vexatious. Again, Parker's artwork on *The Wizard of Id* provides us with a superb example of the way a facile cartoonist can make what is difficult seem easy. A diagram (Figure 127) shows some of the devices working to create pressures and pathways from image to word, word to image, and image to image. Excellent use is made in the final panel of the symmetry of Rodney, the pile of earth, and the spear jutting up from its quiver.

Composition and flow are important in any comic strip, but they loom as more evidently problematical in adventure strips because most of the latter are modeled after traditional book and magazine illustration.

COMPOSITION AND DESIGN

Several times I have remarked on the futility of trying to convey *everything* about cartooning in a book of this sort. It is not possible even to touch upon all that one must know in order to draw an acceptable strip in a so-called "realistic" style. The bibliography can help. That's why it's there. And one of the books contained therein, although first published in 1947 and terribly dated-looking, contains some rather good shortcuts to traditional composition. Andrew Loomis, in *Creative Illustration,* gives several examples of what he calls "formal composition." They depend upon symmetrical subdivisions to guide the imagination in positioning things in a rectangle. Figure 128 shows how some of them might be applied to cartoon imagery. But such arrangements are rare in the comics, for they imply dignity, solemnity, and imperious power. More useful for our purposes is what Loomis called "informal composition."[1] This also involves subdivision of the area, but it is done in such a way

[1] Loomis' term is a slightly misleading one because what he calls *informal composition* would be considered a variety of formal composition by most artists and critics. Technically, better terms would be *tectonic* for his "formal," and *a-tectonic* for his "informal."

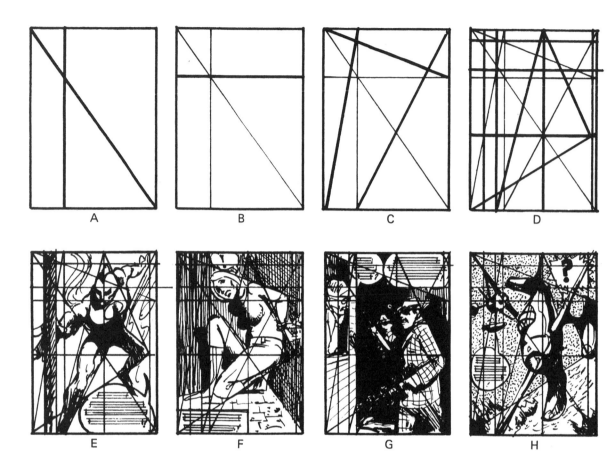

Fig. 129. Loomis's "informal
subdivision" in cartoon imagery

(Figure 129) that the results are asymmetrical. First, you divide the area by a vertical or horizontal line placed somewhere other than on center, a quarter, or third. Then (A) you strike a diagonal through the rectangle, from one corner to the opposite one. At the point of intersection of this diagonal and the other line, draw still another (B) at right angles to the first one. Within the resultant rectangles, draw new diagonals (C) one to each rectangle, so that they cross through one of the verticals or horizontals. At these new points of intersection, draw still other horizontals or verticals (D). The work continues in this fashion until you produce a network of interlaced lines. Given the network that here resulted, a number of possibilities suggested themselves to me (E, F, G, H). Try this for yourself, emmploying various proportions and subdivisions.

What can be applied to individual panels can, with a

166

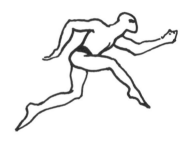

little effort, be extended to whole strips. For example, the top panels of a Sunday *Steve Canyon* (see Figure 134 for a variation) might well have been laid out according to my after-the-fact diagram (Figure 130), which utilizes a diagonal passing through all four panels and takes the panel divisions as the first set of verticals. I do not for one minute believe that Milton Caniff laid out the composition by any procedure as organized as this, but he might have. What he obviously did work out consciously were the linkings of panel to panel. The axis of the old B-25 wings and elevators is on the same slant as the cabin interior of Bitsy's plane in the next panel. And the B-25's starboard engine nacelle is not only the same height as Bitsy's windscreen in panel two, its lower edge is continuous with the back of her headrest. The third panel pitches the B-25 wing into line with Steve's shoulders but at the opposite angle to them. That wing, and the wheels of Bitsy's Bug have their common thrust carried over to panel four by the splatter of rifle fire.

The way in which such relationships actually develop on paper is made clearer when they are seen in working drawings. Gil Kane's preliminary layout for his book

Fig. 130. Informal subdivision applied to the upper register of a Sunday Steve Canyon

Milton Caniff, *Steve Canyon.* ©1976 Field Newspaper Syndicate, Inc.

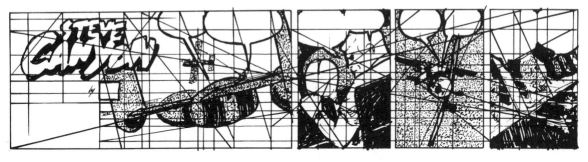

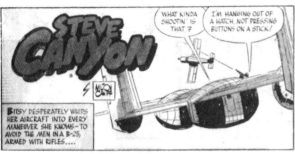

Fig. 131. Preparatory sketch for a comic book page

Gil Kane, *Blackmark.* Courtesy of *Fantasy Crossroads,* ©1975 Jonathan Bacon, Lamoni, Iowa

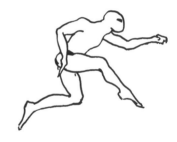

Blackmark (Figure 131) is uncommonly coherent, but it gives a very good sense of the way in which a skilled and extremely conscientious artist composes the graphic elements of an illustrated epic. No one simply starts drawing a comic page without working up the correlations beforehand. And notice that the figures have been conceived in terms of anatomical masses rather than as outlines or vague and hazy notions. The sweep and movement is characteristic of the dynamics of swashbuckling combativeness and derring-do in the comics. But the general idea of follow-through from one panel to another is instinct to most comic strip art.

ADVENTURE STRIPS

"Comic strip," the original designation for stories in the form of a a sequence of pictures containing dialogue or text, was a good name for the early ones. But after 1928 the strips began a strong shift away from humor toward fantasy and adventure. This had begun in conventional "funnies," where adventure and rather realistic family problems had been introduced to provide contexts for the jokes. Then, first in Crane's change of *Wash Tubbs* to *Capt. Easy,* later in Segar's *Popeye* and Harold Gray's *Little Orphan Annie,* the elements of danger, mystery, and suspense emerged as qualities relished for their own sakes. In 1929, on the very same day (January 7), two strips appeared that were destined to change the history of the medium: Harold Foster's version of Edgar Rice Burroughs' *Tarzan of the Apes* and Philip Nowlan's adaptation of his own science-fiction novel, *Armageddon 2419,* as *Buck Rogers in the 25th Century,* drawn by Dick Calkins. In 1931 Chester Gould took adventure from exotic places and distant times and set it down onto the streets of contemporary Chicago, where his police detective *Dick Tracy* battled mobsters. Soon the "funny papers" were full of things that were anything but comical.

Most of us still call all of the strips "comic strips," but some with a special interest in them always refer to them as *graphic stories.* Whatever your preference, there is plenty of variety, even within the adventure mode.

Some of the adventure strips have been quite close to humor strips in appearance. Most of those were older strips, such as the venerable *Dick Tracy.* Practically

COUNT KORRO TRIES EVERY MEANS HIS NOBLE BIRTH PERMITS TO END QUEEN FRIA'S GROWING INTEREST IN FLASH.

"URGE FLASH TO COME EXPLORING WITH ME," HE SUGGESTS TO DALE, "IT WILL GET HIM AWAY FROM THE COURT--- AND THE QUEEN---"

DALE'S LOVE FOR FLASH IS TOO UNSELFISH---
"DON'T GO ON THIS EXPEDITION WITH ZARKOV AND KORRO," SHE BEGS, "I KNOW IT'S FAR MORE DANGEROUS THAN THEY SAY!"

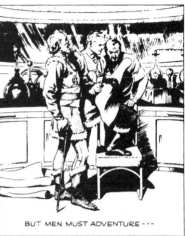

BUT MEN MUST ADVENTURE ---

---AND WOMEN MUST WEEP.

HOWEVER, UNABLE TO ARGUE FLASH OUT OF GOING, FRIA SENDS FOR KORRO. DESPITE THE CHAGRINED COUNT'S PROTEST, SHE DECLARES FLATLY--- "THERE WILL BE NO EXPEDITION UNLESS DALE AND I ACCOMPANY YOU."

A FEW DAYS LATER AMID SECRET JEALOUSIES AND INTRIGUES, THE ROYAL EXPLORING PARTY SETS OUT TO HUNT THE DREAD MONSTER WHICH HAS TERRORIZED THE GLACIER COUNTRY OF FRIGIA.

NEXT WEEK:~ TRAIL OF THE MONSTER

Fig. 132.

Alex Raymond, *Flash Gordon.* ©1939 King Features Syndicate, Inc.

every contemporary adventure strip has been influenced in appearance by either Milton Caniff or Alex Raymond—particularly by Raymond's post–World War II invention, *Rip Kirby,* which was drawn in a slickly decorative style apparently derived from magazine illustrations by such notables as Al Parker and Coby Whitmore. Raymond's most famous strip was rather different in character, being full of detail and brilliant rendering in a sleek drybrush style of extreme clarity.

Raymond's *Flash Gordon* (Figure 132) was a sort of *Prince Valiant* of science-fiction. Flash and his friends, Dale Arden and Dr. Zarkhov, are earthlings marooned on the planet Mongo. This is a wonderful place, combining elements of ancient and medieval fairy tales with futuristic gadgetry to create a new kind of legendary epic for the popular audience. The characters of the strip are

quite stereotypical, but the events are extremely involved and pleasantly diverting.

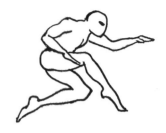

Harold Foster envied Alex Raymond his sense of glamour and the easy grace of his figures. Raymond was jealous of Foster's thoroughness and it is safe to say that the influence of *Prince Valiant* upon *Flash Gordon* was marked. That's not surprising; Foster's *Prince Valiant* (Figure 133) had everything (except balloons; both Foster and Raymond felt that they got in the way of the art). The Foster Sunday pages of the 1930s and '40s have never been emulated successfully. They are positively stunning.

Most commentators remark on the historical accuracy of *Prince Valiant,* but that is giving credit where it really is not due. The costumes aren't right for the dates, or else the events don't square with the period, or the premise of the story is itself an anachronism. For instance, the armor and tournaments are from the period of Sir Walter Scott's *Ivanhoe,* the late thirteenth or early fourteenth centuries, but many of Val's adventures would have to have occurred hundreds of years earlier. In one sequence he's up against Attila the Hun, who died in 453. His Viking acquaintances are from around 800. But if King Arthur existed at all, he would have ruled about 500. None of this is of real importance, however. Foster's world is the world of the King Arthur of romantic poetry and story-book legend; it is a pseudo-historical fancy based on myth. And, to that extent, it is not as different from *Flash Gordon's* planetary environment as one might at first suppose.

One very striking difference between the Foster strip and Raymond's is this: Prince Valiant and the people he encounters have some depth. The protagonist began the strip in 1937 as a six-year-old boy and has retained, even as I write (when the strip is being drawn by John Cullen Murphy), a slight aura of immaturity, despite his constant heroism and cleverness. His wife, Queen Aleta of the Misty Isles, is a matronly temptress whose personality is marked by the imperfections from which none of us is free.

Caniff (see Figure 134) also develops the personalities of his characters and strives for a very documentary effect as well. The authenticity of his strips is partly due to painstaking research and reliance on photographs of set-

Prince Valiant

IN THE DAYS OF KING ARTHUR
BY HAROLD R. FOSTER

Registered U.S. Patent Office

ALETA QUEEN OF THE MISTY ISLES

Synopsis: PRINCE VALIANT BELIEVES HE HAS BEEN BEWITCHED BY ALETA, GREY-EYED QUEEN OF THE MISTY ISLES. HE CANNOT FORGET HER FACE AND HER NAME RINGS IN HIS HEART LIKE A BELL. HE GOES TO SEEK AID FROM HORRIT, WITCH OF THE FENS.

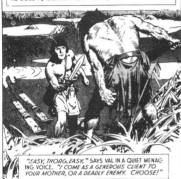

"EASY, THORG, EASY," SAYS VAL IN A QUIET MENACING VOICE. "I COME AS A GENEROUS CLIENT TO YOUR MOTHER, OR A DEADLY ENEMY. CHOOSE!"

THORG'S SMALL, MAD EYES SURVEY THE SHINING BLADE AND THE RESOLUTE FACE BEYOND. MUMBLING, HE TURNS AND LEADS THE WAY.

HORRIT'S HUT; SO WILD AND DESOLATE IS THE SCENE THAT VAL'S HEART IS FILLED WITH DREAD.

HORRIT DOES NOT LOOK AT VAL, HER EYES FIX THEMSELVES IN HORROR UPON THE 'SINGING SWORD'. "'TIS FLAMBERGE, THE ACCURSED BLADE!" SHE MOANS, "TAKE IT FROM MY SIGHT!"

VAL REMOVES THE SWORD-BELT AND HANGS IT IN A HANDY PLACE OUTSIDE. "SEE, PRINCESS OF EVIL, I BRING PRECIOUS GIFTS FOR YOU AND YOUR FINE SON. I SEEK KNOWLEDGE OF MY FUTURE....NOW TELL ME, CAN MAGIC OF YOURS PROVE POTENT AGAINST ALETA'S SPELL?"

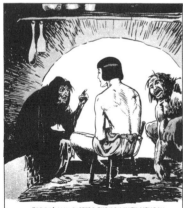

"FOOL! MAN SUFFERS ENOUGH WITH MEMORY OF THE FOLLIES OF HIS PAST. THRICE CURSED IS HE WHO KNOWS HIS FUTURE!"

314 2-14-43

"CONTENTMENT IS A GIFT BEYOND PRICE. AGAIN I READ YOUR FUTURE. TOO BAD! FOR AGAIN I SEE ADVENTURE, WEALTH, MUCH TURMOIL, BUT NOWHERE ANY CONTENTMENT," AND HORRIT CACKLES GLEEFULLY.

IN THE COOL, CLEAR DAWN, THE YOUNG KNIGHT STANDS OUTSIDE THE UNWHOLESOME DEN....A LONELY, UNHAPPY FIGURE. NEXT WEEK **Homesick.**

Fig. 133.

Harold Foster, *Prince Valiant.* © 1943 King Features Syndicate, Inc.

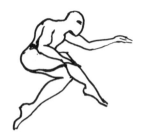

tings and machinery and partly due to the fact that he
was the first cartoonist to incorporate the events of con-
temporary history into a comic strip; he has seen his man-
ner become identified with truthful recording in the
public imagination. Still, without the harsh chiaroscuro
of the Caniff drybrush technique, the public would never
have been persuaded. That brush technique was first
used in comic strips by Noel Sickles in an airplane strip
called *Scorchy Smith.* Caniff's real contribution to the
style was his application to the graphic story of cinematic
camera angles that shift the viewpoint from panel to
panel. There is no question that these effects have
enhanced the feeling of verisimilitude that his strips in-
variably project.

The shifting point of view associated with Caniff ap-
pears in all adventure strips and their related offspring.
Raymond used it and so did Foster. Yet the compositions
and viewpoints in *Flash Gordon* and *Prince Valiant* owe
as much to traditional illustration as to the motion pic-
ture. All of the adventure styles derive, ultimately, from
either classicism or realism in serious art and illustration.
The skills required to do such strips in the grand manner
are numerous. Figure drawing and a knowledge of
perspective are important and versatility is essential.
Notice the constant variation of distances in Figures 132,
133, and 134. We're far, then close, very close, extremely
distant. Where in the humorous cartoons we are held at
arm's length, in the more serious ones we are brought in-
to intimacy with the actors and also are shown the set-
ting in its entirety.

The breakdown of the adventure story is more com-
plicated than that of the humor strips because (1) the plot
runs for a long period of time and each day only a tiny bit
of it is revealed; (2) each daily strip and Sunday strip
must contain rhythmic elements similar to those of a
joke. From the situation in the first panel, action builds
toward a minor climax in the last one. The trick is to
develop a continuously suspenseful and exciting plot
from minute episodes. Let us consider, first, the overall
structure of a typical newspaper adventure strip.

Most newspaper strips develop their story lines from
the beginning to the conclusion in ten or twelve weeks.
But some are shorter and some longer. The *Flash Gordon*
strip introduced by the page you saw in Figure 132 ran

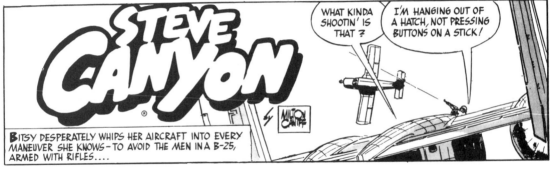

Fig. 134. Caniff has made an invaluable contribution to the comic strip with his application of cinematic camera angles that shift the viewpoint from panel to panel (Newspapers often modify an artist's design to fit a comic strip into its particular format, as can be seen in the contrast between this version of Steve Canyon and the one reprinted in Figure 130)

for six months. But *Flash Gordon* appeared only on Sundays, like *Prince Valiant,* tending to prolong the telling. Major titles usually appear on Sundays and in the daily papers as well. Usually, the Sunday page continues the week's story and, normally, the first half of the Sunday page will pick up what happened during Saturday and the last part will preview what is going to occur on Monday. The repetition and foretelling enable those who do not get a Sunday version to follow the story without serious impairment of understanding. (Of all cartoonists, Milton Caniff is most cavalier about this consideration. At one time he completely ignored it; if you didn't read his stuff every day you'd be lost. Nowadays he makes some concessions.)

Graphic stories follow the same pattern as traditional literary fiction and can be described in terms of their plots. The *plot* is the blueprint of a story, its plan. Always, a plot grows from some kind of conflict. This conflict may be objective or subjective, but it must seem genuine. In graphic stories the conflicts are nearly always objective ones, occuring between people or people and forces. In our *Prince Valiant* page, however, the motivating conflict for Val is subjective; he's mistaken sexual urgings for occult enchantment. In this individual episode there is a more or less self-contained dramatic conflict between Val and the witch Horrit and her brutish son. Speaking in generalities, it is possible to say that stories told in the numerous strips will, regardless of the conflict, all follow this broad plan of development:

1. *Initial situation* in which one or more conflicts are presented, at least by implication.
2. *Buildup* of rising action which brings one to the climax of the story through a series of episodes that may contain subsidiary conflicts, buildups, and climaxes. (For instance, in Defoe's *Robinson Crusoe* there are, embodied in the story of survival on a desert island, the smaller stories about Crusoe's first voyage, the second voyage and shipwreck, the first twenty-four years on the island, the appearance of Friday, the confrontation with savages, the English ship and mutinous crew, return to England.)
3. *Climax.* At this point the opposing force either conquers or is conquered. (In *Robinson Crusoe* the climax occurs when Crusoe, Friday, and three

seamen retake the English ship from the mutineers.)

4. *Denouement.* The loose ends get tied together and the plot is, or appears to have been, resolved. (In the Defoe story there are at least two, the first being Crusoe's return to England and eventual marriage.)

5. *Aftermath.* In *Robinson Crusoe* it is unusually long, since the hero takes subsequent voyages (on one of which Friday is killed). In serialized fiction with continuing characters it is usually a transition to a succeeding story. Typically, some elements in the denouement will provide the germs of the story that follows.

In the *Flash Gordon* sequence about the arctic world of Frigia the basic conflicts are stated or implied in the (1) *initial situation.* The motivating conflicts are Dale's anxiety over Queen Fria's interest in Flash, and Count Korro's envy of Flash and fear that an alien may rise to the throne. The principal conflict is also introduced; this is the conflict between the hunting party and the Glacier Monster, a reptilian octopus the size of the Matterhorn, equipped with electrocuting tentacles that end in eyes. The (2) *buildup* begins on this page, too, when Korro contrives an expedition to hunt the monster in hope that Flash can be killed along the way. Unexpectedly, the women insist on going along. From September 3, 1939 through the fourth of January 1940, the buildup continues. During most of it the adventurers are trapped in a vast ice cave where Flash must contend with the machinations of Korro and his henchman Lupi, with Dale's irrational jealousy, and with Fria's passionate interest, as well as with environmental hazards and the presence of the Glacier Monster. At one point he nearly dies. The (3) *climax* occurs on January 21st when he is able to harpoon and electrocute the monster. The (4) *denouement* is inseparable from the (5) *aftermath.* It is fraught with tension and confused feelings growing out of secret agreements made between Korro, Fria, and Dale during Flash's prolonged coma. It takes four weeks to clear these up as a secondary plot in the form of a love story unfolds. Finally, as Flash and Dale are preparing to leave Frigia, an agent of Ming the Merciless (the continuing arch-enemy of the earthlings) kidnaps Dale. With that, another adventure begins.

Even the single page here reproduced contains all of the elements of the whole. Panels one and two have the motivating conflicts. Panel two begins the buildup and introduces the idea of some sort of expedition. Panel four (composed to emphasize the dignity and determination of the queen) introduces still another conflict. Panel five is climactic because of its grandeur, exotic content, and promise of great things to come. If you look carefully at the other strips reproduced in this chapter you will see that they too follow the same kind of development. Even the little daily episodes do. Each one begins with a situation established, builds up in the next panel, and provides a minor climax to tease one on into reading the next episode on the following day.

GENRE STRIPS

In many books on cartooning most of what I have in mind when I speak of "genre strips" are referred to as "soap-opera strips." I prefer the term *genre* for two reasons: First, although the television serials frequently sponsored by detergent manufacturers deal with romantic love and related entanglements, their themes are suffocatingly narrow compared to graphic stories like Stan Drake's *Heart of Juliet Jones* (Figure 135). They can't afford to go on location to exotic places, so the atmosphere is claustrophobic; a strip artist can take his heroines to any corner of the earth. Second, *genre* is a more comprehensive term that takes in—according to art-historical usage—everything having to do with "everyday life." Therefore, it easily comprises graphic stories about love, family life, children and their pets, professions, and even some kinds of mystery and suspense. Thus, *Rex Morgan, M.D.* fits as easily into the pattern as *Apt. 3-G.* The glamorous life of Mary Perkins *On Stage* can be treated in the same breath with the kid strip of the 1950s, *Rusty Riley.*

Some genre strips look as though they'd been drawn in a bank. This is true of *Judge Parker, Mary Worth, Apt. 3-G,* and *Rex Morgan, M.D.* The medical strip is very neat, inexpressive, and evokes about the same sentiments as a textbook diagram. As it happens, the mood fits the strip as well as anything could. This is the documentary look that comics apply to ordinary happen-

ings, whereas Milton Caniff's is the documentary vision of international crises writ small, where an individual adventure may involve the destinies of nations.

Genre strips such as *On Stage* (Figure 136) employ still a different kind of objectivity in drawing. It has been called *neo-realism* but a better term would be *eclectic realism. Eclectic* means to combine in a single style the best elements of various styles. And Leonard Starr certainly seems to have absorbed into his technique the

Fig. 135. Stan Drake, *Juliet Jones.* © 1975 King Features Syndicate, Inc.

The Heart of Juliet Jones ® By Stan Drake

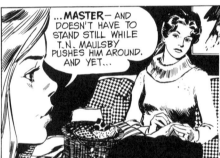
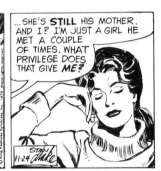
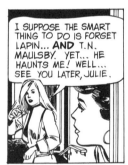
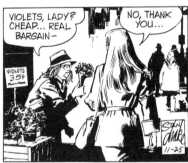
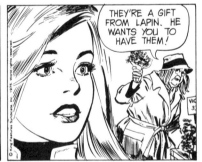
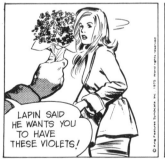
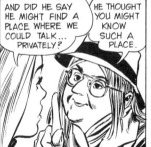
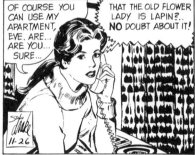

distinctive fluencies of Raymond, Caniff, and others. The Raymond influence is particularly evident in the figures of both Starr and Stan Drake. Neither of them, however, is as concerned with decorative effect, overall pattern, or design to the extent Raymond had been. Their emphasis is, instead, upon naturalism as a setting for beautiful people and romantic events.

Plot development for this group of strips is identical to that of the adventure stories except for the fact that the ultimate threat to a character is less often violent death and more often the heartbreak that comes with re-

Fig. 135. (cont.).

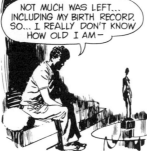
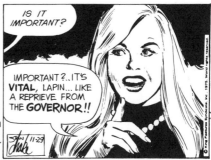

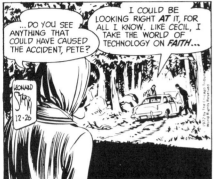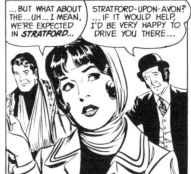

Fig. 136.

jection or abandonment. Not that Juliet Jones, Mary Perkins, the girls in Apt. 3-G, or any of the other genre heroines live lives of cushioned safety. On the contrary, they and their male friends are disaster-prone, forever treading on precarious ground populated by gangsters, swindlers, kidnappers, psychotics, and sinister females who (whether sultry sirens or wide-eyed ingenues) tend to share softness of heart with Lucrezia Borgia. Intrigue is the life's blood of romance as well as adventure. And many of the plots of the genre strips might have been lifted from so-called "gothic novels." Today, such novels blend romantic love (characterized as a sort of sexless passion for one of the opposite sex), mystery, suspense, and high society. The best-known modern tale in this mold is *Rebecca* (1938) by Daphne du Maurier. The greatest of the type was Charlotte Bronte's *Jane Eyre,* published in 1847.

ADVERTISING STRIPS

One other kind of graphic story does appear in the newspapers—the comic strips used to plug products. These are always conceived of and scripted by an advertising agency. And, unless the ad campaign calls for the use of famous copyrighted cartoon characters (and sometimes even then), the artwork will be done by agency artists. Very rarely, one of these little huckstering strips will catch on.

During the thirties an agency came up with character called "Mr. Coffee Nerves" to advertise a coffee substitute. He was a transparent, top-hatted villain dripping with evil. He became enormously identifiable with the

badness of the old nerve-jangling excess intake of caffeine. He was not clearly connected, in the public mind, with Postum. He didn't have to be; at the time Postum had the market cornered on what my father always referred to as "castrated coffee."

Some advertising strips are capsule adventure stories. Of these, the most effective are probably those designed to sell Eveready flashlight batteries, because they are represented as authentic narrow escapes from floods, fires, shipwrecks, mine and mountain disasters, abductions, and just about everything harrowing you can imagine. Moreover, even if the stories are not precisely genuine in every respect, they certainly could be true. They seem perfectly plausible.

The customary adventure in search of increased sales has little or nothing to do with the product being pushed. When I was a boy Melvin Purvis, the federal agent who shot Dillinger, was made the hero of a series of unconnected adventure strips that ran in the Sunday paper, advertising some product or other—a breakfast cereal, I believe. Baseball star Dizzy Dean also figured in a similar array of adventures. The connection of these people with the cereal (or breakfast drink, or whatever it was) was never clear to anyone except adults like my father, who understood endorsements a good deal better than baseball. In any case, the product (unlike flashlight batteries) couldn't help you or Purvis or Dean out of the situations the two men found themselves in. To snare the criminals who made it a practice to stick up a bank or store just as Purvis was cashing a check or buying cereal you had to be a G-man. If, like Dizzy Dean, you were to save the kidnapped child from being dropped off of a roof 50 yards away, you had to be able to knock out an anarchist lunatic with a hardball thrown 150 feet. Even at age ten I figured that no breakfast cereal was going to turn me into a Dizzy Dean. But I did join Melvin Purvis' club, The Junior G-Men, so I had to eat "his" product to get the boxtop to send in. That was the real objective, of course, the purchase made to get the premiums. And this is still being worked to death.

The genre (lovelorn, medical, family relations) version of the advertising strip is always concerned with interpersonal relations. Most often, the idea is to put you in fear of your mental balance and physical and moral well-

being if you fail to brush your teeth with a particular dentifrice or use a laxative that will not just do the expected but will, incidentally, make the world seem rosy and take about fifteen years off your age. (Anything that could do what those laxatives and dietary supplements claim to do would have to be listed as a "controlled substance" for sure!)

Humorous ads are a bit less offensive. Whether or not they are effective I'm not sure. Many of them simply take advantage of popular cartoon characters in the way that celebrity endorsements try to transfer some of the popularity of the celebrity to the product. No examples of really fine humor strips devised explicitly for an advertising campaign come to mind. There have been some notable animated cartoons done for television commercials. But animation is a topic too specialized for detailed consideration in a book like this one. For those with a particular interest, however, the following treatment may be of some value.

ANIMATED CARTOONS A motion picture is nothing more than a strip of photographs breaking action down into a series of still pictures. When these are run through a projector at the rate of *24 frames per second* they convey an impression of continuous, uninterrupted movement. Such effects can also be achieved by hand. For example, in the upper right corner of this and surrounding pages is a little acrobat, drawn in slightly modified positions from one image to the next. If you hold the book up and let the pages flicker by running your thumbnail along the edge of the corner, the acrobat will appear to do a full flip through the air. This is an example of animation. It is a crude example, of course, but it is not different in principle from what animators do at Walt Disney Productions in California.

The sort of thing done for the movies requires synchronizing drawings to dialogue, movements to music and sound effects, and entails a tremendous amount of planning and a radical division of labor. Overall coordination of the separate activities is essential, and a strict procedure has been developed to ensure that everything comes out together on time and correctly.

Animators do not begin working until the plot has been turned into a frame-by-frame description of events, music, sound effects, and dialogue. The background and essential layout of the imagery will also have been finished before the animators begin to provide the illusion of movement. Charts are provided them to show—in terms of single frames—the length of words, syllables, vowels and consonants, pauses, beats of music, noises, and anything else in which synchronization is critical to the final effect. The chief animator works out the major phases of the action and his assistants fill in according to his indications, working by tracing successive drawings on top of one another, progressively varying them just enough to produce an illusion of smooth, flowing motion.

The animators do not render their drawings for filming; they merely pencil them out with great care, working on glass surfaced drawing tables that are illuminated from beneath. The animators' layouts are traced onto animation *cells* of transparent acetate by inkers who outline the figures (and other moving things) with great care. Color is applied by painters who work on the *reverse sides* of the inked transparencies. As you can see, the processes involved are such as virtually to eliminate any possibility of spontaneity or individual expressiveness.

Once the cells are completed they are photographed. Settings will have been painted onto bands of acetate and these are arranged in levels ahead of or behind the figure cells as the situation requires. Since whatever has not been colored in on the cell is completely transparent, backgrounds for the figures can be created merely by placing cells upon painted settings. Similarly, foreground elements such as pieces of furniture, shrubs, rocks, fences, etc., may be painted onto otherwise clear sheets of acetate and used to overlap the moving figures. By shifting the background forest, say, and the foreground trees while separate cells showing a deer bounding along are exposed to the camera a very complete illusion can be created. The photographing itself requires about an hour for every eight feet of film. (There are sixteen frames to a single foot of modern motion-picture film and the film is projected at ninety feet a minute.)

Individual cells used for ordinary motion-picture and

TV screens are 16 × 13"; those used for widescreen projection range from a minimum of 30 × 13" to a maximum of 90 ×13".

What has been described above is the procedure used for the most elaborate kinds of professional production, such as those from the Disney Studios. Most TV animation is of the limited motion variety; it requires far less work, fewer artists, and is correspondingly more economical. For, where the motion-picture animators will make whole faces move according to the requirements of human speech, the TV animator is usually required only to make mouths open and close. It is possible to get by with far, far less than this.

Anyone with a good 8 mm. camera, some artistic ability, and modest studio facilities can turn out an animated cartoon. A simple way to produce the artwork is to ignore all of the business about transparent cells and overlaid spatial levels and make the pictures themselves moveable. For instance, you might cut figure elements from colored construction paper and scraps of fabric, then lay these out onto a background (perhaps even a photograph) to be photographed. After each exposure you can shift the elements just a bit. As it happens, amazingly little is needed to convince a viewer that the motions of the fragments are realistic. A "dog" whose body is a simple rectangle and whose legs are mere strips of paper that pump up and down like pistons will seem to be running along if a background shifts behind him at a steady rate.

You might also experiment with animation in the form I have employed on the page corners of this book. It is relatively easy to trace successive moments of action onto tracing paper "cells" that can be glued to 3 × 5" filing cards so that a flip of the thumb evokes the magic of the movies.

GRAPHIC STORIES IN BOOK FORM 7

The newspaper comic strip is to all other forms of the graphic story as the best-selling novel is to the routine detective story. It represents the pinnacle of success in terms of popularity, status, and material reward. But, by the same token, only the tiniest minority of professional cartoonists ever work on a syndicated strip. Of the few who do, most do so for a very short time because the competition for space on the feature pages is terrific and, for every successful strip, dozens fail. And sheer skill will not turn the trick. *Friday Foster,* a strip concerning the adventures of a black fashion model, had a lot going for it: an unusual but noncontroversial heroine, a glamorous setting, interesting stories, and a really brilliant illustrator in Jorge Longaron. Yet, all of these together were not enough to keep the first black heroine alive. For some reason, the mixture just didn't "click." That is more often the case than not. And long-running strips

like *Blondie, Steve Canyon,* and *Li'l Abner* are rarer than
genius. There are a lot more strip cartoonists than
geniuses, however, and most who work steadily draw
comic books.

Like newspaper strips, comic books run the gamut
from funny animals through genre to adventure. About
80 percent, however, are adventure-oriented. Nearly any
reader interested in drawing for the mass-marketed com-
ics will already know everything about the types
and kinds, the relative prominence of superbeings and
crimefighters over and against comical cutups and
teenaged heartbreakers. You may also know a little or a
lot about the history of the books, from their beginnings
as pamphlets reprinting newspaper strips through June
of 1938 when Superman made his debut in *Action Comics*
and the booklets became independent entities. Until after
the close of World War II they were almost entirely
dominated by heroes with various kinds of superhuman
or nonhuman prowess. Then, in 1950, something that
fans of the comic books consider nothing short of revolu-
tionary occurred; a company called E.C. (for "Educa-
tional Comics," but soon identified on the logo as "enter-
taining comics") began issuing science-fiction, horror,
and crime comics of a very startling sort. The artwork
was markedly superior to the then-existing standard and
the stories were sometimes based on *ideas*—at least to
the same degree that stories in the better science-fiction
magazines concerned themselves with conflicts between
human beliefs and alien conceptions rather than with no-
ble spacemen protecting half-naked females from bug-
eyed monsters. And they tended to be full of effects that
produced shock. Dismembered bodies and decaying flesh
proliferated the panels. Organs were plucked like purple
fruits from bodies torn open by monsters that might be
human, subhuman, or superhuman. The extreme edges of
adolescent sanity were tested in gruesomely ironic tales
told by characters who lived in crypts and funeral vaults
and, later, by a fantastic satire magazine called *Mad,*
predecessor of the less diverting *Mad Magazine.* As Les
Daniels said of E.C.'s publications in his history, *Comix,*
"The atmosphere . . . was one in which imaginations were
not only stimulated but jolted."

Among the jolted imaginations was that of one

Frederick Wertham, M.D., a psychiatrist. In his book
Seduction of the Innocent he criticized comic books for
their violence and unwholesome social attitudes. Wer-
tham saw in the pages of the recent comics, and in E.C.
comics in particular, the seeds of madness, racism,
perversion, and illiteracy. The eventual effect of his
polemic was a housewifely crusade against the excesses
of the comic books. But theirs was only part of a general
movement in support of censorship for the Public Good.
The books had also come under the eye of the federal
government when a U.S. Senate subcommittee on
juvenile delinquency investigated them. The major
publishers, fearful of government regulation and utterly
terrified by the spectacle of outraged mothers tightening
the purse strings upon which the industry depended,
reacted strongly. They imposed upon themselves a more
oppressive kind of censorship than any government com-
mission would have dared even to suggest. In October of
1954 they adopted a code of ethics for comic book
publishers, established a Comics Code Authority to pass
judgment, and permitted acceptable publications to
display a seal saying "Approved by the Comics Code
Authority." Given the temper of the public and the fact
that comic books were marketed in neighborhood
drugstores and ice cream parlors, any publication lacking
the seal was doomed to boycott by its former
distributors. And a tremendous number of companies
went under because they could not or would not adapt
their material to the Code. Among these, of course, was
E.C.

This brief excursus into the history of the comic book
seems, perhaps, to have taken us far from our presumably
practical concerns. But it is a digression with a pertinent
objective. For the character of today's comic books is a
direct result of the emergence of the Comics Code. And
nowhere is this more obvious than in the division of the
comics into two broad types: overground comics and (ac-
cording to custom) underground comix.

The overground books are those that are mass-marketed **OVERGROUND**
through customary retail outlets such as drugstores and **COMIC BOOKS**
magazine stands in similarly "straight" businesses. Not

all, but virtually all of these comics carry the seal of the Comics Code Authority. There is lots of action, even violence, but its consequences are either implied or negligible. The good guys always triumph and the evil-doer is punished. Nudity and exaggeratedly sexy women are "out." These are among the requirements of the Code. But the Code was written to answer specific kinds of objections and is so worded that it leaves room for interpretation. It is not very imaginative. Clever writers and artists, therefore, can find ways around many of its provisions. The most successful evasions of the spirit of the Code have been those of Stan Lee, chief editor of the Marvel Comics Group.

Lee's villains are evil but they rarely expire; they aren't required to by the letter of the Code because they are never able to carry their nefarious designs to fulfillment. Either by pluck or by luck the protagonist always manages to interdict them. And both heroes and villains are more complicated than the typical comic strip characters. They are always *worrying* about something; they have ego problems and adjunct insecurities. The heroes invariably suffer some defeats—although the baddies never really win a victory. Moreover, in Lee's comic books, a some-time good guy may turn bad in later issues and bad guys often do good or become champions of virtue in some other book of the Marvel line. There are frequent "guest shots" and cameo roles. During the late 1960s Lee's formula became so successful that it influenced the other big comic book publisher, National Periodicals Publications, Inc.

National is the dignified old party of the comic book industry. Superman, Batman and Robin, Wonder Woman, the Justice Society of America, and the Legion of Superheroes are among National's stars and many of them date (if only in name) from the 1930s and '40s. Some of Marvel's do too; Marvel is an outgrowth of Timely Comics of the '40s and has revived a few of the old Timely characters. In the case of Timely's all-time superstar, Capt. America, the revivification was literal. He was brought back from a frozen death. The Human Torch and Submariner were recreated and given much more introspective attitudes.

The other fairly large overground companies are Charlton, Gold-Key, Dell, and Archie Comics. Charlton specializes in comic strip versions of successful newspaper strips, animated cartoons, and television shows. Its original material runs to romance and the supernatural. Archie, of course, depends upon *Archie* types of strips, most of them spinoffs from the newspaper characters. Gold-Key and Dell are similar to Charlton, but with greater emphasis on funnies.

Before the advent of the Comics Code, practically anyone who knew anything about preparing mechanicals for photo-reproduction—even if he could draw only a little—could find some kind of work on comic books. Rendering was often rudimentary to the point of crudity. Even National did not maintain a very high standard of draftsmanship. There were plenty of exceptions, certainly. Will Eisner, Jack Kirby, Reed Crandall, Lou Fine, Mort Meskin, Wayne Boring, Charles Biro, Mac Raboy all did things of astonishing quality, considering the mediocrity of their competition. But it wasn't until after the rise of E.C., the subsequent appearance of the Code, and the ultimate demise of multitudinous small operations that skill became a prerequisite for drawing comic books. The alarming increase in artistic quality was also connected with some changes outside the world of the comic book.

Even before the number of mass-circulation magazines began to shrink up in reaction to the TV deluge, the magazines needed fewer professional illustrators of the conventional sort. On the one hand, various kinds of photographic conversions were replacing artists' drawings in the columns and the ads of the magazines; on the other hand, the growing sophistication of the postwar public was bringing into greater prominence the layout man, the designer, the typographer. Good design was actually squeezing conventional illustration from the slick magazine market. What remained of it was either the cream of the American tradition, such as Norman Rockwell's material for *Look,* or the spectacularly inventive styles of people like David Stone Martin, Bernard Fuchs, Milton Glaser, Bob Peak, Leroy Nieman, and others. At the same time, since the G.I. Bill

Fig. 137. Burne Hogarth, *Tarzan.* ©1949 Edgar Rice Burroughs, Inc.

had paid for art school training as well as college educations, there had never been so many expertly grounded professionals available. Inevitably, a few of these gravitated to comics.

A fair number of the trained commercial illustrators of the 1950s and '60s came out of The School of Visual Arts on Manhattan Island. One of the founders of that school, and its first master of life drawing, was also among the finest of the newspaper strip artists. This was Burne Hogarth, most inventive of all the *Tarzan* (Figure 137) artists. His influence on comic book art has been marked, as can be observed in a quick glance at the superheroes in Figure 138. Gene Colan's rendering owes a good deal to Hogarth's stylizations of Tarzan's anatomy. Colan's composition is the less studied and elaborate, but a comic book artist has scarce time for such niceties. The images do flow from panel to panel and the page bursts with dramatically exaggerated action. (This page, incidentally, is a good example of Stan Lee's melodramatic version of "situational ethics." The lead figure, a now-defunct "Capt. Marvel," was an alien from outer space, an advance man for a Kree invasion of Earth. He *had* to obey his commanders, but he was torn by humanlike pangs of conscience and the plots usually involved his avoidance of duty. His opponent here is another Marvel Comics standard, Submariner, an earthbound son of Atlantis who is constantly harassed by the human Establishment. In this comic book he and Capt. Marvel had come into territorial conflict, producing exciting action and violent combat, although neither is a villain in the ordinary sense of the word.)

Actually, Gene Colan didn't draw what you see here, at least not all of it. He did a careful pencil drawing—something like that in Figure 139—and it was then inked by Vince Colletta. Colletta, however, didn't do the lettering; I. Watanabe was responsible for that. And the story had been written by Roy Thomas.

Normally, a comic strip story is written up like a motion picture, with each scene described and the dialogue and captions set down in form of a script. The artist may make changes in the breakdown or pacing for better visual or narrative effect and will surely add elements of his own to what the writer has provided. At Marvel Com-

Fig. 138. The superheroes here reflect the example of Hogarth's artwork

ics Stan Lee instituted another innovation in assembly-line production of strips. There, the artist does his "pencils" from a rough plot outline and the writer later adapts dialogue to the pictures. Essentially, this has the effect of producing the most talk where there is the least action and little conversation where a lot is going on. The Marvel procedure is unusual, but it provides a simple way to coordinate the writing and drawing of strips being turned out on the regimented schedule of today's publishers. It also tends to emphasize the purely visual impact of the Marvel Comics products.

Aside from the preconditions set up by the Comics Code, the main considerations for the writers are audience level and pacing of the stories. As for the level, it is very capacious; that is, the books are read by kids in grade school, by teenagers, by college youths, and by a

Fig. 139. Pencil drawing after Colan's Capt Marvel *(Figure 138)*

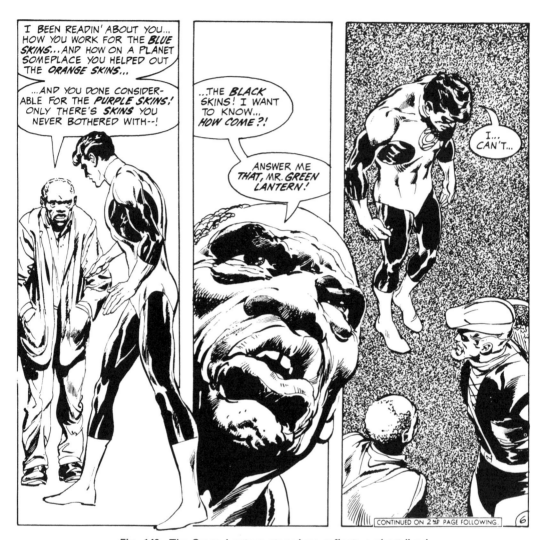

Fig. 140. The Green Lantern *story here reflects a short-lived attempt to portray liberal and humanitarian causes*

Neal Adams, *Green Lantern.* © 1970 National Periodical Publications, Inc.

few older people. The consequence of the wide range is that writers slant their material at a twelve-year-old mentality. There's enough action and repetition to sustain a younger child's interest and, with luck, hidden undertones and sufficiently impressive drawing will interest the more mature segments of the public. Of course, some

publishers slant material at the younger set; some, like Marvel, aim at the teenage market; and others tailor different titles to different age and interest groups.

Difficulties inherent in making so broad an appeal are endless and account in part for the emergence and abrupt decline of certain kinds of story fads. For instance, during the late 1960s, in response to the widespread popularity of liberal and humanitarian causes, the comic books began to express a social conscience. Masked do-gooders, like Neal Adams' *Green Lantern* (Figure 140), suddenly took on as their antagonists such super-evils as racial prejudice, environmental pollution, dire poverty in the midst of affluence, and the drug problem. Generally, this got a good press. After all, who openly favors bigotry, filth, want, or addiction? Usually, it's not the wickedness of the thing we differ about; it's the proposed solution to the problem that causes argument. And the strips rarely got so controversial as to suggest that the roots of America's difficulties might go deeper than personal selfishness, ignorance, or racketeering. Ideologically, the aproach of the comic book industry to manifest social evils was as timid and simplistic as its approach to freedom of the press. Still, the whole trend was a "bomb" as far as sales were concerned. And sales volume is everything in the overground comic book industry, because the company profit on each book is about two cents. Moreover, most of the publishing companies today are subsidiaries of gigantic, impersonal conglomerates run by people whose sole interest in the product is whether or not it returns enough money on the corporation's investment. In the case of the social consciousness trend of the late 1960s, the collegians ate up the new relevance. But their share of the market is far too small to rely upon. Commercial success calls for a much broader appeal.

For these reasons the typical overground comic book is an assembly-line, committee production. Unlike newspaper syndicates, comic book publishers are less interested in some unique imaginative capacity in an artist or writer than they are in sheer journeyman skill. Something like *Doonesbury* could never have begun in a comic book publishing house; almost inevitably, it had to come (as it did) from the campus newspaper of a prestige university or else from the underground.

Fig. 141. Richard Corben, *Creepy*. ©1973 Warren Publishing Co.

Lest the emphasis on skill in what I have said discourage the tyro, let me say also that a large number of new comic book artists have come into the profession by way of amateur publications and also from underground comix. Not all of them live on the East Coast and work out of "bullpens." Don Newton, who draws for Charlton, is an art teacher working in Phoenix, Arizona. His publishers mail him the scripts and Don sends them the artwork. Similarly, Richard Corben lives in Kansas City, Missouri.

Corben has drawn for an overground publisher whose company has a peculiar relationship to the rest of the industry. Warren Magazine comics are not altogether different from some underground comix, but neither are they altogether removed from the overground. The best term for them may be "ground-level comics." Distributed through overground outlets that ordinarily sell only what has been sanctioned by the Comics Code Authority, Warren comics defy the Code by ignoring it.

Jim Warren, head of the operation, entered the comic book field through a side door, so to speak, by way of specialty magazines devoted to horror films. He next put out a *Mad* type of magazine called *Help!* which featured work by Kurtzman, Davis, Wood, and Elder, of the old E.C. staff, as well as that of future underground artists Robert Crumb, Jay Lynch, and Gilbert Shelton. *Help!* was intended for an adult audience and appeared on the racks among the film, male interest, and adult humor publications. It folded in 1965 and Warren began publishing a quarterly black and white comic book with color covers. That was *Eerie,* a horror comic that went directly against many specifications in the code criteria. That caused rumblings and grumblings but, because *Eerie* was the same dimensions as *Time* or *Newsweek,* a bit larger than the standard comic book, it went on the magazine shelves instead of the comic book racks. This, evidently, was sufficient evidence of its "adult" nature to insulate it from attacks by Code supporters. The success of *Eerie* spawned *Creepy* and, in 1969. *Vampirella.*

All along, the artwork in Warren Magazine comics has been of a quality equal or superior to that of the standard in the overground. The contents are, of course, much more sophisticated than the typical comic book—which is

nòt to say that this fiction poses a serious threat to Thomas Pynchon or Vladimir Nabokov. It is dominated by what the adolescent mind is apt to find profound: The Ironic Twist of Fate. Still, the relatively greater complexity of the Warren books has drawn some of the larger overground publishers—notably Marvel and Charlton—into competition with Warren for the adult comic book market. A number of outstanding graphic story illustrators have drawn for Warren, among them Al Williamson, Frank Frazetta, Wally Wood, Reed Crandall, Alex Toth, and Gray Morrow. As I write Richard Corben (see Figure 141) is the ascendent star amid the workers of the varicose vein. He garnishes his work with mordant wit and irony so that it always has some satirical component. Which is precisely what one might expect from a cartoonist who gained an international reputation in underground comix.

UNDERGROUND COMIX

The principal distinction between underground and overground comic books is that, while the latter are sold through conventional channels of commerce, the former have been available largely in stores catering to an unorthodox clientele. Bookstores that carry lots of erudite paperbacks, poetry, and radical political tracts have usually had undergrounds for sale. They appear in so-called "head shops" where drug paraphenalia and the related accoutrements of the counterculture are merchandised. They are very definitely "for adults only." Underground comix emerged out of the radical free presses of the late 1960s and early 1970s and have retained their hostility to ordinary standards of decorum. Unfortunately, they have only barely survived. The 1973 Supreme Court decision having to do with pornography left decisions about what was obscene up to "community standards." Knowing how conservative most American communities are, the underground began to sink from sight.

The problem with the ruling was not that every underground comic was "dirty." Although they shared an absolute commitment to uncensored expression, many of them weren't even suggestive. Sut since *some* of them

were aggressively pornographic, and since the books were usually marketed by "freaks" in little shops that many "good people" wanted to see shut down anyhow, the hip shopkeepers were fearful that some local district attorney would walk in, proclaim the macramé "offensive to community standards," and book everyone in the place. Litigation costs would, in this case, soar. There was not, in times of such anxiety, much interest in increasing inventories of the comix. Orders were canceled. The presses stopped. The underground was so depressed as to be only barely visible. The radical young publishers could no longer meet their payrolls and several of them went into bankruptcy. Ironically, the hysterically puritanical storm everyone expected never came to pass. But as much damage had been done by our fear of the threat that hung in the air.

While the underground flourished it set a standard of anarchic liberalism that was a very refreshing alternative to the conventional market for strips. The underground not only brooked no truck with the Comics Code, some would say that it was innocent of common decency. There's something in that allegation; many of the comix were ruled by rebellious disdain for the conventional. Even the titles of the books were calculated to offend "straight" society. Four-letter words, sexual organs and acts, drugs, and revolutionary propaganda were customary. By reason of such freedom, though, there was artwork that could have appeared nowhere else. Such hip creators as Rick Griffin and Victor Moscoso (Figure 142) created a graphic universe rivaling the surrealistic vistas of fine art. There was also material that was not exactly countercultural—material that would, in fact, have been easily accommodated by popular literature as science-fantasy, horror, or detective fiction—but which, when made visually explicit, was far too strong even for the anti-Code overground. Too, since all the stops were out and every underground comic was for "adults only," the work was much more literary (if not always more literate) than anything publishable in mass circulation comics. The underground did *everything* that other publishers could not. Much of what it did was in the poorest possible taste and some of the artwork scarcely deserved the name

Fig. 142. Some underground comix artists created a graphic universe that rivaled the surrealistic vistas of fine art

Fig. 143. Shary Flenniken, *Trots and Bonnie.* © 1973 Shary Flenniken

201

Fig. 144. Jones' cartoon work here combines traditional conservative figure drawing with Art-Nouveau-type decorative composition

Jeff Jones, *Idyl.* ©1973 Jeff Jones

of art in any sense of that word at all. But the vital, the imaginative, the genuinely experimental made up for that. It also made the overground look terribly dull by contrast and led commercial publishers to be somewhat more daring in their approaches to the public.

I have consistently spoken of the underground in the past tense because, truly, the phenomenon has pretty much passed by. But there are still undergrounds being published, though largely for mail-order purchase. And there are a few indications that the underground may experience a rebirth in somewhat the same way that horror comics did through Warren Magazines. Recently, in response to the question, "What became of underground comix?" someone answered that they had died and gone to *National Lampoon.* And, for a fact, some of the finest underground artists have been doing cartoons for that highly successful overground satire magazine. Charles "Spain" Rodrigues, Shary Flenniken, (Figure 143), Bobby London, and others have made regular appearances there. So have some overground professionals with experience in the underground—for instance Jeff Jones.

Jones' work under the rubric "Idyl" (Figure 144) is very traditional in rendering; it combines conservative figure drawing with decorative compositions in an Art Nouveau manner, spotting blacks and whites with great effectiveness. The themes of the anecdotes are sophisticated whimseys with a wry twist. Here, for instance, the subtitle is "Aristotle" and the references are: (1) to the comparative reliance on experience of this fourth-century B.C. Greek philosopher, and (2) to his formulation of the "law of the excluded middle" in formal logic. One doesn't have to know anything about Aristotle to find Jones' strip amusing, but to know augments the humor. The smile it evokes also, it is true, contains a trace of the supercilious smirk, that element of self-congratulation that is part of all "in jokes."

Jones' work appeared in the undergrounder *Spasm* and also in a very special magazine entitled *Witzend. Witzend* was founded in the early 1960s by E.C. cartoonist Wally Wood to provide an outlet for graphic story material of an experimental or extreme nature. Neither

underground nor amateur, it was a professional, non-profit undertaking devoted to liberalizing comic book contents and "showcasing" new talent. *Witzend* still makes sporadic appearances under the aegis of Bill Pearson, the very capable editor. Although highly professional, it is a specialized form of "fanzine," of which we shall have more to say in the next chapter. The fanzines deserve mention here, too, because the underground comix are, as I write, either buried among the fanzines, which have miniscule circulations, or are adult overgrounds.

DOING A COMIC BOOK
Most overground comic books are prepared in a studio called a "bullpen," where artists specialize in penciling, inking, lettering, and doing color separations for the printer. But we shall assume that you are going to do the entire thing, from initial layouts to finished ink rendering. As it happens, what was said in Chapter 4 will apply to the comic book. And much of what we say here could have been said there as well. Indeed, the only significant difference is that comic books are booklets with pages you must turn.

The first thing to know in setting out to do any comic strip is, of course, how big it is going to be when it is printed. Most overground and underground comic pages measure 6 3/4 × 9 3/16" and the original art is usually done 18 × 23 1/2", including margins. Some artists, however, work much smaller than that. Thus, the Gil Kane page from *Creatures on the Loose* (Figure 149) is approximately 11 × 17".

Page size is but one measure of scale. The number of pages is another factor. Now, since the average comic book is nothing more than a sheaf of paper folded in the middle and saddle-wire-stitched (stapled through the spine), the book will have pages in some multiple of four, no matter how long it is. You see, one sheet of paper folded in half has a front page (1), two inside pages (2, 3), and a back page (4). This means that, exclusive of the covers, comic books always have 4, 8, 12, 16, 20, 24, 28, 32, . . . pages. Regular overgrounds average 32 pages, of which a number are taken up by advertising. Warren comics are usually 64 pages long, although the last

regular page is often numbered as 66 (because Warren counts the inside front and back covers as pages 1 and 2). We are using the typical binding situation here. For some special editions more elaborate bindery techniques are brought into play. Still, they usually do not involve sewing or stitching as is the case in hardcover book manufacture. Most frequently, a comic book that is too thick to be held together by single staples through the spine fold will consist, in effect, of two or three spine-stapled comic books glued to a flat-spined wraparound cover. Even so, the four-page multiple is the most common type.

Some of the pages in any comic book are quite likely to be advertising. It is important for a writer to know how many ads there will be and where they'll occur because the last panel of the right-hand page should contain some sort of "teaser" to impel the reader onward. Most comic books have a miniature drama on every page, in the way each daily strip in a newspaper contains conflict, buildup, and climax. Normally, the first panel establishes the conflict or sets the stage for its occurrence. The others build up to the climax in the last or next-to-last panel. Should the climax occur in the penultimate panel, the last panel will provide a teasing aftermath. In the "Capt. Marvel" strip (Figure 138) the conflict has been carried over from the preceding left-hand page, but the fight is just beginning. It builds up through panels two and three. Submariner's retaliatory blow is the climactic event.

Another kind of development occurs on a right-hand page in *Maxor of Cirod* (Figure 145). The situation is established in panel one, setting the stage for the conflict that manifests itself in the third panel. The next three panels build up to a climactic "kill" in panel six. The last frame, then, reveals the aftermath of the fray, whetting the reader's curiosity.

Once a script has been completed and the number of pages determined, the first thing the artist will do is a series of small "roughs" about the size of the printed page, working out formal associations within the panels and plotting the relationship of each panel to the others. These roughs are mere notations, used to put passing thoughts into concrete form. The roughs for the Maxor

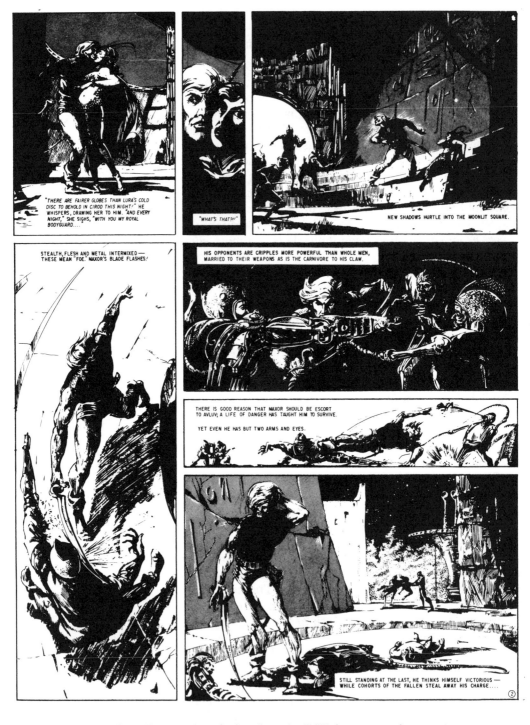

Fig. 145. Even though the climactic "kill" has occurred on this page, the last panel teases the reader on by setting up a new problem situation

John Adkins Richardson, *Maxor of Cirod.* ©1971 John Adkins Richardson.

page developed through three states (Figure 146). Those in A proposed a more conservative arrangement of panels. But it was too full of bird's-eye views of the figures. (By the way, those numbers in the roughs stand for panels as referred to in the script and the letters refer to captions.) The second trial (B) was a bit better but still too fixed in terms of viewpoint; in it, the scale of the hero seemed monotonously constant and the ordinary arrangement of panels in parallel registers struck me as too undynamic to suit such violent action. The final rough shifted things around. I liked it and went along with the design although (as you can see from my corrections) it did lack graphic clarity so far as panel sequence was concerned. I simply relied on the text and the convention of reading from left to right to take care of things. This was an imperfect solution, but I preferred it to the other alternatives.

Now, then, let it be clear that real alternatives were present in the roughs and that further planning would have refined the layout more. I am *not* showing you this page because it is of incomparably high quality. It isn't. I am showing you this one because roughs are usually discarded and I just happened to have the three of this particular page. Each rough indicates possibilities with enough precision to indicate scale, viewpoint, position, general posture, movements, and so forth. Where things might have become obscure to me in the interim between laying out the comic and beginning to do more elaborate preparatory drawings, I made written comments to indicate what was supposed to be going on.

It really is best to work things out this way beforehand, from a script and roughs, although most beginners resist it. If you've no plan of where you are going, you are likely to end up in a cul-de-sac. And in a comic book, that is a real dead-end situation.

Following your roughs, a preliminary drawing the size of the finished mechanical should be prepared. Since Gil Kane's are especially thorough, I am using one of his studies for a *Giant Size Conan* (Figure 147) here. Some of this is pencil, some is fiber-tip pen. Far from being a finished drawing, it is nevertheless sufficiently complete

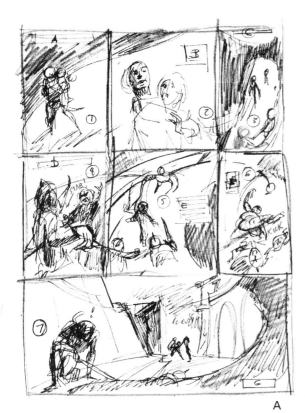

A

Fig. 146. When the script is complete and the number of pages decided, the artist roughs out the story, determining panel relationships

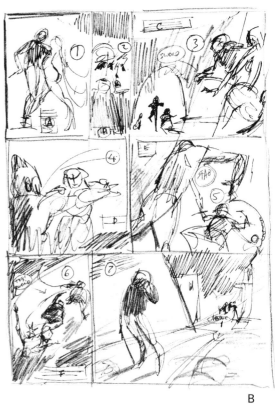

B

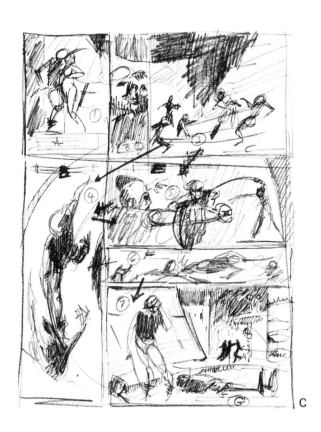

C

209

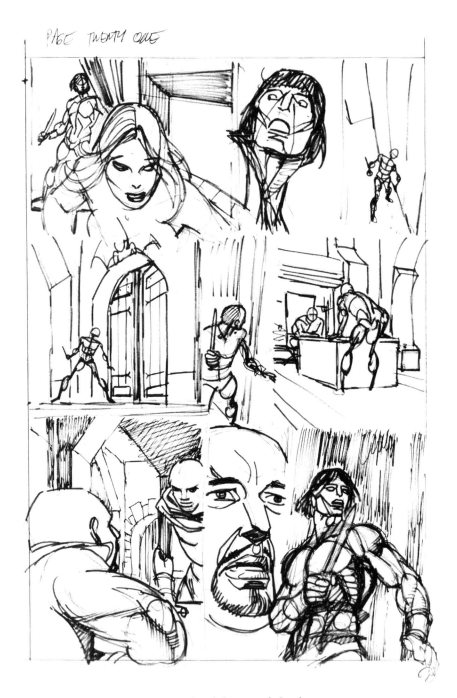

Fig. 147. Preparatory sketch for a comic book page

Gil Kane, *Giant Size Conan.* Courtesy of *Fantasy Crossroads,* ©1976 Jonathan Bacon, Lamoni, Iowa

to give anyone a clear idea of the spatial relations, figure attitudes, and overall patterns. This drawing could be placed on a light table beneath another sheet of bristol paper and a blue pencil tracing then made of the lines. On this the finished pencil rendering—like that in Figure 148—would be made. Next, the balloons and captions could be lettered, then the drawing could be finished in India ink with drybrush and pen. Figure 149 is a finished Gil Kane page from a "Gulliver Jones" story in *Creatures on the Loose*. All that remains to be done are mechanical color separations. Figure 150 shows the lower left panel reproduced the actual size of the original drawing.

Fig. 148. Pencil drawing after Colan's Capt. Marvel *(Figure 138)*

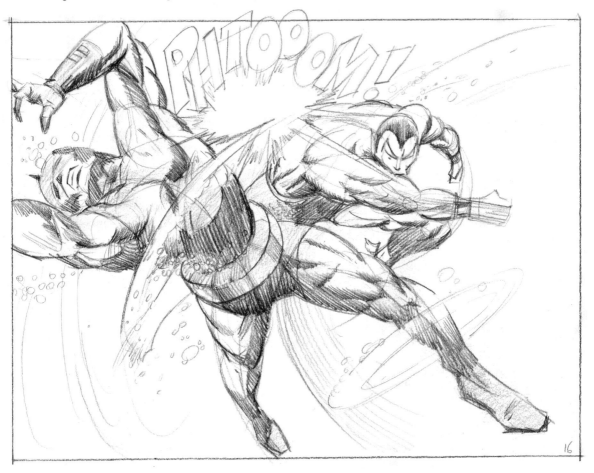

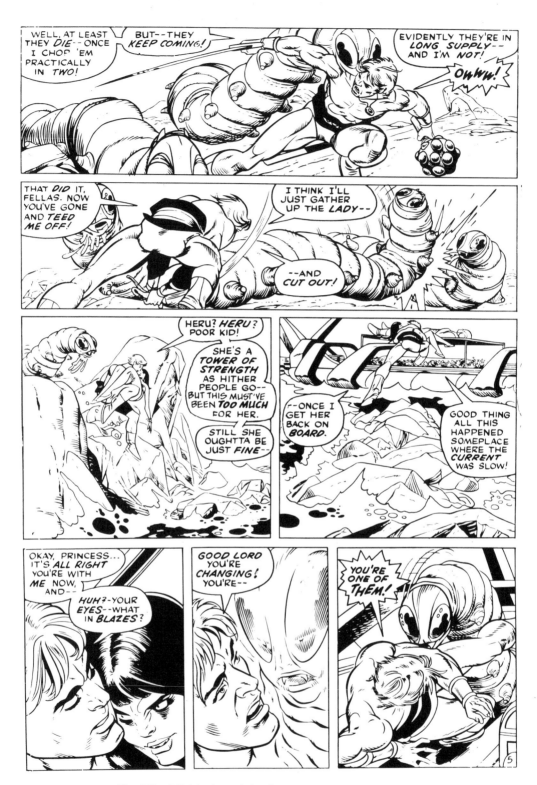

Fig. 149. A finished comic book page

Gil Kane, *Creatures on the Loose.* ©Marvel Comics Group

Fig. 150. Detail to size of original drawing of Figure 149

Gil Kane, *Creatures on the Loose.* © Marvel Comics Group

While the process has been outlined here in terms of an adventure strip, precisely the same steps would be undertaken for any graphic story, whether about funny animals, true love, or horrors of the occult and the depraved. Or anything else that you can come up with.

Assuming that you have stayed with us this far, it is a safe bet you'd like to see your work in print. If you have absorbed the instructions and practiced the various exercises as I suggested, you should be able to find an outlet for your work simply because you will know more than most others sharing your ambition. Studying the contents of this book is not an absolute guarantee of success, but it will immensely enhance the likelihood of publication.

I am not thinking of publishing for payment at first, you understand. Most cartoonists begin as amateurs, doing their stuff for fun, and if some patron wants to widen the audience by printing the artwork, that is all to the good. For you have not really learned about cartooning until you have gained some experience in actually preparing artwork to be reproduced. In any case, the only reward most of you will receive for your first efforts is the pleasure of seeing your work in print.

215

Even that reward is hard to come by for many people. I am perpetually startled by the naiveté of the neophytes. Some of them seem to imagine that the world is full of publishers lusting after any crude effort anyone happens to produce. Apparently, love is blindest when it comes to what we ourselves have created. And no textbook can anticipate the queer vanities to which its readers are subject. These need not be the vanities of conceit. Most often, in fact, they are not. The worst kind are those born from want of experience.

Much of what I am about to say will be well understood, even taken for granted, by those of you who are using this volume as a textbook in a formal course of instruction. Still, buried in the discussion are bits of information that are essential. The first thing an amateur must understand is that the ability to *trace* something a professional has done should not impress anyone at all. You may prefer the result to anything you could do on your own, but the fact is that tracings and copies are the fruits of theft, requiring nothing from the thief but a steady hand and a little patience. Moreover, publishing your version of a copyrighted character is usually illegal under common law, even when the copyright statute doesn't cover the exact situation. Using *Peanuts* characters in school posters and the like is something that will never come to the attention of either Schulz or the United Features Syndicate. Even if it should, they'd probably look upon such use as a harmless theft advertising their product. If, on the other hand, a local furniture dealer allowed you to use the "Peanuts" in newspaper ads for his spring sale, he would run a very serious risk of being sued for the share of the profits gained at United Features' expense. A fairly close imitation of the Schulz *style* as opposed to characters, however, would probably be safe. Derivation is permissible; reproduction and near duplication are what's outlawed.

But let us assume that you have created some original cartoon characters and you can draw them with some degree of skill. Wishing to publish, you cast about for an opportunity. Soon it will become obvious that *Playboy* and *The New Yorker* are not interested in your

gags. Every comic book publisher and feature syndicate has rejected your overtures. This is just what you should have expected all along, because these people almost never use unsolicited material mailed in to them. That's partly to discourage its submission. To do otherwise would elicit such a deluge of material as to be altogether unmanageable. And, of this mass, not one submission in a thousand would be worth looking at, nor one in ten thousand worth serious consideration. Sure, there's always the exception to every general truth. But why don't we assume that you aren't it?[1]

There remain a great number of possibilities for publishing your material, depending on what sort it is. So let us consider a few of the more obvious ones. Never fear, if you are a potential Trudeau, Thurber, or Caniff the ladder you begin to climb at lower rungs will still take you to the top.

If you are on a college campus the opportunities are multitudinous because a campus is a sovereign community with its own newspapers, advertising campaigns, special facilities, and channels of communication. Also, there will be faculty who have contacts in the commercial art world. Everything is made easy, at least in comparison with the situation faced by other readers. But nearly anyone has more opportunities than he thinks.

LOCAL PUBLICATION

The first thing of mine that got into print was a sports cartoon featuring the star halfback of my high school football team. I began doing those for my high school paper when I was a junior. Owing mostly to the "originality of incompetence" my caricatures were a source of great hilarity to all except the players themselves. They weren't good. But they had, all the same, a faintly professional appearance because I had studied a few books on how-to-do-it and so I rendered the cartoons with drybrush, coquille board, pen and ink. This

[1]Of course, you may actually be. Whatever the case, a guide to possible markets that contains information on what kinds of things are suitable for specific publishers, syndicates, advertisers, and how you should approach each of them is included in the bibliography under the category "Markets."

perhaps, was the reason they caught the eye of the editor of the local weekly. Whatever the case, he ran eleven of the cartoons and actually *paid* me for them. About $5 apiece, I believe. But to a teenager in 1947 that was a good bit more than it would be today. Of course, I really did the cartoons for the ego gratification of being a real newspaper cartoonist. In fact, I'd have done them for nothing at all.

When the series ran out, the local daily contacted me about doing a basketball series at the same pace, one cartoon each week. The pay was higher but when the season ended the job ended too. That was just as well, because I had already run through the first and second strings and was frantically wondering if I could do a couple of panels on cheerleaders. All this while I was also doing a comic strip for the high school paper. It was typical of high school humor during the decade—cloddishly conservative, a combination of *Freckles, Blondie,* and *Our Bill* done in a style derived from God knows where.

Why am I telling you all this? Because it happened in a town of about 18,000. In a large metropolitan center my efforts would have paled to insignificance beside the accomplishments of more talented teenagers. I knew that at the time. I had seen some of the student cartoons in high school papers being published in Los Angeles and New York City during that era. The quality scared me half to death.

Just because you aren't the most facile comic artist in a large city does not, however, mean that you are without opportunity. The high school or college newspaper is only the most obvious outlet for youthful ambition. There are lots of others. (Anyhow, you may be a senior citizen or a middle-aged hobby seeker.) In any case, there are numerous organizations eager to put your interests to work on behalf of their objectives. Many clubs issue newsletters. Some of them are national in scope although limited to very special groups.

Rarely do I see a newsletter that is much more than a grimy-looking thing that has been run off on a Multilith press from a "paper master." For hardly anything more, if any more at all, that same newsletter could have been printed from zinc or aluminum litho plates on an offset press by a professional printer. And then it could have

sharp logos and snappy spot cartoons to help drive home the points the editor wishes to make. The difference in effect is remarkable. And all that is required to turn out a first-rate job is a clean typescript done on an electric typewriter with a carbon ribbon. Where you intend to have the artwork appear, make appropriately scaled rectangles of solid black. (Before the platemaker exposes the plate through the negatives he will strip in the negatives of the reduced artwork or halftones after positioning them against those "windows.") With pressure-sensitive transfer type, even the rank amateur can do absolutely perfect lettering. And the cartoons can be done just as they would be for any other publication printed on the same sort of stock. The book in hand contains all the information you will need to scale and render your contributions.

Newsletters are not the only kinds of publications put out by clubs. Flyers are sometimes sent out to advertise events or fund drives. And these things usually look as if they had been done by the kinds of people who most often do them—the totally uninstructed. It will be no boast on my part or yours to claim that the least able of my readers will seem prodigious compared to the average layperson. Cartooning, in particular, is a specialty in which a little learning can take you quite a long way.

None of the above may appeal to you, particularly if you are a young person interested in doing comic strips. For you, as well as for many, many others, including people who care nothing at all about cartooning, there exists a vasty realm called *fandom.* And what is its most apparent feature? Why, that it publishes *fanzines.* And, believe me, there is a fanzine for every conceivable interest and odd angle of that interest, from comic books to collections of barbed wire. (Yes, reader, there are people who collect that, too. Contrary to your expectations, it isn't all alike at all.)

Fandom isn't an organization; it's an international phenomenon, reaching from the very estimable heights of France's *Société d'Études et de Recherches des Littératures Dessinées* (Society for Study and Research of the Graphic Story) all the way down to the dregs of near

FANZINES UNLIMITED

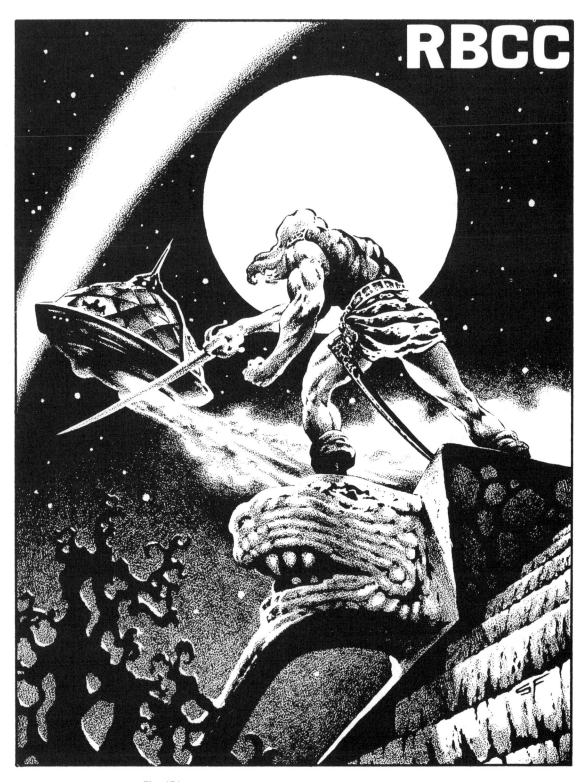

RBCC

Fig. 151. Steve Fabian, cover for *Rocket's Blast Comicollector* No. 3. ©1976 James Van Hise

illiteracy. Fandom comprises many interests—pulp thrillers, horror movies, old serials, antique radio programs, offbeat collecting interests, and all fantasy and science-fiction writing—but it is the comic fan who predominates and it is the fanzine that holds it all together. The neologism *fanzine* is, of course, an etymological howler. But fans tend to deify mass art and incorporate into their jargon some of the sloppiest language in the land. There are subcategories of fanzines: adzines, published for collectors and sellers of old comics; articlezines, which publish articles on subjects of interest; artzines, devoted to popular illustration and cartooning; stripzines, which publish original graphic story strips as well as reprint strips from the past; and even "Marvelzines," "EC-zines," "DC-zines," and so on, dealing with specific lines of comic books. They range from slick operations like *Witzend,* run by professionals, to mimeographed documents put out by semiliterate kids.

Compared with the smallest circulation commerical publications, fanzines have genuinely tiny subscription lists. Even the *most* successful have never reached more than 10,000 readers. Fanzines are produced for the sheer pleasure of it, and for them even to break even is an achievement. The oldest really successful, self-supporting fanzine was *Rocket's Blast Comicollector,* a combination adzine, artzine, stripzine, articlezine with a circulation of 1,600 per issue. It was a fairly competent production. Figure 151 is the cover of RBCC number 123, featuring Steve Fabian's version of a scene from my comic strip *Maxor of Cirod.* Fabian is a professional science-fantasy illustrator whose use of coquille board is worth a bit of study. Work like this is a donation to the fanzine and is one of the reasons that some fanzines have proved to be stepping stones to careers in illustration and design. The contents of RBCC number 123 were as follows:

25 pages—Advertising.

2 pages—LOCs (fandom slang for "Letters of Comment").

6 pages—Serialized reprint of Maxor of Cirod.

10 pages—Don Rosa's informational question and answer column on comics, pulp magazines, television, radio, and movies.

7 *pages—Critical article on TV's* Space: 1999.

3 *pages—Reviews of books, fanzines, and underground comix.*

4 *pages—Reproductions and comments on newspaper articles and features relating to motion picture* Jaws.

2 *pages—An article reprinted from a Star-Trek-zine.*

1 *page—Article on a convention of fans in Orlando, Fla.*

1 *page—Full-scale reprint in black and white of a one-page comic strip (1948) by Kurtzman.*

1 *page—An original one-page comic strip by Alan Hanley telling a werewolf anecdote.*

7 *pages—"Caged Animal," an original strip by Kerry Gammill.*

4 *pages—Continuing feature on Dell Comics, this one being Part II of a history of Walt Kelly's* Pogo *from Dell's funny animal comic books to the daily newspapers.*

All of the articles and features are illustrated with line and halftone reproductions by offset lithography.

Obviously, the RBCC was a goldmine of information for those interested in comics and it was well worth the cost per copy. Two, more recently founded fanzines of similar character are *The Comics Journal* and *The Buyer's Guide.* (For the addresses of these fanzines see the bibliography at the back of the book.)

Comics Journal and *The Buyer's Guide* editors Gary Groth and Alan Light might be interested in publishing your work. They are offered far more artwork than they can use even though all but a tiny bit is given free of charge. But if one of them does use your drawings, you will be inundated with requests from other fanzines begging for art to use. There are more people wanting to print fanzines than there are competent amateur or student artists interested in seeing their work published in association with cartoons. As far as you are concerned, this is good news. Quite a few professionals learned the ropes in fandom and went on to do underground or overground work. The underground was

a part of fandom to begin with. And the possibilities for original, unfettered expression are probably greater in fandom than anywhere else still today. As a matter of fact, they are so appealing that you may even wish to publish your own fanzine!

You will be able to turn out a pretty snappy-looking fanzine if you have read this book carefully and consult it along with some others as you proceed. For an articlezine, or anything else involving a good deal of text, an electric typewriter using a carbon ribbon is virtually mandatory. But we shall suppose that what *you* want to put out is your own comic book. Technically, you have all the information you need to do that.

The best printing method will be offset lithography, a technique that is almost universally available from commercial printers. To have a 28-page comic book printed will cost you a few hundred dollars for a fairly limited run. If you collate and staple it yourself you will reduce overhead quite considerably. But additional color increases expenditures spectacularly. The first thing you must do is buy a number of fanzines and study them. Then ask some local printers for estimates. (Any printer can print a comic book.) Be very, very clear about what you are planning to do. And, in this connection, before you lay out the fanzine, read some books on graphic production. The bibliography contains some superb ones. You will discover that some effects that look bafflingly difficult, and give the publication a sharply professional "look," are very easily accomplished. For example, a "dropout," which runs white line drawings or lettering across halftones, entails nothing but a note to the platemaker.

You may discover, once the estimates are in, that you will have to reduce the page count to 16 pages or even to 8. Or you may decide to use smaller pages. Most fanzines are 8½ × 11" and a few are half that size.

Once you know how much you can afford you can calculate how much to charge for the sale of the zine. Don't try to make any money. The idea is to break even on production costs and postage. If the first printing sells out and looks like a winner, you can always print a few more. By the second or third issue of the publication

you'll have a fairly good picture of the sales potential and you can increase your runs, thus lowering the price to you per copy and giving you a slight profit on the issue.

What you do beyond that is none of my affair. Perhaps you'll become another G. B. Love, the founder of RBCC, and actually make a living through the fanzine and its associated enterprises. Or maybe you'll go on to become a professional, as Robert Crumb, Berni Wrightson, Don Newton, and others have done. Perhaps, like philosophy professor Kenneth Smith, you'll produce a fanzine as a labor of love.

Smith publishes, on an irregular schedule, a fanzine entitled *Phantasmagoria.* Each issue is absolutely crammed full of stupefyingly intricate drawings of lizards, sea monsters, and curiously contrived humans and hybrids. They are cast as characters in provocative graphic stories. To enjoy Smith's stuff you have to like reptiles, rendering, or ratiocination. But *Phantasmagoria* is a good example of a fanzine published for the satisfaction of noncommercial, aesthetic ends.

One more thing you will have to know a little about if you are going to get into the fanzine business is copyright.

COPYRIGHT There are times when one needs an attorney. But copyrighting a comic strip isn't one of them. Your legal counselor will charge you plenty for his time and expertise. And what he can do for you in normal circumstance the Copyright Office will do free. All you have to do is write to it (Library of Congress, Washington, D.C. 20540) requesting its informational circulars on "Cartoons and Comic Strips" and "Copyright Notice." What follows does not substitute for the circulars, but it will give you some idea of what to look for and expect.

It is possible to secure a copyright on unpublished as well as published material. Since we are primarily concerned with the fanzine over which you will have control, I am restricting myself to published comic art. (Hopefuls are always interested in copyrighting their original art to

protect it from piracy. The work is usually not that vulnerable to theft, however.)

A copyright is not a patent; strictly, it is the right to copy or reproduce something. And what the Copyright Office in Washington does is register works so that the originator's rights (or rights of others legally entitled to them) are secure. It is, in other words, a source of evidence of ownership in the event your work is plagiarized or reproduced without proper permission and you wish to sue for damages or recompense. All you can secure copyright to is *expression* of an idea; the idea itself cannot be protected by copyright. Neither can the title of a comic strip or a cartoon. This doesn't, however, mean that you can start doing your own, original version of *Superman.* The copyright statutes don't cover everything pertinent to publishing. Titles and characters may sometimes be protected under the principles of common law and to determine whether a given case is or is not covered is a job for the courts and requires the help of legal counsel.

For your own protection always assume that whatever anyone else has published with a copyright notice requires permission to reproduce. The book you are reading reprints a lot of material covered by copyright. Each time someone other than myself held the copyright I had to write to them requesting permission to reproduce the image. And, being in the comic art business, most of these individuals and concerns charged me for their permission.[2] Most fanzine editors just go ahead and reproduce stuff with a credit line, either because they are ignorant of the law or because they realize that publishers are tolerant when no money is made from a suit and their products are being given free advertising. But invasion of copyright is a chancy practice. If you are going to reproduce anything from a comic book, for example, write to the publisher and say something like this:

[2]Indeed, the reason for including the author's own work was usually the high level of such fees, which—it may surprise you to learn—ordinarily run between $100 and $150 per use.

COMIXENE-ZINE
Thomas Tyro, Editor
188 North Elm
Midville, Ia. 51900

Stanley Wildino
Associate Editor
Nifty Magazines, Inc.
2148½ Mudison Avenue
New York, New York 10022

Dear Mr. Wildino:

 In the next issue of Comixene-zine, I am including an article
on your publication CLODMAN. May I please have your permission to
reproduce the following material:
 CLODMAN #19, page 6 (photocopy enclosed)
 CLODMAN #23, page 11 (photocopy enclosed)
This would be for one-time use only in Comixene-zine #2.
 Should you not control these rights in their entirety, would
you please let me know whom else I must write?
 Unless you indicate otherwise, I will use the following credit
line: © 1977 Nifty Magazines, Inc.
 I would greatly appreciate your consent to this request. As
you have surely guessed, Comixene-zine is an amateur publication
published to further the growth and development of the comic strip
as art. I am afraid that the only fee we can offer is our gratitude.
Should that be too little, I do, of course, understand and thank
you for your attention.
 For your convenience, a release form is provided below, along
with a copy of this letter for your files and a self-addressed,
stamped envelope.

 Very sincerely yours,

 (Thomas Tyro)

. .

I (we) grant permission for the use requested above.

Date_____

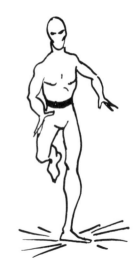

Sending such a letter will not insure receipt of permission; it won't even guarantee a response. But it makes it easy and inexpensive for the editor to reciprocate your courtesy. Demanding a lot of time and effort from a busy person just to do you a favor practically makes certain that your request will be filed in a wastebasket. So make it easy. Send a copy for his files and keep one for yours; give him a form to sign and be done with; be gracious enough to send along a self-addressed stamped envelope.

Getting proper clearance to republish old comics put out by companies that were dissolved 35 years ago is a difficult chore. Sometimes the present, legal holders of the copyright won't even know they own it. Frequently, they are impossible to trace except through title searches and similarly expensive work by attorneys. For a fanzine it may not in fact be worth the effort to try and track down the copyright holder since the chances of being sued are so negligible as to be practically nonexistent. That would not, however, be true of a profit-making venture. In any event, make a first attempt. The bibliography has works that will provide leads.

What will be required to secure the copyright on your own fanzine? First of all, it is essential that every published copy contain the notice required by statute. The precise form and position of the notice are set forth in the instructions appearing on the application forms you will be sent by the Copyright Office. The form for comic books is the same as that for published books of any kind. The specification is as follows:

The copyright notice for books shall appear on the title page or verso thereof, and shall consist of three elements: the word "Copyright" or the abbreviation "Copr." or the symbol ©, accompanied by the name of the copyright owner and the year date of the publication. Example: © John Doe 1970. Use of the symbol may result in securing copyright in countries which are members of the Universal Copyright Convention.

Make your notice obvious, clear, and follow the suggested pattern *exactly.* This is important because *if copies of the book are published without the required notice, the right to secure copyright is lost, and cannot be restored.* A

statement like this one has no copyright status at all: "Tom Tyro reserves all rights to entire contents. Nothing herein may be reprinted without written permission from the publisher." Without the copyright notice that assertion will give you some protection under common law *if* you can prove it preceded a theft.

The moment the book is off the press and assembled you send the following to the Copyright Office: (1) two copies of the publication, (2) the completed registration forms, and (3) the required registration fee (under $10). If you have done everything properly, you'll receive a carbon of the registration form bearing the official seal of the Copyright Office. If you have goofed up somehow, you'll be informed of why you have been denied copyright on the publication.

Securing your own copyright on cartoons or comic strips you have contributed to a magazine that is itself to be copyrighted requires a different form and a slightly different procedure. Similarly, cartoons and comic strips used as advertisements have their own special form. If you become *so* successful that your comic book appears at regular intervals under the same general title it becomes a "periodical" and, just like the overground comic books and syndicated newspaper features, must be copyrighted on a form appropriate for periodicals. All of this is described with admirable clarity in circulars available from the Copyright Office.

One of the great advantages of doing work that appears in the fanzines is that it can become part of your résumé and can be used to impress potential employers. Too, if you are trying to catch someone's attention by mail, printed material is a good deal easier and cheaper to send than is original artwork.

Other books will have information on how to make up résumés. Suffice it here to say that the more polished the work and the more variety in style, media, and technique, the better. Any portfolio of original and published art should contain examples of everything a cartoonist is apt to do, including straight illustration, funny animals, lettering, etc. It will be assumed by whoever looks at it that it represents the best you can do. It should be neat,

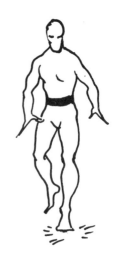

Fig. 152. *A portfolio should contain examples of everything a cartoonist can do — the more polished and varied, the better. The examples should be displayed, when feasible, in mats such as these*

CHIPBOARD

ARTWORK

TAPE

HINGE OF
PACKING
TAPE

WHITE,
PEBBLE-
GRAIN
MATBOARD

4"

4"

4¼"

CUT MAT SO THAT TOP AND
SIDES ARE EQUAL (AT
LEAST 3" WIDE) AND
BOTTOM *SLIGHTLY*
LARGER.

clean, and really sharp. Samples of original mechanicals, comprehensives, and so on should be matted as shown in Figure 152. (Tape the artwork to the backing sheet with stamp hinges or dermacil tape rather than masking tape because masking tape contains acids which, over prolonged periods of time, turn the paper it contacts brown.)

When you send artwork through the mails you ought to mail it flat, sandwiched between two sheets of corrugated cardboard sealed with nylon-reinforced gummed packing tape. Write or stamp on the package: *Artwork. Please do not bend.* Put your address inside on the back of the work so that if worse comes to worst there will be some way to identify its owner. Insure the package so that it will be easy to trace if it gets missent. Pay for a return receipt so you'll know that the material arrived, when it was accepted, and who signed for it. The Federal Postal Service goes awry often enough to make these precautions absolutely necessary. For years I never had any trouble at all in mailing artwork. Then, the mechanicals for an entire underground comic book, including the oil paintings for process color back and front covers, was lost. But, because it had been insured properly, Denis Kitchen, the head of Krupp Comic Works, was able to trace it down in the wilds of Chicago.

CONCLUSION One could go on and on. I have a tendency to do that, no matter what. But we have accomplished what we set out to do. Other books will advance your understanding far more than a longer version of this one could. I have tried to select the most useful of these to include in the bibliography. I hope that whatever remains unclear because of my carelessness or ignorance will be set right by the books of my betters.

We cannot have too many cartoonists, it seems to me. They are alert to the seeds of folly that lie germinating in all of our hearts. The credo of the courageous few was well phrased by the late Walt Kelly who said that "on this very ground, with small flags waving, and tiny blasts of tinny trumpets, we have met the enemy, and not only may he be ours, he may be us." And, to those who find such inky efforts a bit too transient, far too popular,

and infinitely lacking in all of those things that make us take high art seriously, I must say that I am ever reconvinced that the aesthetic emotion can blossom even in the poorest, most neglected soil as something no more elegant than a child's copy of a crude cartoon. Dreadful though this sort of thing may be to those of finer sensibility, it still harbors the little "leaven" that may at last leaven the whole.

Thus, I shall be pleased should this small lump of a book help leaven the whole of that field of Walt Kelly's where so many of us are fearful of meeting ourselves.

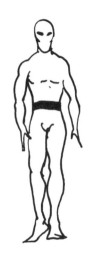

GLOSSARY

The following list contains many terms not used elsewhere in this book. Cross-references are indicated by words in small capitals.

Agate. A unit of measure used to calculate column space in newspapers. 1″ = 14 agate lines.

Airbrush. See index.

Arc Lamp. The light source used in platemaking. Usually, it is produced by a current arcing across two carbon electrodes.

Artype. Brand name for type printed on clear sheets that are waxed on the back. The letters may be cut out with a frisket knife and made to adhere to artwork by burnishing. Available in a wide range of fonts and sizes.

233

Backbone. The spine of a book—that is, the part connecting the back and front covers.

Backing-up. To print the reverse side of a sheet.

Basis Weight. The weight in pounds of a REAM of paper that has been cut to a standard size called *basis size.* (Basis size varies with different grades of paper.)

Bastard Size. Anything nonstandard in size.

Bite. In PHOTOENGRAVING this is the time needed to ETCH a given depth into the metal.

Bleed. To print a design onto paper so that its limit extends beyond the edge to be trimmed. In other words, to eliminate one or more margins.

Blocking. In LETTERPRESS, this is mounting an ENGRAVING onto a block of wood so that it will be raised to type height.

Blowup. To enlarge COPY. An enlargement of copy.

Book Paper. A category of paper used for printing. The other categories generally used are PULP PAPER and NEWSPRINT.

Bristol Board. See index.

Built-up Lettering. Refers to letter forms in which the outlines have been drawn mechanically and then filled in with ink.

Caption. Text accompanying illustrations, especially gag cartoons.

Chase. In LETTERPRESS, the frame into which type and ENGRAVINGS are clamped or LOCKED UP for printing.

Chipboard. A substantial board made from wastepaper. Gray in color. Used as a support for cloth or padded covers in bookbinding, it is ideal as backing for MATS, to use as a cutting surface, and for packing.

Coated Paper. Paper, the surface of which has been covered with pigment and adhesive to improve the

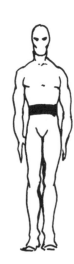

printing surface. Usually thought of as a glossy STOCK, it may be dull as well. Is especially well-suited to HALFTONES.

Collate. To arrange pages in such an order that when they are bound they will be read in the correct sequence.

Collotype. A printing technique using gelatine-coated, light-sensitive plates. Good for extremely fine and precise color reproduction of very limited PRESS RUNS, it produces truly graduated values without any HALFTONE dots.

Color Terminology. Printers use slightly different terms for color characteristics than do artists or laypersons. What most laymen call "the color," artists call "hue" (i.e., red, green, red-violet, yellow-green, blue, orange, etc.), and the printer refers to as CHROMA. Darkness or lightness, which artists usually term "tone" or "value," is called GRAY. And intensity of hue—how bright or dull the color is—is named STRENGTH by printers.

Column Inch. A measure used by smaller newspapers. It is based on a unit of space which is one column wide and 1″ long.

Comprehensive. An accurate representation of a design as it will appear when printed. In effect, it is an artist's conception of exactly what effect his design will have, containing all colors, display lettering, and so on. Common in advertising, it is not so suitable to most of the work cartoonists do as cartooning *per se.* There, LAYOUTS are usually sufficient to give an impression of the ultimate character of the image. Commonly, a comprehensive is referred to as a "comp."

Connected Dot. In either a plate or a negative, HALFTONE dots that touch one another. Thus, the dot pattern formed in a halftone field of 50% or greater value.

Continuous-Tone Copy. See index.

Copy. See index.

Copyright. The legal control of reproduction of a work.

Cropmarks. Short lines drawn on an OVERLAY or on the margins of a photograph so that if they were all connected they would indicate where a picture was to be trimmed.

Cut. Any printing plate. In Europe the term is *block.*

Cyan. Process blue. Turquoise.

Day-Glo. See FLUORESCENT INK.

Dead Metal. Areas in an ENGRAVING that must not print. These are routed out.

Deep Etch. When used in connection with ENGRAVING, the term refers to BITES beyond the initial etch. In offset LITHOGRAPHY, the reference is to recessing of the plate below the surface for printing areas in order to use it for very long PRESS RUNS.

Die-Cut. Excising a portion of a sheet of paper or cardboard by striking it with a set of steel blades formed around a die.

Dimension Marks. Arrows drawn on the margin of a MECHANICAL beyond the area to be reproduced to indicate the size of the printed image. In the break between the two arrows a notation gives the amount of reduction. (See Figure 103.)

Double Burn. Exposure of a plate to two or more negatives.

Dropout. To produce, in a HALFTONE, areas of solid white. This is commonly done with titles and other lettering in ads, magazines, and on book jackets.

Dummy. The mockup of a printed piece, showing where all the elements are to fit.

Duotone. A two-color HALFTONE made from a single black and white photograph by making two plates—one that emphasizes extreme contrasts of value between shadow and highlight, the other emphasizing middle values. The first plate is run in black ink over

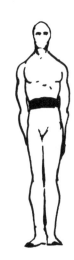

the second, which has been printed in a color. This creates a printed image with a full range of values and the appearance of being a monochromatic variation of the values of the color plate.

Editing. Checking COPY for quality, consistency, grammatical correctness, style, etc., before it is released to the printer.

Eggshell Paper. Drawing or printing paper having a surface similar to the texture and color of the shell of a hen's egg.

Elite. The smallest regular typewriter type. It has 12 letters per inch as compared to 10 in PICA type. See also PITCH.

Ellipses. Three dots used to indicate the omission of quoted material. For example: "Four score and seven years ago, our fathers brought forth . . . a new nation . . ."

Emboss. To produce a raised surface on a printed sheet by using male and female dies on a heavy-duty press.

Engraving. In commercial printing, a relief printing plate used by LETTERPRESS. More strictly, letterpress plates are PHOTOENGRAVINGS and the term "engraving" refers to a handmade intaglio plate printed by hand or by GRAVURE processes.

Etch. Acid solution used in platemaking. Thus the process of preparing a plate for printing by exposing it to such a solution.

Fake Process. MECHANICAL COLOR SEPARATION applied to reproduction. Common today nowhere except in the comic strip industry.

Fanzine. A magazine or tabloid published for, and usually by, enthusiasts of something having to do with the popular arts or the mass media. The majority of fanzines are concerned with fantasy-science-fiction or with comic strip art and popular illustration. English- and French-speaking countries seem to lead in publica-

tion of these largely amateur efforts, with the U.S. bringing out the most.

Feathering. In dry brush illustration, the use of a series of brief strokes to suggest the shaded edge of a form. In printing, the term refers to ragged edges in printed areas caused by poor ink distribution.

Flat. A grouping of film negatives, in register, attached to GOLDENROD or similar masking material. Placed against the plate and exposed ARC light, the flat conveys a positive image to the plate which can then be ETCHED and prepared for printing.

Flat-Tint Halftone. To print a black HALFTONE on top of a flat tint of another color. Also called a "fake DUOTONE."

Flexography. Aniline printing. Used widely in the packaging industry, this process uses wraparound plates made of soft rubber or plastic and very fast-drying inks. It is especially well-suited to printing onto irregular surfaces.

Fluorescent Ink. Inks containing substances that reflect ultraviolet light, producing an impression of extreme brilliance. *Day-Glo* is the best-known brand name of such an ink.

Flop. To turn a negative over so that the image is transposed.

Foot. The bottom of a page.

Form. Type and ENGRAVINGS locked into a CHASE for LETTERPRESS printing.

Format. Overall appearance of a piece of printed work.

Formatt. Brand name of a type printed onto acetate sheets with a self-adhering backing. Similar to ARTYPE.

Foundry Type. Metal type cast into hard metal and used in hand TYPESETTING.

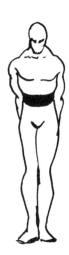

Fountain. The ink reservoir of a mechanical printing press. It is from such fountains that the ink is fed to the ink rollers and thence to the plate. In offset LITHOGRAPHY the term is also used to designate a reservoir that holds a *fountain solution* (made of water or alcohol, acid, gum arabic, and a buffer) used to dampen the plates so that blank areas will not accept ink.

Frisket. Any thin film that can be used to mask out areas to protect them; it can later be removed. Used by artists in airbrushing. Also, the term in LETTERPRESS for paper used to cover a part of the plate so that it does not print.

Furniture. Pieces of wood, metal, or plastic having a rectangular configuration and a height just below that of type. They are used to fill in areas around type and engravings when these are LOCKED UP in the FORM.

Galley. The shallow tray used to hold type forms not in use.

Galley Proof. An impression of type to be checked for errors. Normally, a galley proof will not be spaced out precisely and is not fully assembled. Casually, called "galleys."

Gang Printing. Printing various jobs on the same sheet of paper. The paper is then cut up so that the jobs are separated.

Goldenrod. A sheet of yellow-orange paper that is highly opaque and is used as a basis for STRIPPING negatives to make up a FLAT.

Gravure. A printing technique that is the commercial version of intaglio printing (such as line engraving or etching in fine art.) In intaglio printing the areas that carry the ink to the paper are *lower* than the surface of the plate. More expensive and capable of subtler effects than LETTERPRESS or LITHOGRAPHY, it requires better grades of paper for printing. The most familiar products printed in the manner are currencies.

Gray Scale. A set of gradations of values in 16 or 21 steps from white through grays to black. The steps are determined logarithmically rather than arithmetically and are used in processing photographic materials.

Grippers. The mechanical clamps or "fingers"that hold paper onto the impression cylinder of a press during printing and release it when an impression has been run.

Halftone. See index.

Halftone Screen. See index.

Head. The top of a page.

High Key. Describing CONTINUOUS-TONE COPY in which the majority of values are lighter than middle gray.

Holding Lines. These are lines drawn by the artist on the MECHANICAL to indicate the precise zone that will be used for a HALFTONE or an area of color.

Imposition. The way pages are set up in a press FORM so that after printing, BACKING UP, folding, and trimming, the large printed sheet will have the pages in the correct order.

Indirect Processing. A form of four-color process in which the original COPY is first SEPARATED into four CONTINUOUS-TONE negatives. These negatives are then screened separately. In ordinary four-color processing the copy is screened and separated in one step. The indirect method is slower but has several advantages. Color can be corrected by RETOUCHING, for example. But the major advantage is that the unscreened negatives can be enlarged or reduced to make any number of reproductions without having to go back to the original copy.

Italic. Slanted lettering, *like this.*

Job Press. Often, *jobber.* A platen press (see index) used to print small runs.

Justify. To make each line of type come out flush on the right, the left, or (as in this book) both, by adjusting

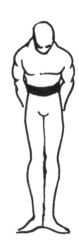

the space between words and letters to make the lines even. A printed page with *justified margins* has lines of type that are even on both sides. Typewritten pages usually have UNJUSTIFIED right-hand margins.

Kid Finish. Paper surface that is dull and smooth, having a slight roughness resembling the texture of kid leather.

Layout. The plan of a design, showing the positioning of various elements. Preliminary to a COMPREHENSIVE from which it is distinguished by tentativeness and lack of finish. Usually layouts are done in pencil on tracing paper.

Letraset. Brand name for dry-transfer type. Letter forms are printed on the back of a clear sheet, from which they are transferred to the MECHANICAL by burnishing.

Letterpress. See index.

Line Conversion. The modification of CONTINUOUS-TONE COPY into line copy by the use of special-effect screens that simulate cross-hatching, stippling, crayon drawing, fabric textures, line engraving, and so on.

Line Copy. See index.

Line Cut. A plate that prints a reproduction of LINE COPY.

Lithography. See index.

Lock-up. In letterpress, the positioning and securing of type, CUTS, and FURNITURE in a CHASE for a PRESS RUN.

Logo or Logotype. A trademark or emblem made of type characters linked to a common unit so that it can be printed as easily as a single piece of type. Used for trademarks and the like.

Lowercase. Small letters as opposed to capitals.

Low Key. Describing CONTINUOUS-TONE COPY in which the majority of values are darker than middle gray. Opposite of HIGH KEY.

Magenta. Process red.

Mat. A decorative cardboard frame for display and support of a piece of artwork.

Mechanical. See index.

Mechanical Separation. See *Separation, color,* in index.

Multilith. Brand name of a little offset press used to print small jobs. Manufactured by the Addressograph-Multigraph Company.

M Weight. A measure that is exactly one half that of BASIS WEIGHT. It is the weight of 1,000 sheets of paper stock of a given size. Written as 50M, 75M, 78M, 100M, etc.

Newsprint. An inexpensive grade of paper used for newspapers and other low-cost jobs. The BASIS WEIGHT is between 30 and 45 pounds. It has a coarse, absorbent surface.

Offset or Offset Lithography. See *lithography* in index.

Overground. Widely available, conventional, uncontroversial. Contrasted with UNDERGROUND.

Overlay. A sheet of transparent or translucent film or paper placed over a base MECHANICAL. It may be for protection, a part of the artwork, or a sheet carrying instructions for the platemaker.

Pagination. Numbering of pages in consecutive order.

Pencil. To draw with a pencil. A preparatory drawing done in pencil.

Photostat. Brand name for a specific kind of photographic print, often referred to as a *stat.* Original copy is photographed to make a paper negative from which the positive print is made. Stats are rather widely used in MECHANICALS as substitutes for VELOXES, but this should be avoided when possible because it is difficult to get sharp effects with them. Their best use is for indication of halftones in COMPREHENSIVES and in instructions to platemakers.

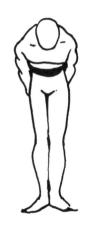

Pica. The most common typographic unit of measure. One pica is 1/6″ wide. To each pica there are 12 POINTS and 6 picas make one inch. Also, typewriter type that is 10 characters to the inch as contrasted with the smaller ELITE.

Pitch. A unit of width in typewriter type. It is based on the number of letters to the linear inch. ELITE is 12 pitch, PICA is 10 pitch.

Plate Finish. Paper surface that is hard and slick. Compare KID FINISH.

Point. The smallest typographic unit. It is 0.01383″, or about 1/72″. See PICA.

Press Run. The number of sheets printed.

Presstype. Brand name for a dry-transfer type. See LETRASET.

Process Camera. See index.

Progressive Proofs. Sample runs pulled of color plates showing each color in isolation and in combination with the others. The ordinary sequence in four-color process work is this: (1) yellow, (2) MAGENTA, (3) yellow + magenta, (4) CYAN, (5) yellow + magenta + cyan, (6) black, (7) yellow + magenta + cyan + black.

Pulp Paper. A low-grade paper that is coarser and bulkier than NEWSPRINT. Used for very low-cost printing. During the 1920s, 1930s and 1940s in particular, this rough stock was used for printing science-fiction magazines and other cheap, popular literature. Consequently, such magazines are known as *pulps.*

Push Pin. A tack used by commercial artists to hold work to drawing boards and tackboards. It has a cylindrical head that makes it easy to use without damaging surfaces around it.

Ream. 500 sheets of paper.

Recto. The right-hand page of a book lying open. Opposite of VERSO.

Register. Positioning one thing over another so that the elements of each have a correct relationship.

Retouching. Correcting or otherwise altering a photograph before it is reproduced.

Reverse. The technical jargon for a printed image in which the blacks and whites are in exact reverse of the original COPY. In other words, a printed negative. To achieve a reverse, the negative of the shot is used to make a positive on film instead of paper and this is then used to produce the plate.

Rough. A sketch that gives the general notion of the design. Sometimes called a *thumbnail sketch.*

Saddle-Wire Stitching. The common way of binding magazines and comic books by driving wire staples through the BACKBONE into the center-spread where they are clinched. Compare SIDE-WIRE STITCHING.

Scaling. Calculation of the amount of enlargement or reduction artwork is to undergo for reproduction. Usually expressed in form of percentages.

Screen. HALFTONE SCREEN.

Screen Process Printing. See SILKSCREEN.

Separation. See index.

Serigraphy. The production of fine arts prints by SILKSCREEN printing done by hand.

Side-Wire Stitching. Binding books or pamphlets by driving wire staples through the binding edge from the top sheet to the back sheet, where they are clinched. Compare with SADDLE-WIRE STITCHING.

Silhouette Halftone. A HALFTONE in which the main image has been set off so as to be isolated from any background or framing rectangle by eliminating the dots surrounding it. Sometimes called an *outline halftone.* See Figure 27 for an example.

Silkscreen. Usually today called *screen process printing.* A printing process in which ink is squeezed

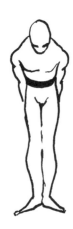

through a screen of silk that has been masked in places by a stencil. Photographic stencils may be used, even in HALFTONE form, as long as the dot pattern is very large and coarse. Silkscreen permits an extremely heavy application of ink or paint on practically any material. Posters are the graphic designs most frequently produced by this process. Printing may be done manually or by mechanical process.

Split-Fountain Printing. A printing technique that involves using one color in the left-hand side of the ink FOUNTAIN and another on the right-hand side so that the left prints a different hue than the right. As the rollers turn they blend the colors into a continuous graduation, producing a third color wherever the two original hues fuse. By using several dividers to separate pools of ink in the fountain, more than two colors can be used to produce rainbow, spectrum effects.

Square Halftone. Any rectangular HALFTONE. So called because the edges are "squared up" by machine-cutting them on a special machine.

Stereotype. Identical relief printing surfaces produced by taking a mold of papier-maché and asbestos (or plastic) from a LINE CUT or HALFTONE so that copies of these may be cast into metal. This is very common in the newspaper industry.

Stock. Any printing paper.

Stripping. Securing the assembled negatives to the FLAT. The worker who does this is called a *stripper* or *makeup man.*

Surprinting. Combining images from two different negatives by DOUBLE-BURNING. Especially when a line image, such as lettering, seems to be superimposed on a HALFTONE. (Compare DROPOUT.)

Swipe. The appropriation of an existing graphic image for use in one's artwork. While this may seem to smack of theft, the practice is general throughout the field of commercial art and is accepted. Thus, it is common to derive backgrounds from photographs and artists lift

one another's poses and lighting effects. Even the greatest, most original of the strip cartoonists frequently steal from themselves, putting old figures in new circumstances. What must be avoided at all costs is *plagiarism*—the actual copying of another's work. To derive an original image from another one is permissible; to imitate an original image is illegal. Needless to say, excessive reliance on swipes marks any artist as an uncreative hack who lacks imagination.

Thermography. A process used to imitate the EMBOSSED effect of true hand steel engraving by producing raised letters on a sheet of paper. It entails dusting the printed sheet while the ink is still wet with a resin powder that will adhere to the ink. When the sheet is passed through a heating unit designed for the purpose, the particles of resin fuse with the ink and cause it to swell up.

Thirty. Newspaper people use the symbol -30- at the end of typed COPY to indicate the end of the story.

Type-High. The height of a standard piece of type. In the United States that is .918''.

Type Metal. The alloy used to cast type. Basically, it is made of lead, tin, and antimony, and sometimes a tiny amount of copper.

Typesetting. Setting type up for printing. This can be done by hand, by machine, by phototypesetting. A person who sets type by hand or by machine is called a *compositor.* Typesetting is also referred to as *composing* type.

Typewriter Composition. Often called *direct impression* or *strike-on*, this is the composition of LINE COPY for reproduction by use of a typewriter. FANZINES are usually made up for the platemaker in this way since it is the cheapest of all composing methods.

Underground. Not widely available, unconventional, radical or controversial. Contrasted with OVERGROUND. Always has some overtones of the subversive.

Unjustified. Lines of type aligned on the left or the right side but ragged on the other due to uneven length. Unjustified right-hand margins are characteristic of typewriting. Compare JUSTIFY.

Uppercase. The capital letters in a typeface.

Varityper. Brand name of a unique typewriter that composes type in several styles and can JUSTIFY right margins semiautomatically. Manufactured by VariTyper Division, Addressograph-Multigraph Company.

Velox. A photographic print made from a HALFTONE negative. Since it is LINE COPY it can be used in a MECHANICAL along with other line copy. The name *Velox* is derived from Eastman Kodak's trade name for glossy photographic printing papers manufactured by them.

Verso. The left-hand page of a book spread open. Opposite of RECTO.

Vignette Halftone. A HALFTONE in which the background or perimeter fades imperceptibly into the surrounding white of the paper. In other words, a halftone with hazy edges. Done by airbrushing.

Wash Drawing. See index.

Watermark. A faint, translucent design used as a trademark by paper manufacturers. It is produced by a relief pattern of wire soldered onto a wire-mesh roller (called a *dandy roller*) that is used in the initial forming of pulp into paper.

Web. In printing, a continuous roll of printing paper.

Web-fed. Descriptive of presses that print from continuous rolls of paper.

Weight. Applied to type, this term has reference to the variations in thickness of elements of a given face from *light* through *regular* to *bold.* In connection with paper measurement it is synonymous with BASIS WEIGHT.

Woodtype. Type made from wood. Normally used only for display lettering over one inch tall.

Zinc engraving. Photoengravings made on zinc for LETTERPRESS.

Zip-a-tone. Brand name for a set of screen patterns imprinted on transparent film with an adherent backing. Dots, lines, and other patterns are available. Used to add dark and light values and decorative detail to MECHANICALS to be employed as LINE COPY.

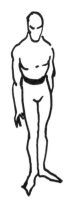

BIBLIOGRAPHY

ALDRIDGE, ALAN, AND GEORGE PERRY. *The Penguin Book of Comics.* Harmsworth, England: Penguin Books, 1967. A survey of comic strip art from its beginnings to the present. Reproduction quality is not always first-rate, but the treatment is generally good.

I. COMICS

BECKER, STEPHAN. *Comic Art in America.* New York: Simon and Schuster, 1959. A superb history of cartooning in the U.S.

COUPERIE, PIERRE AND MAURICE HORN. *A History of the Comic Strip.* New York: Crown, 1968. Excellent treatment of the comic strip from historical and critical viewpoints. International in scope, this book is the result of the Louvre Museum exhibition of original comic strip art in 1968. The approach is much more analytic than most attempts to deal with the comic strip.

DANIELS, LES. *Comix: A History of Comic Books in America.* New York: Outerbridge & Dienstfrey, 1971. A history of the comic book, including E.C. and Warren Magazines, as well as the underground. Touches on material that the other books neglect and is well worth having. Reprints many comic book stories in their entirety in black and white and a *Batman, Donald Duck,* E.C. horror piece, and *Sub-Mariner* in full color.

ESTREN, MARK JAMES. *A History of Underground Comics.* San Francisco: Straight Arrow Books, 1974. Paper. Fine history and commentary on underground comix. It includes much of the best work produced during the late '60s and early '70s, and Estren seems to have overlooked no one connected with the underground.

FEIFFER, JULES. *The Great Comic Book Heroes.* New York: Dial Press, 1965. Reprints in full color of major superheroes in some of Feiffer's favorite strips.

HORN, MAURICE, ed., *The World Encyclopedia of Comics.* New York: Chelsea House, 1976. 785 pp., illus. A genuine encyclopedia of comic art. International in scope, it is flawed but indispensable for anyone seriously interested in the form.

LEE, STAN AND JOHN BUSCEMA, *How to Draw Comics the Marvel Way.* New York: Simon and Schuster, 1978. 160 pp. illus. Exactly what the title says.

MUSE, KEN, *The Secrets of Professional Cartooning.* Englewood Cliffs, N.J.: Prentice-Hall, 1981. 330 pp., illus. By the author/artist of "Wayout", a strip syndicated by McNaught from 1964 to 1970. Quite good, especially on lettering at which the author excels.

ROBINSON, JERRY. *The Comics: An Illustrated History of Comic Strip Art.* New York: G. P. Putnam's Sons, 1974. A handsome volume by a top-flight cartoonist

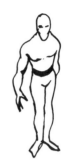

who has worked on every kind of strip and is highly intelligent and well-informed. Included are comments on different eras by celebrated cartoonists.

STERANKO, JAMES. *The Steranko History of Comics.* Reading, Pa.: Supergraphics, 1970, 1972, Vols. I, II. Paper. Steranko is another professional cartoonist and graphic designer. His own company publishes these books, which are the size of large magazines, and they are as innovative in approach as Steranko's work for Marvel Comics was. His treatment of pulps, production technique, and specific comic book heroes is vastly more thorough than that in any of the other books on this list. Additional volumes are promised.

WAUGH, COULTON. *The Comics.* New York: Macmillan, 1947. Waugh was also an innovator in comic strip art and his book is dated but highly insightful.

WERTHAM, FREDERIC. *Seduction of the Innocent.* New York: Rinehart & Co., 1954. The book that shot E.C. out of the comic book business.

II. FANZINES

LUPOFF, RICHARD, AND DONALD THOMPSON, ed. *All in Color for a Dime.* New Rochelle, N.Y.: Arlington House, 1970. Largely, an anthology of outstanding fanzine articles.

WERTHAM, FREDERIC. *The World of Fanzines: A Special Form of Communication.* Carbondale and Edwardsville, Ill.: Southern Illinois University Press, 1973. The only serious treatment of the fanzines by an informed outsider. In view of the abuse the fans have heaped upon him for his book *Seduction of the Innocent,* the author is singularly even-handed in his treatment of these amateur productions.

The Buyer's Guide, ed. Alan Light. 15800 Rt. 84 North, East Moline, Ill. 61244. Weekly tabloid. Contains ads, art, and articles.

The Comics Journal, ed. Gary Groth. Published by Fantagraphics, Inc. 196 West Haviland Lane, Stamford, Ct. 06903. Monthly magazine with some pretension of seriousness. Ads, art, articles. Editing of high quality and coverage very thorough.

Comics Scene, ed. Howard Zimmerman. Published by Comics World Corporation. 475 Park Avenue South, New York, N.Y. 10016. A commercially available trade publication. Very current.

III. GRAPHIC PRODUCTION

BIEGELEISEN, J.I. *Screen Printing.* New York: Watson-Guptill Publications, Inc., 1971. A very complete manual.

CRAIG, JAMES. *Production for the Graphic Designer.* New York: Watson-Guptill Publications, Inc., 1974. The best and most complete instructional manual for graphic designers I have yet seen. *Very* thorough.

GARLAND, KEN. *Graphics Handbook.* Paper. New York: Van Nostrand Reinhold Co., 1966. A small reference manual.

SCHLEMMER, RICHARD. *Handbook of Advertising Art Production.* Englewood Cliffs, N.J.: Prentice-Hall, Inc., 1974. A reliable textbook on the subject. Visually very dull, but deliberately so to reduce the cost.

SNYDER, JOHN. *The Commercial Artist's Handbook.* New York: Watson-Guptill Publications, Inc., 1973. A brief (264 pp.) but informative encyclopedia of things a commercial artist has to know.

Speedball Textbook. New York: Hunt Manufacturing Co., 1972. The standard Speedball lettering manual. Inelegant, but inexpensive and usable.

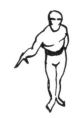

STONE, BERNARD, AND ARTHUR ECKSTEIN. *Preparing Art for Printing.* New York: Van Nostrand Reinhold Co., 1965. Similar to the Craig book and very nearly as good in coverage and clarity.

The Type Specimen Book. New York: Van Nostrand Reinhold Co., 1974. An extremely useful item for anyone doing graphic design. This contains 544 standard typefaces in complete alphabets and 3,000 sizes.

IV. DRAWING BOOKS

BRIDGMAN, GEORGE B. *The Book of a Hundred Hands.* (Originally published 1920.) New York: Dover Publications, Inc., 1971. Paper.

———, *Constructive Anatomy.* (Originally published 1920.) New York: Dover Publications, Inc., 1973. Paper.

———, *Life Drawing.* (Originally published 1924.) New York: Dover Publications, Inc., 1971. Paper. These books by Bridgman are a bit old-fashioned, but the material is still useful and the Dover paperback reprints are reasonably priced.

GOLDSTEIN, NATHAN. *The Art of Responsive Drawing.* Englewood Cliffs, N.J.: Prentice-Hall, Inc., 1973. An ingenious approach to drawing; emphasizes the conceptualization of interrelationships.

HOGARTH, BURNE. *Dynamic Anatomy.* New York: Watson-Guptill Publications, 1957.

———, *Dynamic Figure Drawing.* New York: Watson-Guptill Publications, 1970. These two books by the most creative of the Tarzan artists are academically sound and also peculiarly well-adapted to use by those interested in the human figure as it is used in comic strips of the adventure type. The later publication is the better of the two for general purposes.

Loomis, Andrew. *Creative Illustration.* New York: Bonanza Books, Division of Crown Publishers, 1947. Very dated in terms of graphic design, fashions, attitudes, and so on. Yet a trove of information about commercial illustration and traditional drawing and composition. A good addition to the library of the amateur, it will be of far less value to anyone with art school training in painting or drawing.

Nicolaides, Kimon. *The Natural Way to Draw.* Boston: Houghton Mifflin, 1941. A complete drawing course from a rather expressionistic point of departure. Still in use in many schools and colleges, it is a very solid approach, but is not especially appealing to most people interested in illustration.

Richardson, John Adkins, Michael J. Smith and Floyd W. Coleman. *Basic Design: Systems, Elements, Applications.* Englewood Cliffs, N.J.: Prentice-Hall, 1983. 330 pp., illus. A general introduction to design that contains discussions of perspective, composition, technical illustration, and graphic production techniques.

Walters, Nigel V. and John Bromham. *Principles of Perspective.* New York: Watson-Guptill Publications, 1970. The best and most complete treatment of the theory and practice of central projection (i.e., scientific perspective) on the market. It would be tough going to learn the system from this book without a little prior knowledge of rudimentary principles, however.

Watson, Ernest W. *How to Use Creative Perspective.* New York: Van Nostrand Reinhold, 1957. A good, conservative approach to applied perspective.

V. MARKETS *Artist's Market.* Writer's Digest, 9933 Alliance Rd., Cincinnati, Ohio, 45242. Annual Directory. See next entry.

Writer's Market. Writer's Digest, 9933 Alliance Rd., Cincinnati, Ohio, 45242. Annual directory. This is an invaluable aid for the free-lance cartoonist. It gives addresses, names of editors, the kinds of work accepted, and even the ways submissions, proposals, and contacts should be made, according to the requirements of each firm. *Artist's Market* is a "spinoff" published by the same company. It is useful insofar as it contains potential markets most of us would never have thought of.

BERLYE, MILTON K. *Selling Your Art Work: A Marketing Guide for Fine and Commercial Artists.* Cranbury, N.J.: A. S. Barnes, 1973. As far as the fine art side of this book is concerned, the author seems outrageously optimistic. But the commercial art parts of the book are excellent, dealing with everything from pricing and agents to how to keep financial records. Contains a comprehensive list of art schools and scholarships and fellowships.

VI. PROFESSIONAL JOURNALS

Cartoonist Profiles, ed. Jim Hurd. P.O. Box 325, Fairfield, Conn., 06430. Quarterly. A professional interest magazine entirely devoted to cartooning and cartoonists.

Cartoonews. East coast address: 561 Obispo Ave., Orlando, Florida, 32807. West coast address: 330 Myrtle St., Redwood City, Calif., 94062. An educational magazine for everyone interested in cartooning.

VII. ORGANIZATIONS THAT PUBLISH

Academy of Comic Fans and Collectors. P.O. Box 7499, North End Station, Detroit, Mich., 48202. An organization of people interested in comics from both avocational and vocational angles. Founded in 1963 by *the authority* on comic books, Prof. Jerry Bails. 2,500 members. Publications: *Comic Book Price Guide. Who's Who of American Comic Books.*

Art Directors Club. 488 Madison Ave., New York, N.Y., 10022. Professional organization of the people who do creative work at the "executive" level. 600 members. Founded 1920. Publication: *A.D. Cryer.*

Cartoonists Guild. 156 W. 72nd St., New York, N.Y., 10023. A trade association of free lancers primarily interested in improving economic circumstances of the cartoonist. 200 members. Founded 1967. Publication: *C.G. Newsletter.*

National Cartoonists Society. 130 W. 44th St., New York, N.Y., 10036. *The* professional society. 480 members. Founded 1946. Gives "Reuben Award" at annual meeting. Publication: Monthly newsletter.

Society of Illustrators. 128 E. 63rd St., New York, N.Y. 10021. Organization of professional illustrators. 600 members. Founded 1901. Publication: *S.I. Quarterly.*

VIII. ANIMATED CARTOONS FOR MOTION PICTURES

BRYNE-DANIEL, J. *Grafilm: An Approach to a New Medium.* New York: Van Nostrand Reinhold Co., 1970.

HALAS, JOHN, AND ROGER MANVELL. *Art in Movement: New Directions in Animation.* New York: Hasting House, 1970.

KINSEY, ANTHONY. *How to Make Animated Movies.* London: Studio Vista, 1970.

STEPHENSON, RALPH. *The Amimated Film.* Cranbury, N.J.: A. S. Barnes, 1973.

Page numbers are in roman type. Figure numbers of black-and-white illustrations are in *italics*. Colorplates are specifically so designated. Name of artists whose works are reproduced are in CAPITALS. Titles are in *italics*.